Glückauf

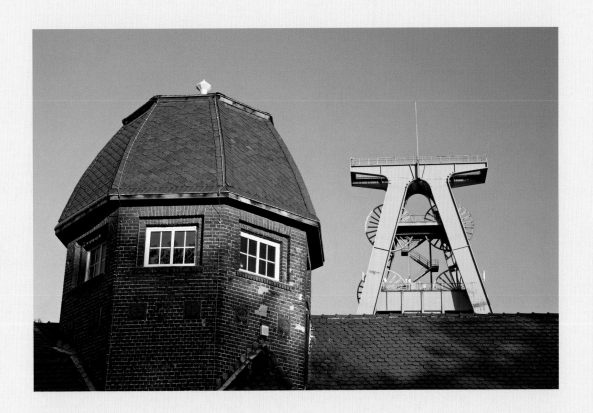

Journey through the

RUHR

Photos by
Brigitte Merz

Text by
Reinhard Ilg and Christoph Schumann

Stürtz

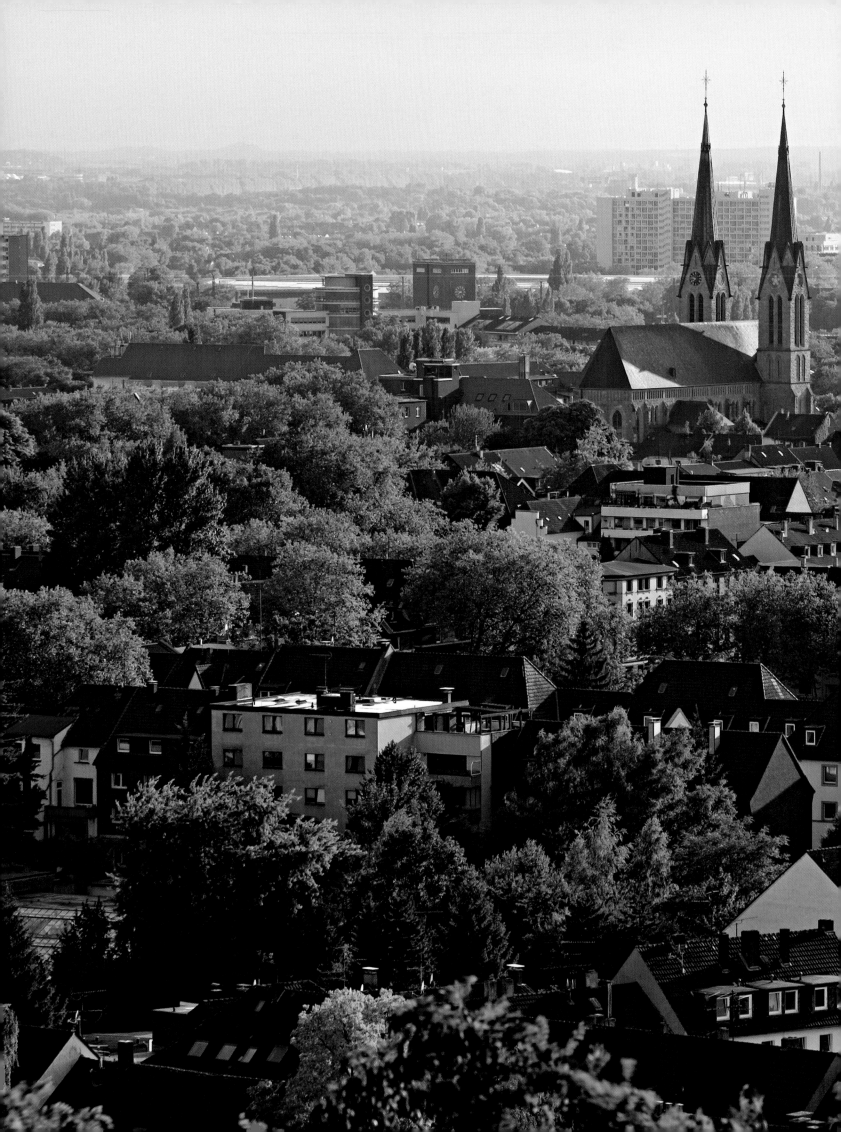

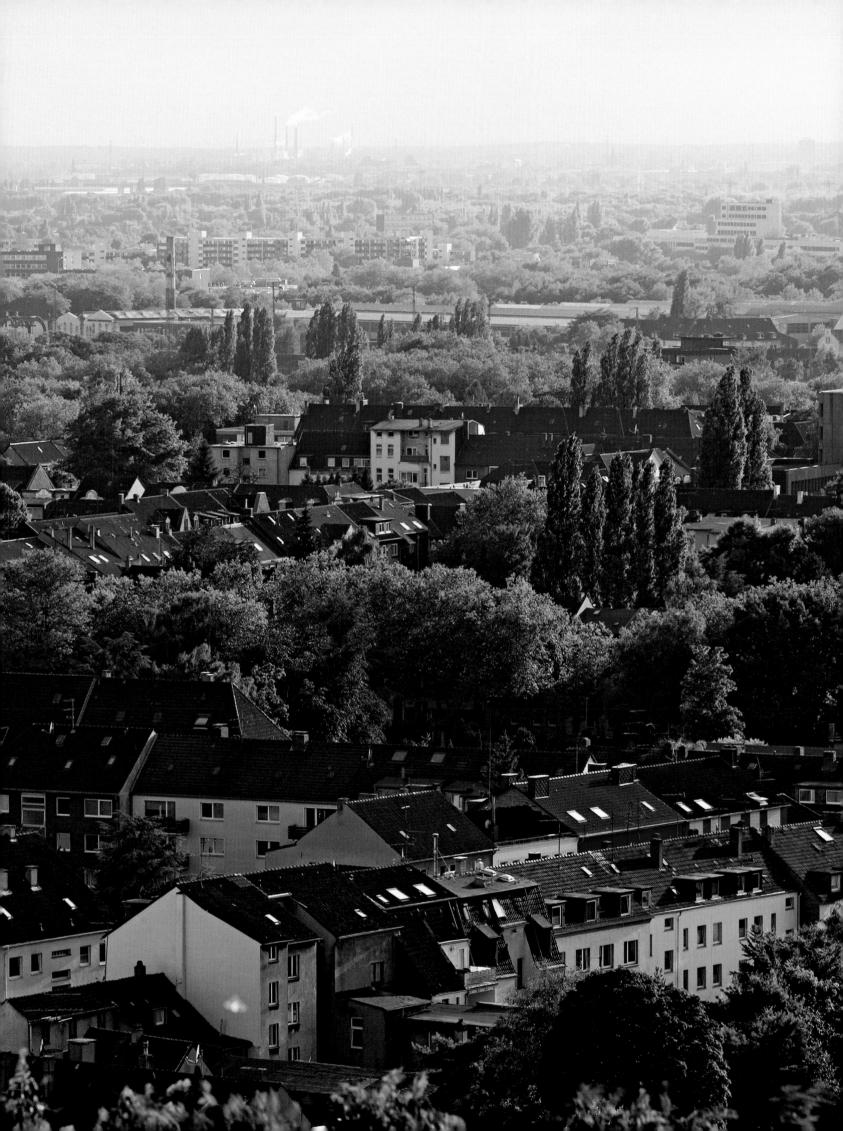

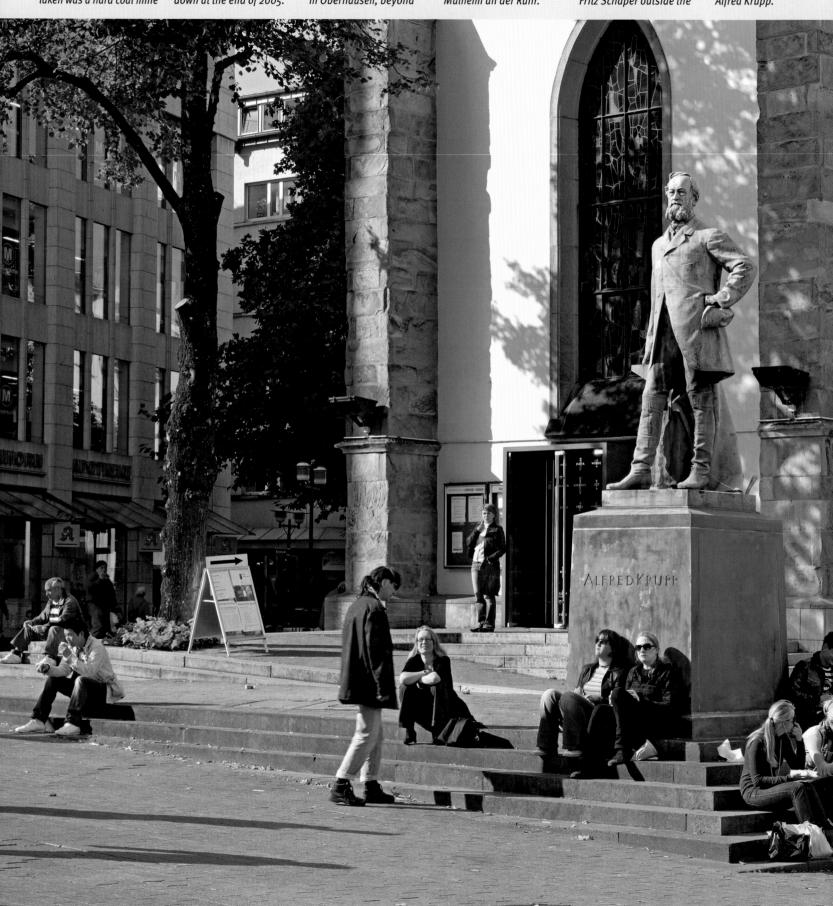

Page 10/11:
In the suburb of Alsum in the north of Duisburg the region is still its typical self, with smoking chimneys and heavy industry as far as the eye can see. From the top of the Alsumer Berg, a grassed-over mine dump, the enormous ThyssenKrupp Steel plant seems to dominate the landscape.

Contents

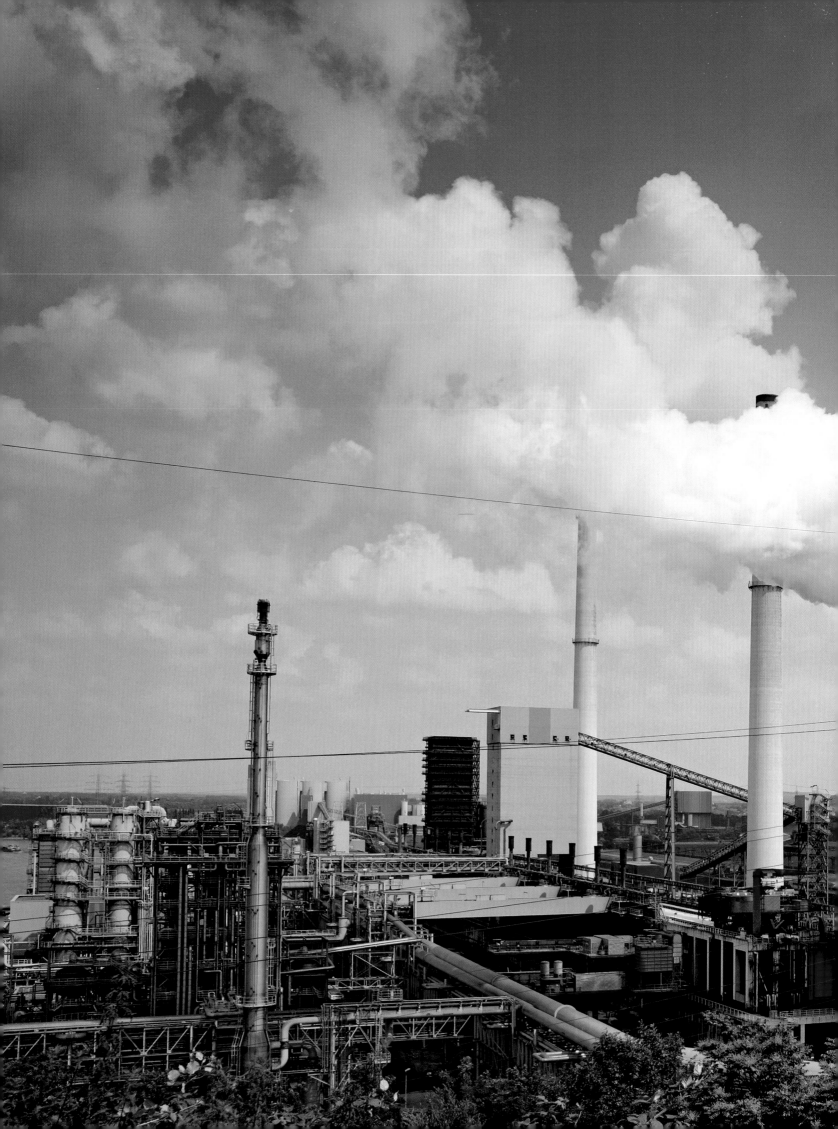

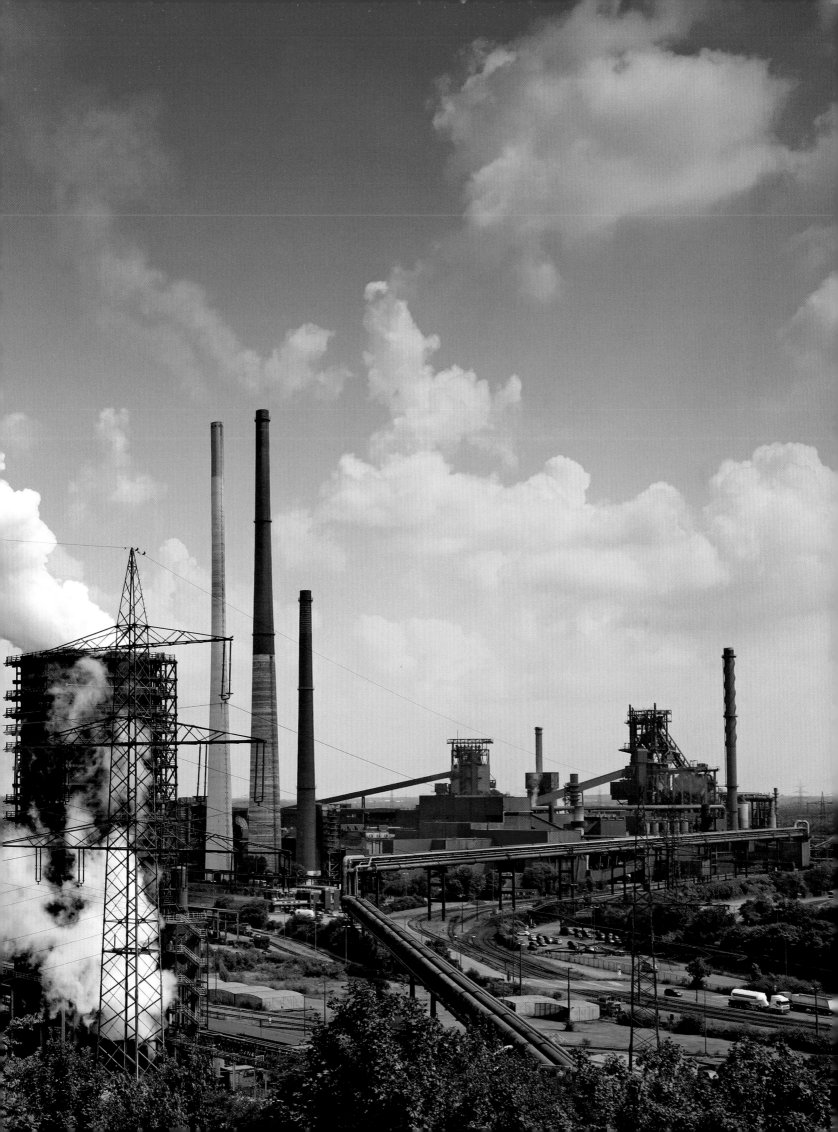

The Ruhr Basin – from mines to metropolis

Whether travelling by car or train, first-timers to the Ruhr are inevitably surprised and even confused by the rapid, apparently seamless transition of one town to another. Coming from Berlin and Hannover, drivers zoom past Dortmund on the A2/A3 motorways en route for Castrop-Rauxel, Gelsenkirchen and Essen. Oberhausen is signposted to the far west. Essen, the pulsating heart of the region, is a short trip along the A42. Further south, the A40 will take you from Dortmund in the east to Duisburg and Moers in the west. The old B1, Germany's first trunk road or *Bundesstraße*, traces the line of the historic Hellweg, once a major royal, military and trade route, making the ring road as heavily trafficked as any of the surrounding motorways and thus an indispensible artery serving the Ruhr Basin – as it was in the Middle Ages. There are also countless north–south links, such as the A45, A43 and A59, to name but a few. Travellers by train will also meet many of the cities of the conglomeration on their journey from Hamburg to Cologne, for example, rattling through Dortmund, Bochum, Essen, Mülheim an der Ruhr and Duisburg on their way south.

No less than 53 towns make up the truly vast area that is the Ruhr, all 4,435 square kilometres (1,712 square miles) of it. With 5.3 million inhabitants the region sprawled between the Lippe and Emscher rivers in the north and the Ruhr in the south, between the Rhine to the west and the Dortmund-Ems Canal to the east is the third-largest conurbation in Europe. People from around 140 countries have made

themselves a home here. When asked where they came from, the locals used to give the name of their native town; after all, what did people from Dinslaken have to with Recklinghausen?! And if you'd been born in Bottrop or Gladbeck, you could quite happily go through life without ever having been to Wattenscheid or Hattingen.

The Rhineland and Westphalia

This autonomy is rooted not least in a mentality that couldn't be more different: the west of the Ruhr belongs to the Rhineland, the east to Westphalia – and the borders are very distinct. The fact that the region is also split into three administrative districts – those of Düsseldorf, Arnsberg and Münster – means that there is no central representative body for the region, with repeated demands to this end voiced in vain. The official nucleus of the Ruhr is constituted by the members of the Siedlungsverband Ruhrkohlenbezirk, formed in 1920 and now the Regionalverband Ruhr (RVR) or regional association of the Ruhr. This includes the self-administrative cities of Bochum, Bottrop, Dortmund, Duisburg, Essen, Gelsenkirchen, Hagen, Hamm, Herne, Mülheim an der Ruhr and Oberhausen and the districts of Recklinghausen, Unna, Wesel and Ennepe-Ruhr.

Nevertheless, over the past few decades a sense of identity has grown in the Ruhr that now transcends city boundaries. Where people once came from the *Pott* or *Revier* (local terms for the Ruhr Basin), they now claim to be from the less colloquial *Ruhrgebiet*, with their native Rauxel, Dorsten or Essen-Kettwig mentioned as a clear second. Where in the 1960s and 1970s you didn't readily admit to being born in the Ruhr, it being something to be slightly ashamed of, today *Ruhries* no longer make a big secret of where they come from. On the contrary.

There is one exception to the rule, of course: football. Any sense of community immediately ceases as soon as the ref blows his whistle for the kickoff. Fans of FC Gelsenkirchen-Schalke 04 e.V. (or Schalke 04 for short, the "04" standing for 1904) are not particularly enamoured of supporters of Borussia 09 e.V. Dortmund, founded five years later. Matches between MSV Duisburg (1902) and VfL Bochum (1938) or between Rot-Weiß Oberhausen (1904) and Rot-Weiß Essen (1907/1923) are also real derby days. The first genuine football club in the region is, incidentally, the one in Witten started in 1892 – like all the others not actually a sports club for the workers but a ball sports association founded by wealthy citizens with a penchant for England.

The Ruhr from above

Once called the *Ruhrpott* or just *Pott* for its many mines and blast furnaces, until the end of the 1980s the region was much as singer Herbert Grönemeyer described it in his hymn to Bochum in 1984: "vor Arbeit ganz grau" or grey from work. Thankfully, this colour has changed to the "blue skies above the Ruhr" Willy Brandt demanded to see in 1961, with plenty of culture and nature to be (re)discovered here.

The best impressions are had from above. From the top of the viewing platform of blast furnace number 5 in the industrial park in Duisburg-Nord, the old iron and steelworks in Meiderich, for example, you can gaze out on your torch-lit tour over the Rhine towards the Lower Rhine in the west and, looking east, to the brightly lit skyscrapers in the centre of Essen or to the Tetrahedron in Bottrop. Even more spectacular are the views from one of the most famous industrial cathedrals of the Ruhr: the gasometer in Oberhausen, 117 metres (384 feet) high. Built in 1929 as a vast storage tank for coke oven gas, the monument on the Rhine-Herne Canal has long become one of the most exciting exhibition halls in Germany. It was here, for example, that in 1999 the masters of wrapped art Christo and Jeanne-Claude staged their The Wall project featuring 13,000 old oil barrels.

The view from the top of the gasometer has also been noted for posterity in a song written by Oberhausen cabaret artists Gerburg Jahnke and Stephanie Überall. Their *Heimatlied* goes along the lines of: why bother with Munich and Hamburg when you can have Oberhausen, standing on top of the gasometer in a howling gale? Whether you feel you can echo these sentiments or not, there's probably nowhere between Duisburg and Dortmund that better illustrates the change the Ruhr underwent in the last two decades of the last millennium. There's also CentrO in Oberhausen-Sterkrade, Europe's biggest shopping centre that now covers the site where at the beginning of the 1990s a steelworks still stood. Towards the north are the green parklands of the regional garden show held here in 1999 – once the coalmine in Osterfeld.

Not far from Oberhausen there are many other marked examples of the structural change that has greatly altered the Ruhr in the past four decades. Countless old mining sites have been transformed into service centres or arts venues and areas of leisure. The lingering goodbyes the Ruhr is saying to the pits and winding towers that dominated it for 150 years are being turned into words of welcome, extended to new and modern branches of industry, such as information technology, medicine, logistics

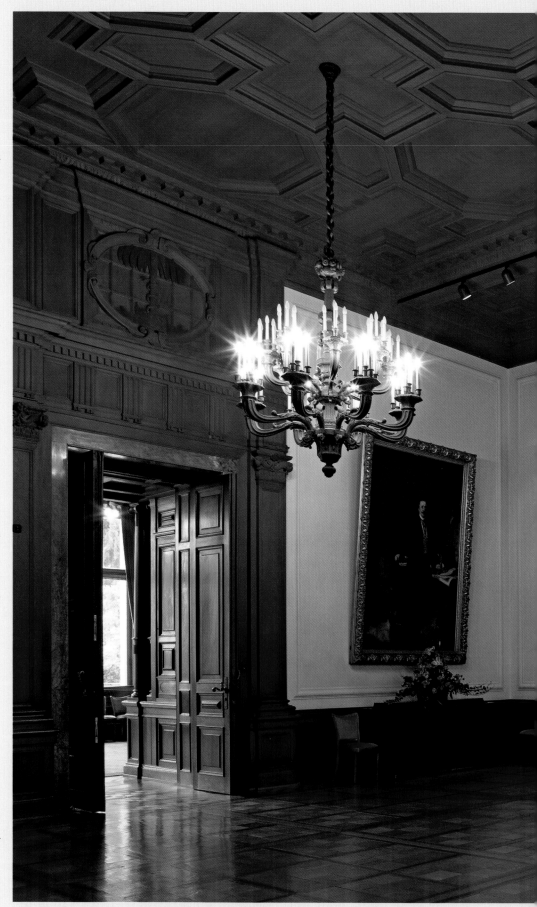

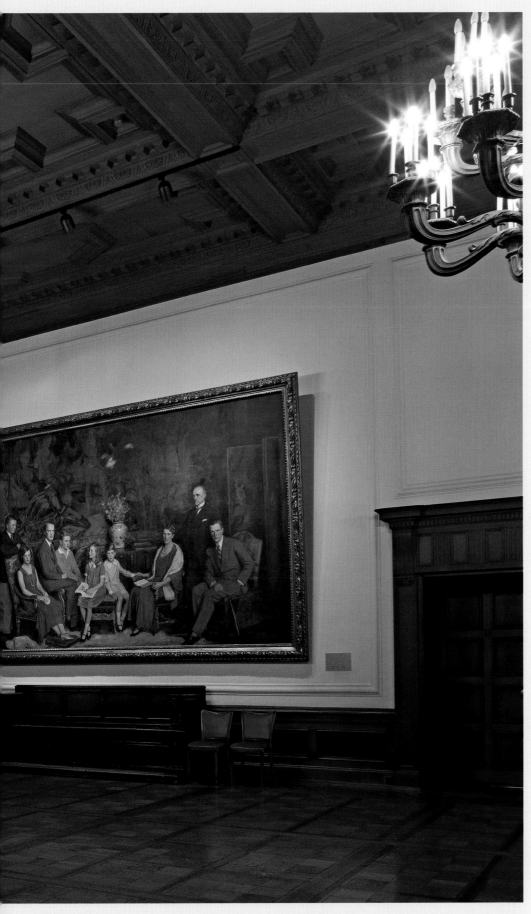

and various water and electricity providers. The economic focus of the *Kohlenpott* has shifted, even if coal and steel continue to play an important, albeit much reduced role here.

Fewer and fewer miners

Just looking at the number of people employed here shows how greatly the Ruhr has been affected by its structural reshuffle since the mining industry began its long demise in the mid 1960s. In 1957 over 470,000 were employed in the pits; now just 30,000 find work in this sector, with numbers falling. Out of the 141 mines that once extracted hard coal, just six are still in business. The two to be closed most recently were those in Lippe and Duisburg-Walsum in 2008. By the end of 2012/start of 2013, three more are scheduled to terminate activity. After the decree passed by the German federal and local governments to abandon coal as a source of energy, the mining of hard coal in the Ruhr Basin is to be completely stopped by 2018.

The majority of jobs has also been lost in the steel industry over the past few decades. At the end of the 1950s the Ruhr had over 300,000 working in steel; now there are just 57,000. Between Recklinghausen and Hagen, Mülheim and Bochum, since the mid 1980s more people have been employed in the service industry than in production. The services sector provides about 1.4 million with jobs as opposed to the 700,000 manning the area's industrial sites. Yet this growth in services has not been able to cushion the loss of around 445,000 jobs which have been cut in the manufacturing industry since 1976 alone. The rate of unemployment in the Ruhr is thus on average about three percent higher than for the rest of North Rhine-Westphalia, with the former hubs of the mining industry – Gelsenkirchen, Dortmund and Duisburg – top of the unemployment league.

The beginnings of the Ruhr

The end of the mining industry and the loss of jobs came as hard and fast as the development of the Ruhr itself. Like the nearby Münsterland and the Lower Rhine, at the end of the 18th century the region was still given over to farming. Along the Hellweg in particular – now the A40 motorway – there were clusters of Hanseatic towns, free cities and sleepy villages. The biggest urbanities were Duisburg and Dortmund with over 5,000 inhabitants. At this time the municipality of Mülheim an der Ruhr to the south was home to a staggering 11,000 plus. Gelsenkirchen and Herne in the northerly Emscherland numbered a mere couple of hundred occupants apiece.

The dawn of the industrial age in the Ruhr was heralded by various ironworks dotted about the countryside, such as the St-Antony-Hütte in Oberhausen-Osterfeld, opened in 1758, the Gutehoffnungshütte in Oberhausen-Sterkrade from 1782 and the Neu-Essen ironworks in Oberhausen-Lirich (1791). They developed important methods of extracting iron by mining ore that was smelted using charcoal. Hard coal was mined in the region from the 13th century onwards. The Muttental near Witten and Hattingen are credited as being the cradles of mining in the Ruhr, with industrial production beginning post 1800. Then things began to happen very quickly; within a few decades over 220 mines had sprung up in the Ruhr area, with the number growing to almost 300 by 1850. Coking plants turned coal into coke needed to fire the blast furnaces of the iron and steelworks to make pig iron and steel. Before the coal resources were exhausted along the River Ruhr, new mines were opened further north and Ruhr mining 'walked', following the seams deep underground, from south to north, from the Ruhr to the Emscher and further up to the Lippe rivers.

Guests who stayed

The economic boom of the Ruhr called for more and more workers. The population practically exploded; where Bochum had 2,200 inhabitants in 1800, by c. 1900 this number had risen to 65,000 and to a staggering 117,000 by 1905. What had been tiny hamlets enjoying a peaceful existence on the banks of the Emscher morphed into giant urbanities. Miners flooded to the Ruhr from the east of the Prussian empire, with an estimated 70,000 immigrants arriving between 1870 and 1914, many of them from Poland and Silesia. The pit workers usually lived on special workers' estates known as the mine colonies. It was here that in the late 1950s Germany's first immigrant workers moved in

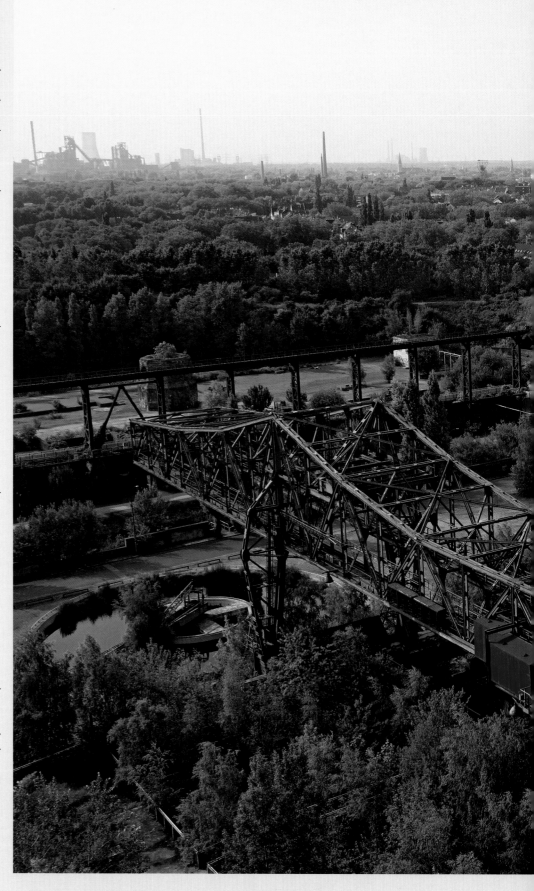

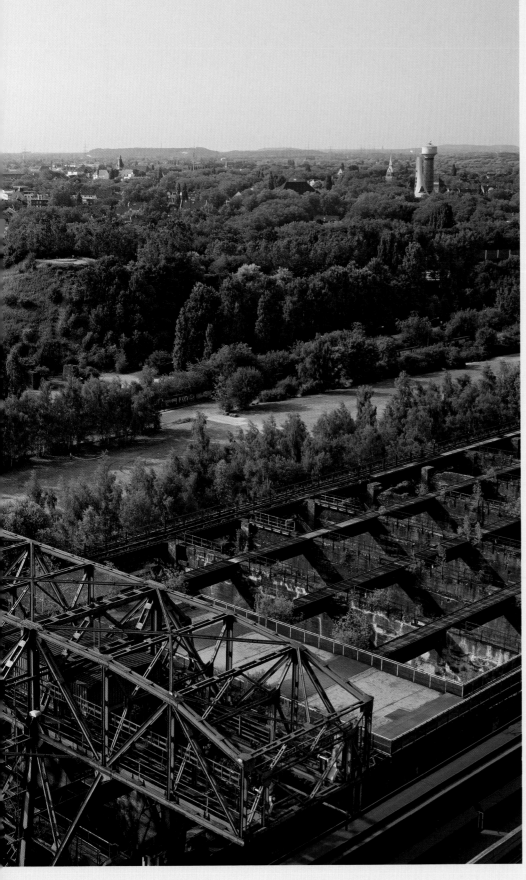

The Landschaftspark Duisburg-Nord, the city's industrial park. From the top of blast furnace number 5, where work at the Thyssen ironworks came to an end in 1985, you can look out across the entire site. The place where steel was once produced was turned into Europe's largest multi-functional park in 1994, complete with enormous climbing frames, diving pools and plenty of culture presented in a historic setting. In the background is Duisburg-Hamborn with its church.

after the Second World War. Enticed by the promise of work in the humming *Ruhrpott*, which boasted full employment, they came from Italy, Spain, Yugoslavia and even a few from Greece. In 1960 they were joined by people from Portugal and Turkey, 'guests' who, like their predecessors 80 years before, have long since made the Ruhr their permanent home. With them came the distinctive names, epitomised among others by police inspector Horst Schimanski in the popular German TV series *Tatort* (scene of the crime). The local lingo itself, often rather casual-sounding to the uninitiated and frequently referred to as a dialect, is a mixture of German spiced with many words loaned from Polish and Yiddish, including "Mottek" for hammer, "Kokolores" for nonsense and many more. The Germans of the Ruhr are also famous among their countrymen and women for their minimalist use of grammar with as few cases as possible and, perhaps as a logical consequence of this, for their love of abbreviated speech and contractions, all of which can be explored at leisure – and in German or 'Ruhrspeak' – in Claus Sprick's book *Hömma! Sprache im Ruhrgebiet* and online at www.ruhrgebietssprache.de. The unforgotten voices and protagonists of the Ruhr are Adolf Tegtmeier, alias Jürgen von Manger, and his alter ego Herbert Knebel, alias Uwe Lyko. They have one thing in common with their live role models: it's easy to get talking to people from the Ruhr about just about everything, whether you're at the market, on a tram or paying one of the estimated 18,000 typical kiosks or *Trinkhallen* a visit.

Soon a thing of the past: hard coal

Like actor Götz George, who in his final case as police inspector Horst Schimanski in 1991 hurls his famous jacket out across the rooftops of Duisburg and with it his proletariat identity, the Ruhr has also lost more and more of its old image. Travelling through the Ruhr today you can still see plenty of winding towers from the coalmines – but many of them are now defunct. From the 141 mines extracting about 125 mil-

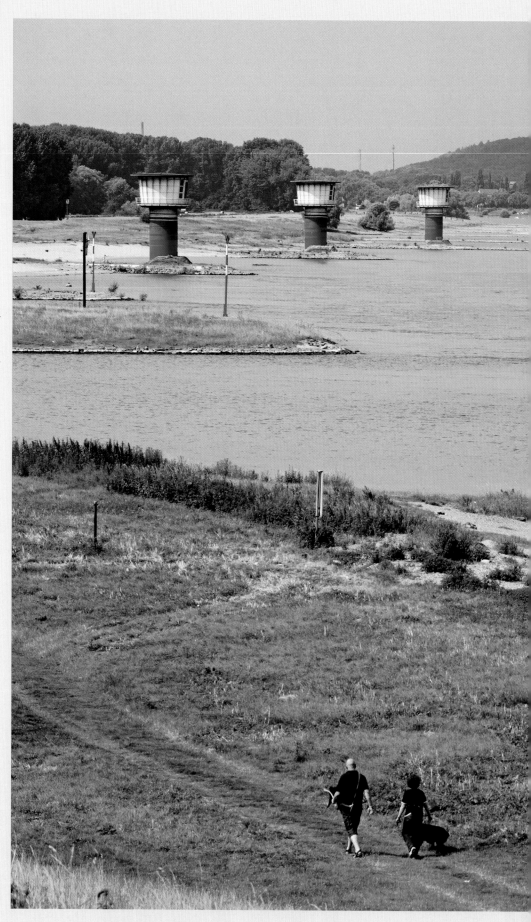

lion metric tonnes of coal a year from the bowels of the earth at the end of the 1950s, only six are still open, producing an annual 17 million tonnes between them. Politically it has long been decided that the mining of hard coal is to continue to drop (to ten million tonnes by 2013) and finally terminated in 2018. Part of the deal is, however, that the German government re-examine their decision in 2012. This scheduled termination of the hard coal industry has also lead to changes in the indigenous business environment. Mine operator Ruhrkohle AG (RAG), itself a product of Ruhr coal and once synonymous with Ruhr mining, is no more. RAG's technology division, with its subsidiaries Degussa (special chemicals) and Steag (power stations and energy) and the RAG real estate sector were fused in 2007 to form the conglomerate Evonik Industries. In the meantime the coal faction was swallowed by the RAG-Stiftung, the foundation which is also the majority shareholder of Evonik. The aim of this construction is that the foundation gradually introduces its shares in Evonik to the money market, using the expected profits of around four billion euros to cover any long-term 'terminal expenses'. These include all costs generated by the closure of the pits – such as any future damages attributable to the mines, the draining of the pits that continues to be necessary and pensions for retired miners.

Of steel and electricity

As far as energy is concerned the Ruhr is still highly powered – and not just by its coal. The region always has been and still is Germany's largest producer of electricity, with power stations fuelled by coal and also gas and oil. The entire energy sector is also a great generator of wealth and growth in the area. Essen, for example, is the headquarters of Germany's power industry, with giants RWE, Evonik and Europe's leading grid gas company Ruhrgas based here.

The situation is similar for steel. "Smaller but still alive and kicking" would be a suitable way of describing the current economic climate in this branch of industry, even if it did suffer

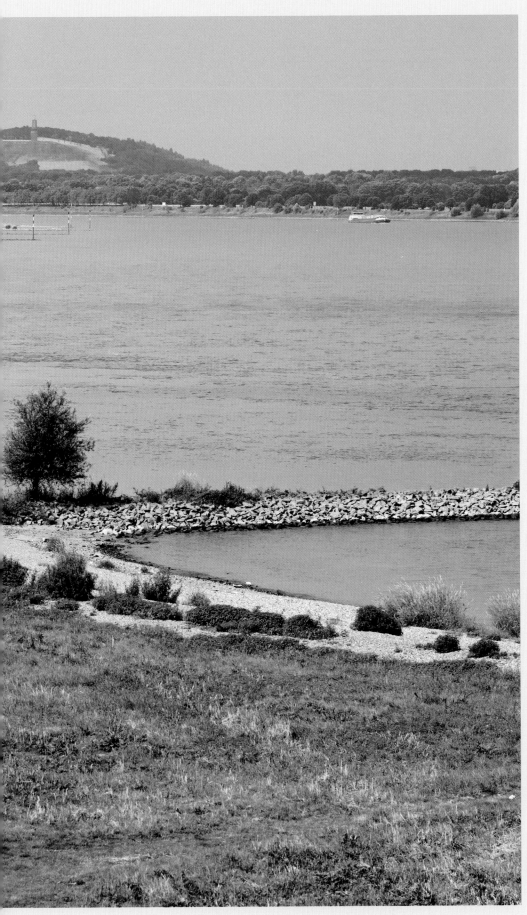

from the repercussions of the economic crisis of 2009. After countless fusions of former competitors ThyssenKrupp Steel AG is now the boss and with an annual production of 15 million metric tonnes of flat steel one of the biggest manufacturers of steel the world over.

The highly-productive steel manufacturing industry, where just a handful of staff can operate huge plants with the help of up-to-the-minute technology, is largely concentrated in the Duisburg area, the largest steel city in Europe where steel is still the chief employer. ThyssenKrupp also represents the successful structural transformation of a former mining giant. Even if the steel business is going well at present, not least thanks to the high purchase prices, it is just one of the concern's many economic activities. Over two thirds of ThyssenKrupp's turnover are attributable to items of capital expenditure, trade and services. By moving its headquarters to Essen ThyssenKrupp has turned its back on Düsseldorf and gone back to its roots; it was in Essen that Friedrich Krupp founded his company of the same name in 1811, with Thyssen launched by August Thyssen in Duisburg-Hamborn in 1891.

Keyword: structural change

The coal and steel crisis of the 1960s and 1970s hit the engine driving (West) Germany's postwar economic miracle hard. It forced the region to rethink its economy. In place of Ruhr coal, more expensive than coal mined in many other countries, the industry began relying more and more on cheaper crude oil and imported coal. In the mid 1970s the steel industry began to flounder, largely as a result of increased pressure from international competitors, making hundreds of thousands redundant. The region seemed doomed. Tax revenue from heavy industry sank. The area's fixation on coal and steel made it practically impossible for other branches of industry to become established here. The Ruhr was faced with the daunting task of more or less reinventing itself, naturally not possible without hefty financial support. Thanks to grants amounting to billions of Deutschmarks, provided as part of a special Ruhr development programme launched in 1968, within the space of a few decades a completely new economic and educational environment evolved. The first university in the region was founded in the mid 1960s in Bochum. There are now six of them, plus nine universities of applied science and Essen's Folkwang University which is devoted to the teaching of music, drama and dance, design and science. Witten-Herdecke is also home to Germany's first private university.

The region's structural metamorphosis gathered momentum in the 1980s with the founding of various centres of technology and business. Around 30 technology centres now service over 600 technology-orientated companies. The technological leader in Germany is the Technologiezentrum Dortmund at the city's university, focussing on biomedicine, environmental technology and mechanical engineering. Dortmund was once an industrial triad of coal, steel and beer, a combination typical of the Ruhr. Coal and steel are now a thing of the past – and of its eleven breweries just two are still open. The famous Dortmund U is synonymous with this change; once the symbol of the Union Brewery not far from the main station, visible for miles around, under the protected historic trademark a new venue is now being setup for the creatively inclined.

The change on the other side of the River Ruhr has proved similarly radical. On the site of what was the Krupp steelworks in Duisburg-Rheinhausen a modern success story is unfolding. Here, as an extension of Europe's biggest inland harbour, a new nerve centre has grown up for the flow of goods within Germany, Europe and to and from the big North Sea ports. Logport, the logistics centre founded at the end of the 1990s, even has its own harbour basin and a container terminal. Over 40 companies employing over 3,000 people have established themselves here, providing half as many jobs as the former Krupp site which its employees fought hard (and unsuccessfully) to keep in 1987 in a campaign that has remained unforgotten.

Tourism + culture = the future?

The retreat of coal and steel has opened up new avenues for the Ruhr in two very different fields: tourism and culture. Many of the once inaccessible industrial sites are now major attractions which are both imposing and appealing. These include the Zeche Zollverein in Essen, a UNESCO World Heritage Site, the Duisburg-Nord industrial park and the gasometer in Oberhausen. There seems to be plenty of interest here; with a turnover of about 1.2 billion euros and 14,000 official jobs – almost as many as the number of permanent labourers still manning the mines in a few years – tourism has become an economic factor on the Rhine and Ruhr that is to be taken seriously.

Besides the many industrial monuments there are plenty of other tourist magnets that are increasingly centring on art and entertainment in the region. Among these are the family-friendly Movie Park Germany in Bottrop and countless theatres, museums and musical venues, from the Folkwang Museum in Essen to the theatres in

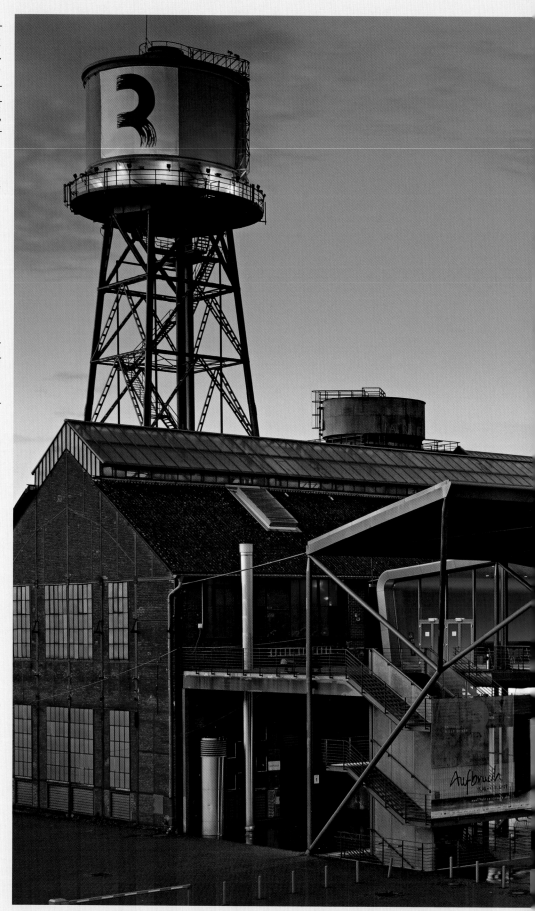

The Jahrhunderthalle in the Bochum suburb of Stahlhausen is on the Industrial Heritage Trail that cuts right through the middle of the Ruhr. Now a popular arts venue, the hall was originally built in 1902 for the Düsseldorf trade exhibition. The steel construction is an early masterpiece of engineering; it could be completely disassembled and was moved from the Rhine to Bochum where for years it functioned as a blower house for the Bochumer Verein's blast furnaces.

Bochum and Essen to the concert hall in Dortmund, the Deutsche Oper am Rhein (opera house), the Starlight Express Theatre in Bochum and the Colosseum musical theatre in Essen – to name but a few. The international climax of this structural change is the Ruhr2010 festival, during which the Ruhr will spend one year celebrating itself as both one huge metropolis and the European Capital of Culture. Whether the motto "We're creating a new form of energy. It's called culture" will prove forward-looking and sustainable enough in the Ruhr Basin after its great structural change – and also provide enough jobs – will only be discernible in the years or even decades to come.

Page 22/23:
Once a railway port and now a set for TV detective series and a place of leisure and recreation, in Duisburg-Ruhrort the cargo ships have been usurped by pleasure boats. Like in many other places in the Ruhr, the industrial warehouses of old are to be replaced by modern apartments and offices.

Page 24/25:
The old town of Essen-Kettwig is one of the most picturesque venues in the Ruhr. Once a village in its own right, Kettwig became part of Essen in 1975. The historic market church and many half-timbered houses are among its distinguishing features. The Kettwig bridge over the Ruhr in the foreground was first mentioned in 1282.

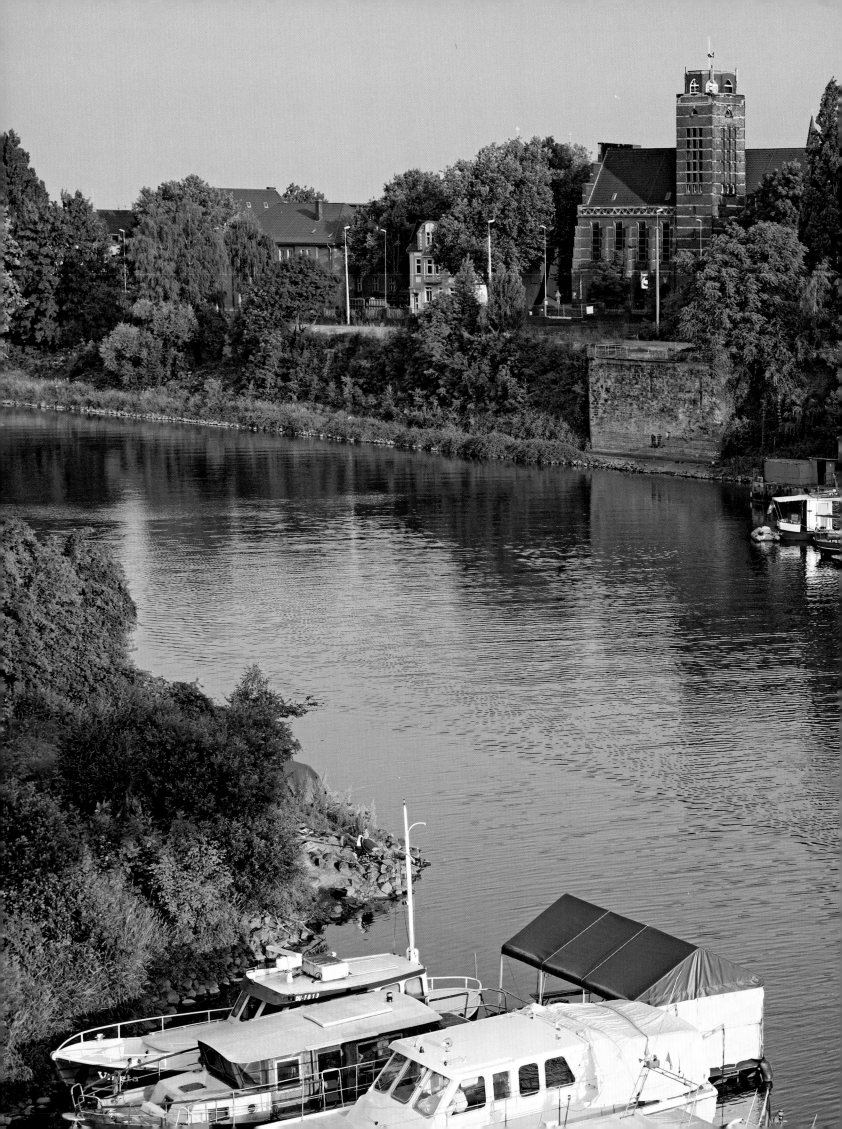

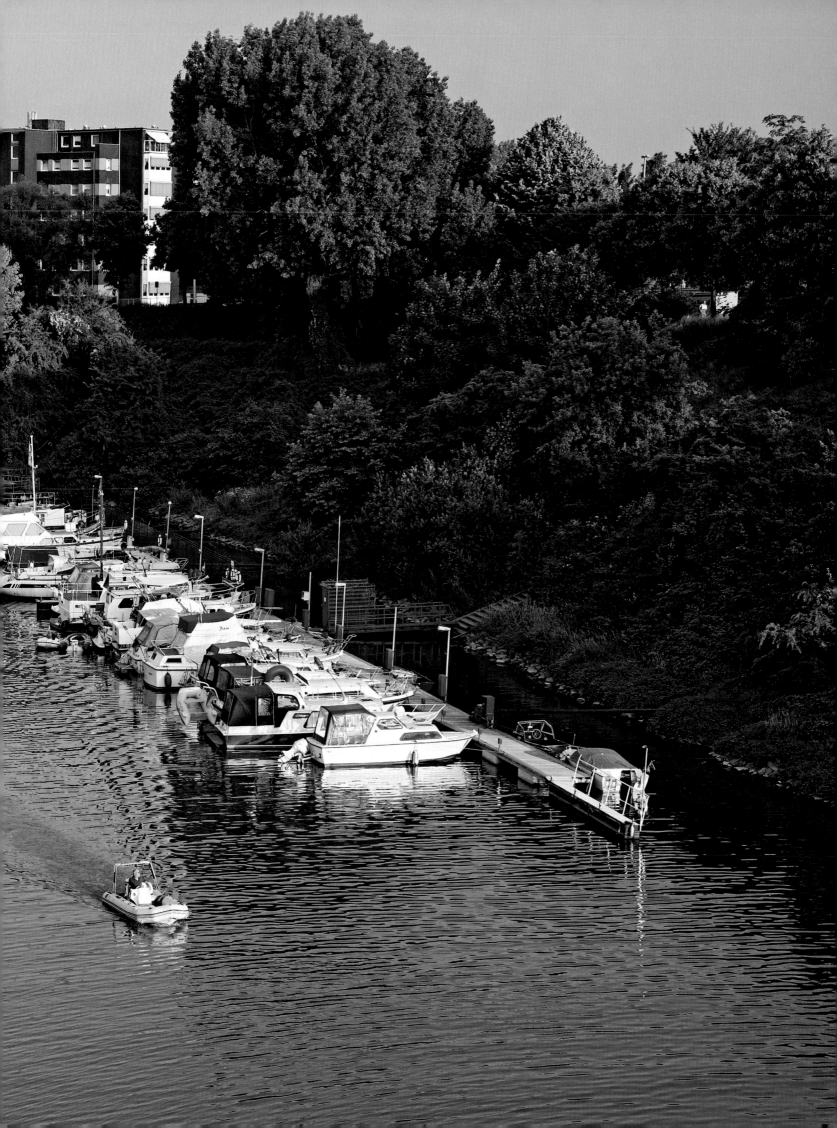

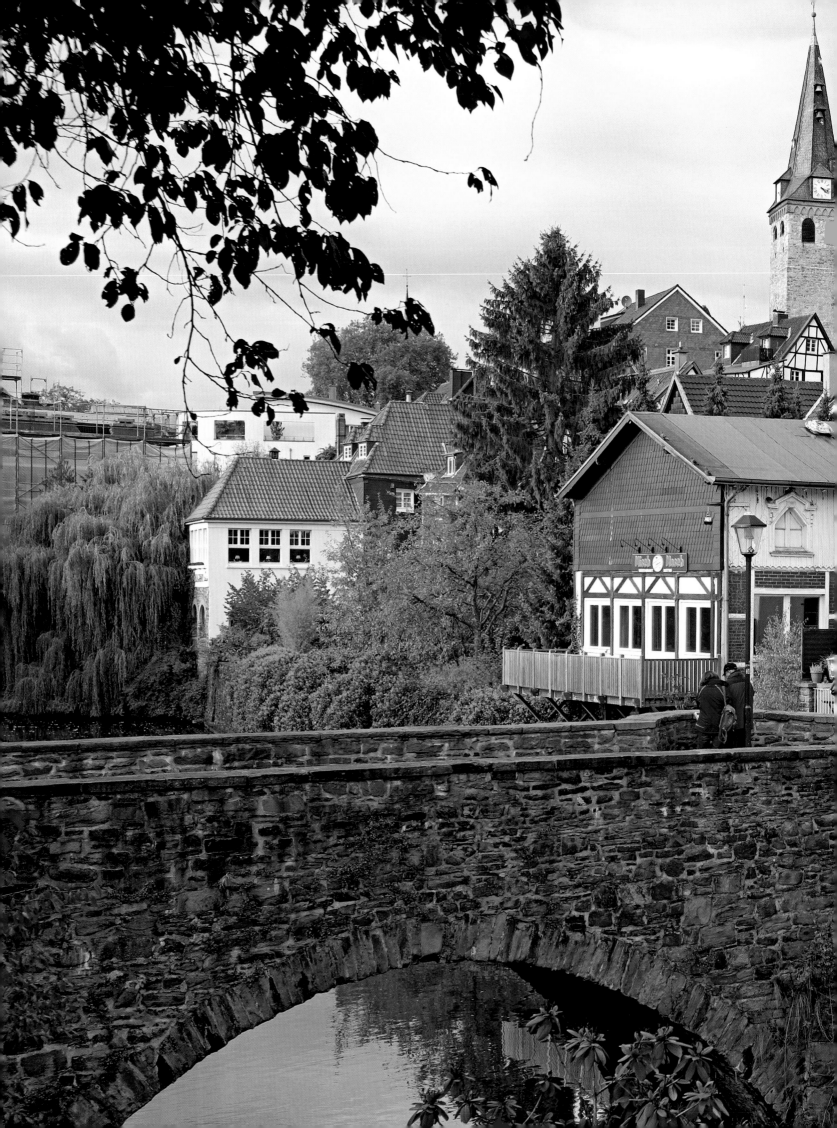

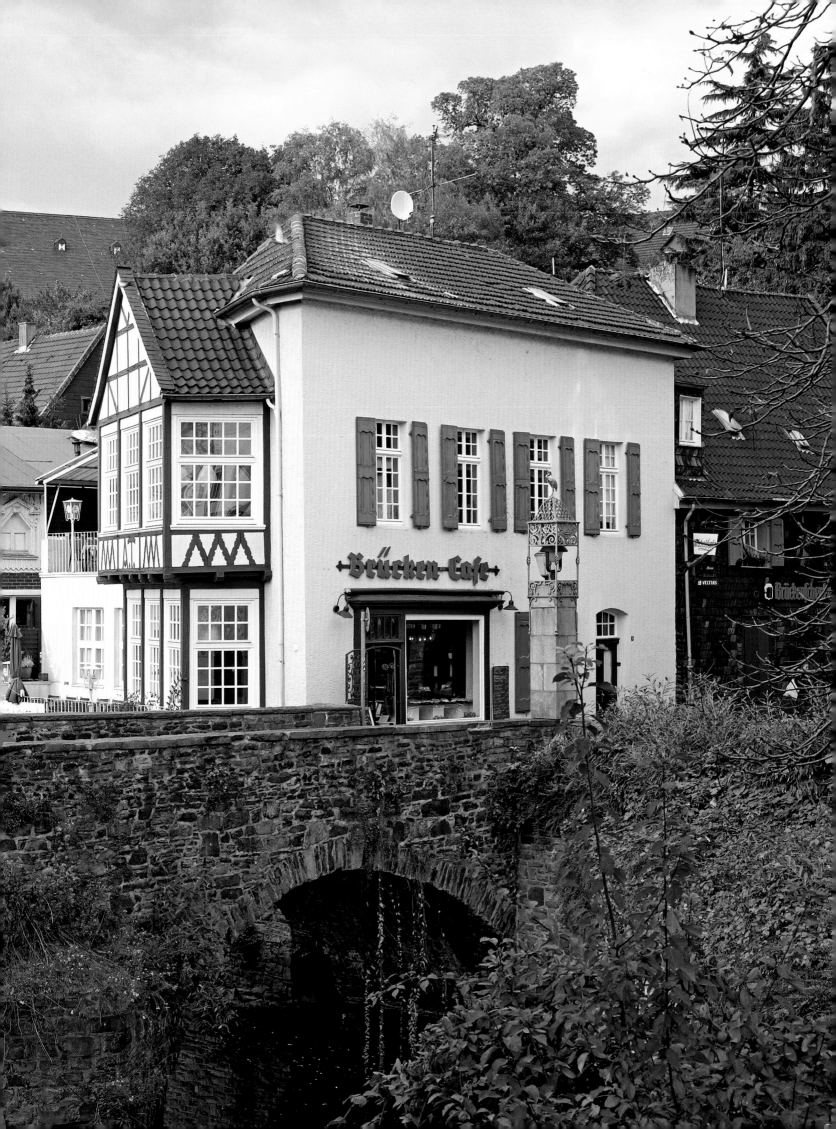

Industrial backdrop in Duisburg-Ruhrort, Europe's largest inland port sited where the Ruhr flows into the Rhine. One popular Sunday pastime here is to stroll along the Rhine dikes near Ruhrort or Beeckerwerth.

Mülheim an der Ruhr, Duisburg am Rhein: in the west of the Ruhr the names alone indicate that this area has a very different orientation to that of the Westphalian east. The Rhineland and the Lower Rhine are much closer to people's hearts here than the Sauerland and pumpernickel. The Rhine between Wesel and Duisburg may have its impressive industrial backdrop of power stations, such as those in Voerde and Duisburg-Walsum, and a distinctive silhouette in Europe's biggest blast furnace in Duisburg-Schwelgern and its largest inland harbour in Ruhrort. Yet if you cross one of the many bridges on the Rhine or take the ferry from Duisburg-Walsum to Orsoy, you will find yourself in another world; between Moers, Alpen, Xanten and Kevelaer the flatlands of the Lower Rhine are extremely rural with their working farms, green fields and church steeples.

On the far side of the Rhine meadows, where each year tens of thousands of wild geese spent the winter, the Ruhr has changed. In Duisburg, where the Ruhr flows into the Rhine, a new centre of culture and entertainment has established itself in the inland port. The 'landscaped' industrial park of Duisburg-Nord with its old industrial monuments and institutions of renown, such as the Wilhelm Lehmbruck Museum and the theatre, is also setting new trends.

The same goes for Bottrop with its impressive Josef Albers Museum Quadrat – or Gladbeck that has discovered an exciting venue in the old Zweckel colliery. Oberhausen is now more famous for its shopping than for its steel, with Europe's biggest mall, CentrO, on the site of the old Gutehoffnung steelworks even attracting visitors from the Netherlands. If you travel a bit further down the road to Eisenheim you will find one of the prettiest industrial housing estates in the entire Ruhr area. For even more finery (and greenery) visit Mülheim, where at the riverside station you can board one of the Weiße Flotte boats for a leisurely trip on the Ruhr.

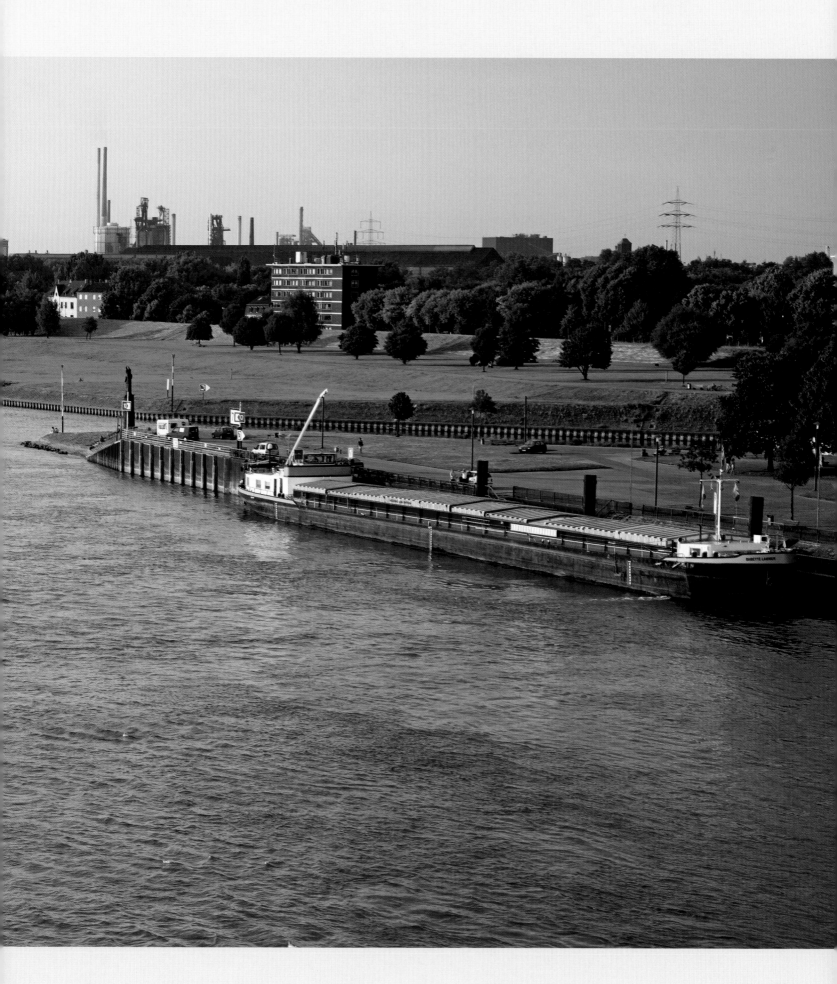

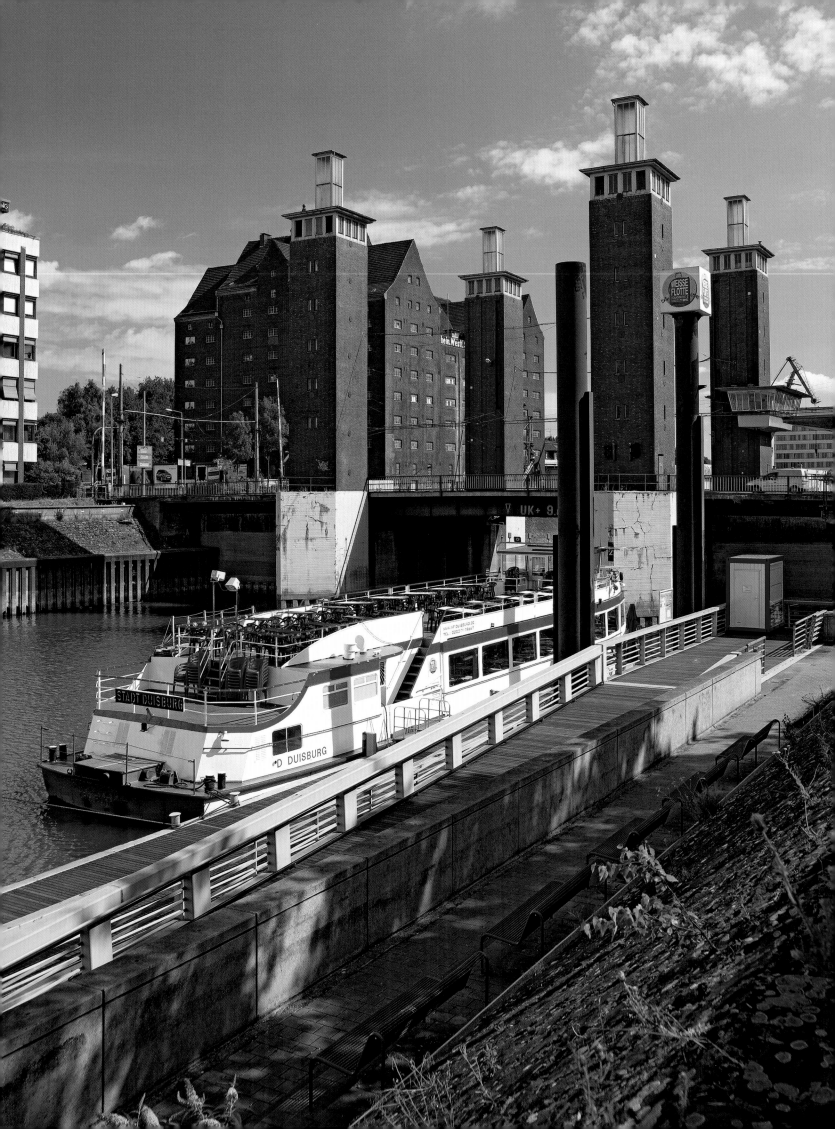

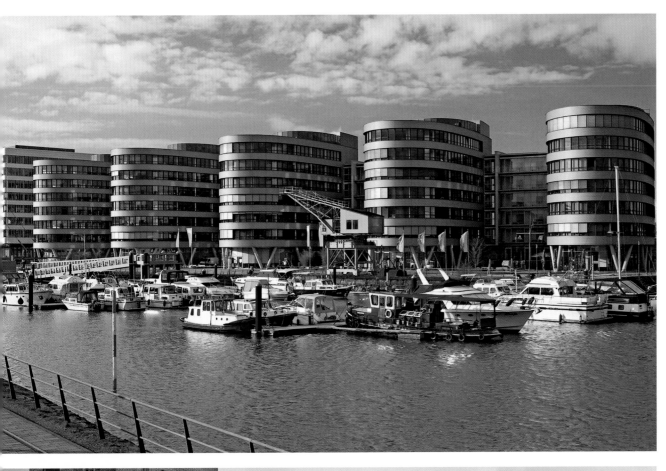

Schwanentorbrücke on the edge of Old Duisburg marks the spot where the Rhine enters the inland harbour. Not far from the lifting bridge the pleasure boats of the Weiße Flotte depart on their trips round the port. The mooring was redesigned by top British architect Lord Norman Foster a few years ago. In the Middle Ages the Schwanentor was one of Duisburg's four city gates.

Schwanentorbrücke on the edge of Old Duisburg marks the spot where the Rhine enters the inland harbour. Not far from the lifting bridge the pleasure boats of the Weiße Flotte depart on their trips round the port. The mooring was redesigned by top British architect Lord Norman Foster a few years ago. In the Middle Ages the Schwanentor was one of Duisburg's four city gates.

Cafés and restaurants for the adults and attractions such as the Legoland Discovery Centre for the kids in an old mill make the old harbour basin in Duisburg popular with visitors both young and old.

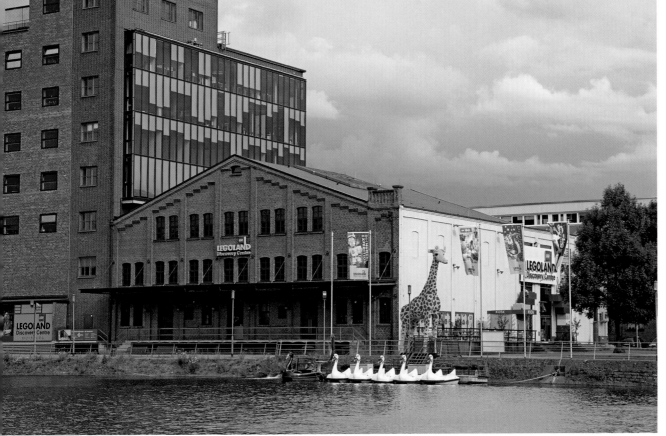

29

The port of Duisburg, now also a yachting harbour, is impressive – and not just to look at. It covers about 1,000 hectares (ca. 2,500 acres) and has no less than 21 harbour basins. Its shores measure 40 kilometres (25 miles). The port processes over 50 million metric tonnes of goods a year, transported all over Europe by ship, lorry and also rail.

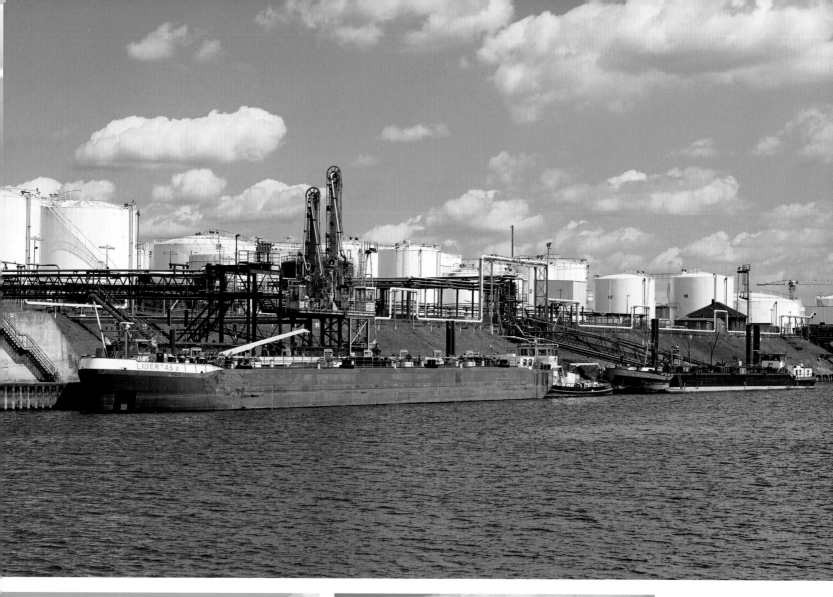

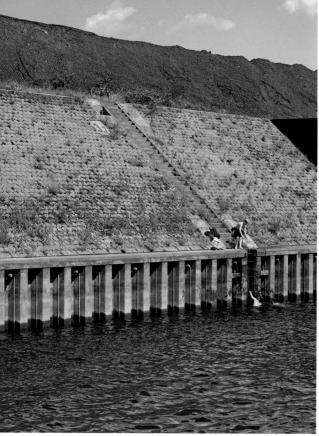

The outer harbour in Duisburg. A trading post was first set up here in 1716 but the port only really boomed when the steel industry began thirsting for ore, desperately needed in the iron and steelworks springing up from Duisburg to Dortmund. The quality of the water in the Rhine and Ruhr is nevertheless good and you can even swim here. Yet care must be exercised at all times as the rivers are still heavily trafficked by huge Rhine barges.

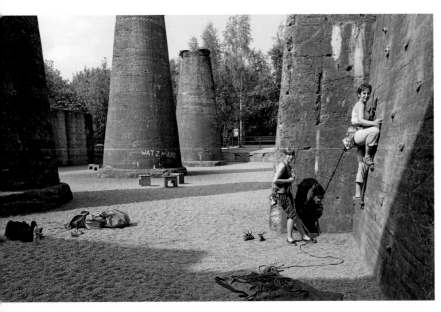

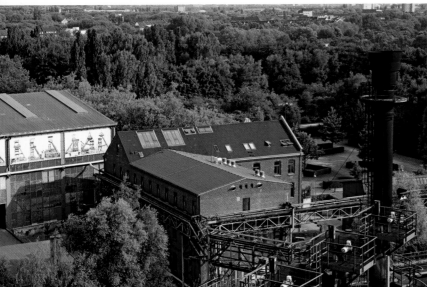

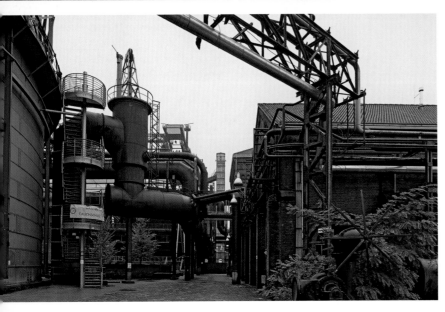

New from old. What was once a disused ironworks in Duisburg-Meiderich has been transformed into the industrial park of Duisburg-Nord. Steel was smelted here until 1985 when the international steel crisis also forced the Thyssen plant to close, in operation since 1901. Luckily, the site was spared demolition and since 1994 the Landschaftspark, to give it its German title, has become a model example of how to adapt our industrial

eritage and secure it for
uture use. The old ore
unker is now a climbing
ourse upheld by the
Deutscher Alpenverein,
with over 400 routes to
choose from (top left);
the gasometer is used by
divers who can train in
its giant innards (below).
And from the top of blast
furnace number 5, there
are marvellous views of
the Ruhr and Lower Rhine
(centre left).

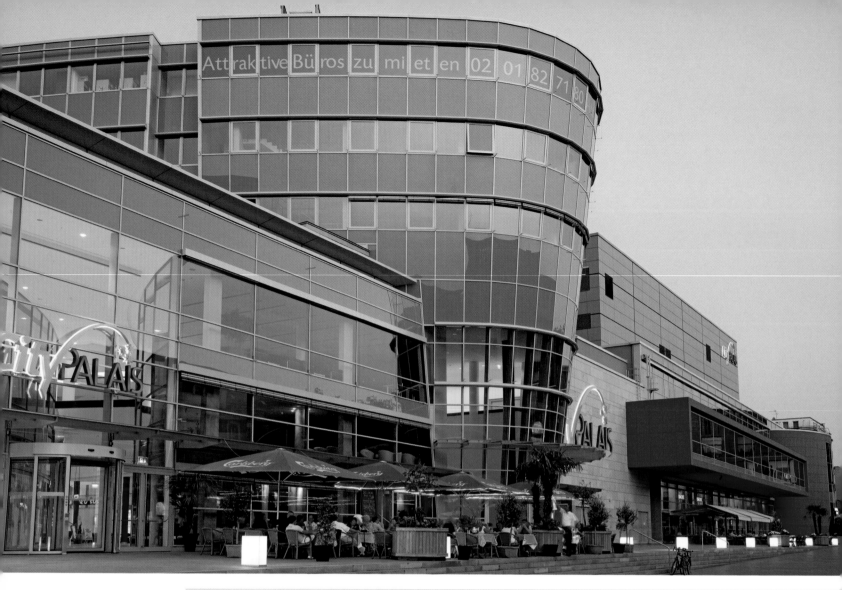

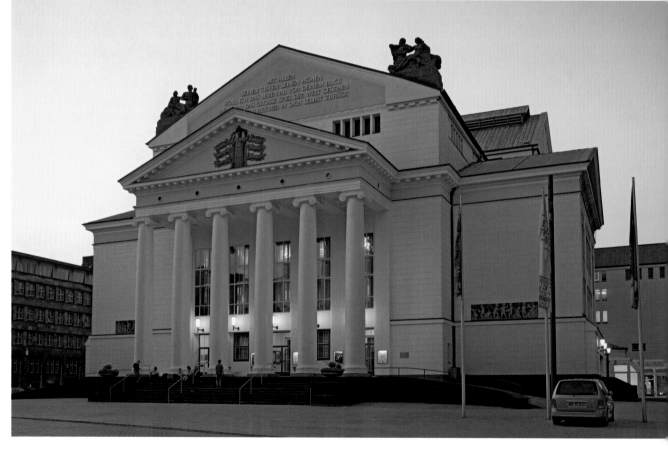

Above:
New architecture on the Rhine and Ruhr. Duisburg's CityPalais is used for congresses, conferences and other events, with the casino one of the most modern in Germany. There are also lots of shops here and in the neighbouring Königs-straße, Duisburg's main shopping street.

Right:
The theatre in Duisburg is in the heart of town. The neoclassical building was built in 1911/12 from plans by architect Martin Dülfer and can accommodate an audience of 1,200. The theatre is also the home of the renowned Deutsche Oper am Rhein, a major opera venue run by both Duisburg and Düsseldorf.

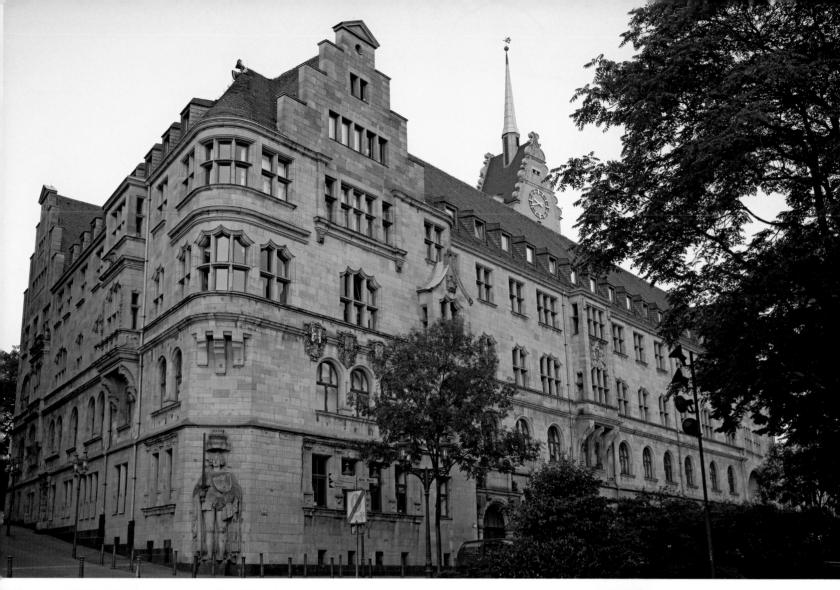

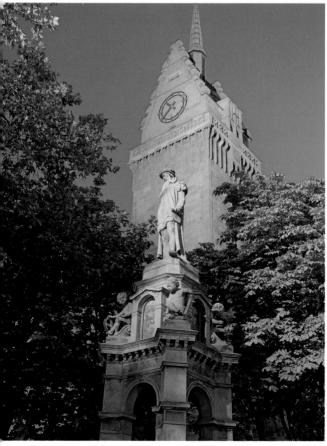

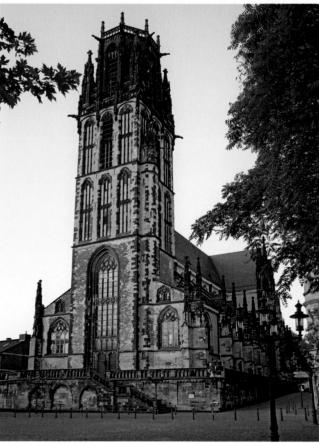

Above:
The Rathaus in the heart of Duisburg stands on the historic site of Burgplatz. The representative edifice was opened in 1902 opposite the Salvatorkirche.

Far left:
The fountain outside the town hall in Duisburg commemorates Gerardus Mercator, born in Flanders in 1594 and famous for his use of map projection.

Left:
The foundations of the Gothic Salvatorkirche in Duisburg were laid in 1316. The place of worship is one of the major late Gothic churches on the right bank of the Lower Rhine.

Left and bottom left:
Duisburg has many international festivals that prove irresistible to appreciators of good art and culture, particularly Akzente. Very young audiences are the focus of the KinderKultur Festival that stages music and theatre for kids each summer in the Kantpark close to the town centre.

Centre left:
Cooling down in the fountains on Königstraße in Duisburg, in summer more paddling pool than artistic water feature.

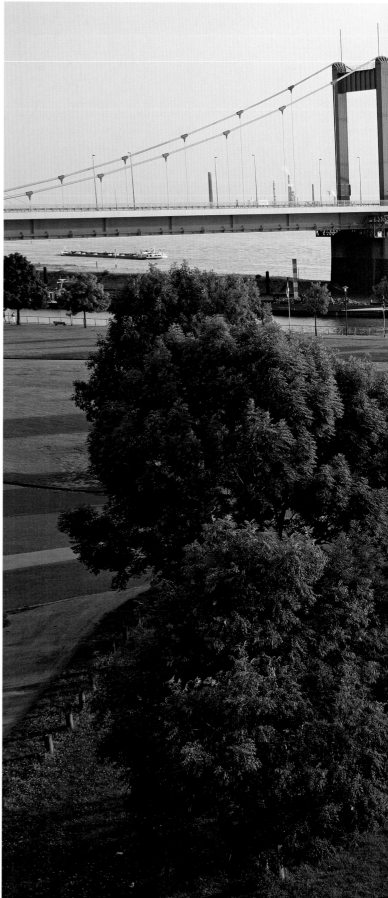

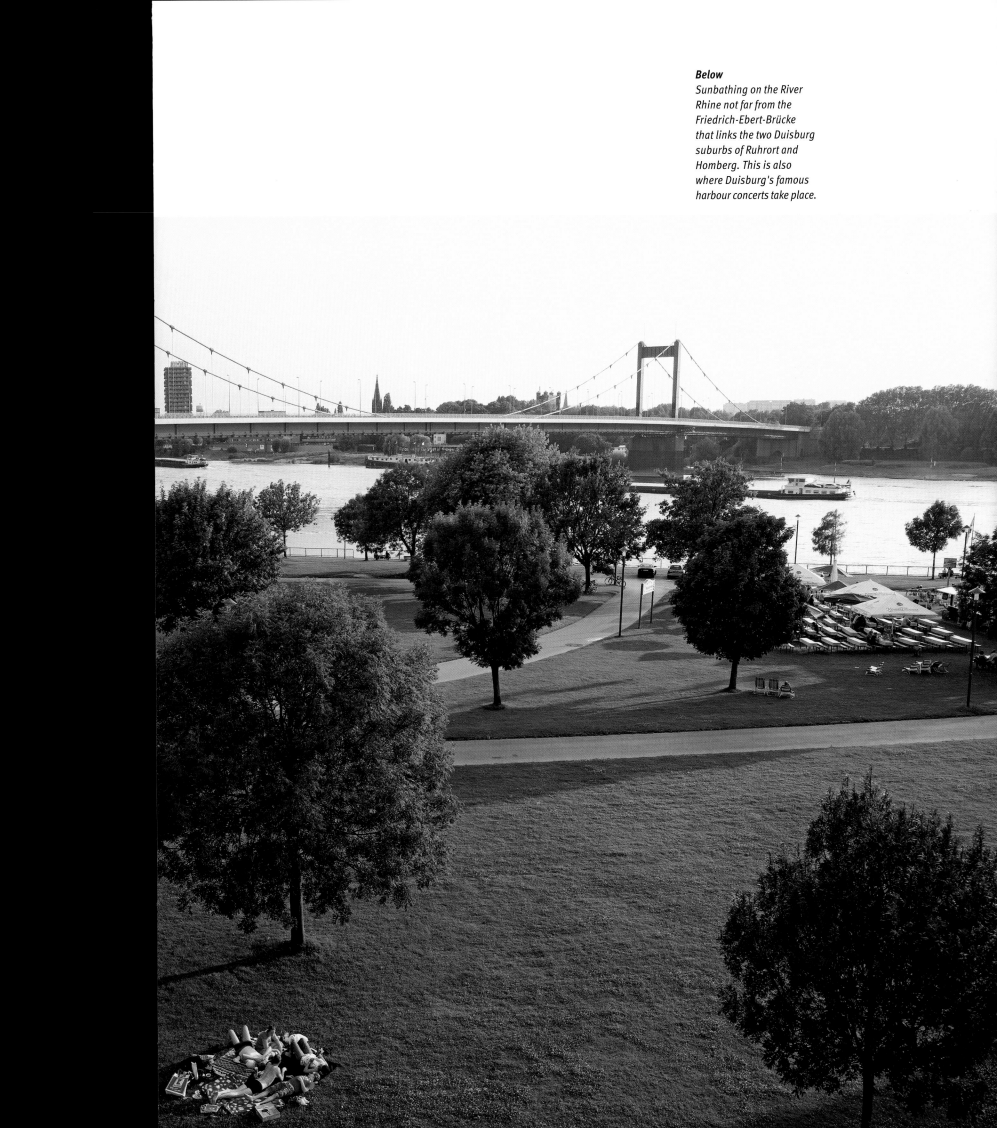

Below
Sunbathing on the River Rhine not far from the Friedrich-Ebert-Brücke that links the two Duisburg suburbs of Ruhrort and Homberg. This is also where Duisburg's famous harbour concerts take place.

GARDENS AND PARKS –
THE GREEN AND PLEASANT RUHR

A Sunday stroll through the Grugapark in Essen; a spring visit to the Westfalenpark in Dortmund; a summer meander along the shores of the lakes to the south of Duisburg: visitors not (yet) familiar with the Ruhr Basin are constantly surprised at just how green the former mining region actually is. There are relatively unspoilt open spaces and areas of forest in all of the cities here. About 1,500 kilometres (930 miles) of signposted cycling track, countless hiking trails, bridleways totalling 350 kilometres (220 miles) in length and plenty of viewpoints provide many verdant spots for recreation and relaxation.

The sheer variety of green and pleasant locations between the Lower Rhine and Westphalia, between the Emscher and the Ruhr is particularly impressive. There are the numerous parks, many of which have a long history – like the one at Schloss Moers or Haus Wettringen in Gladbeck. In the throes of the industrial revolution in the mid 19th century public parks and gardens were created to offer the people on the Rhine and Ruhr a place where they could unwind and indulge in cultural pastimes. The oldest of these is Essen's Stadtgarten or town gardens, laid out by the citizens of Essen in 1863/64. The Stadtpark in Bochum, planted up about ten years later, is the second-oldest municipal park in the Ruhr Basin.

The 1880s saw a veritable wave of patriotic imperial parks (*Kaiserparks*) being opened, still recognisable by their regal-sounding titles. They range from the Kaiser-Wilhelm-Hain in Dortmund to the Kaisergarten in Oberhausen to the Kaiser-Wilhelm-Park in the north of Duisburg. In c. 1900 various campaign groups and local patriots keen to make their cities more beautiful, supported by progressive politicians and civil servants, made ever greater efforts to design more promenades and parks, to replant municipal forests and to fashion green belts on the city outskirts to counteract the rapid growth of industry.

The first of their kind was the Kaiserberg in Duisburg, still extremely popular, which at the end of the 1860s grew into a fully-fledged landscaped garden, complete with woods, ponds, cascades and pavilions. This was later joined by the replanted Stadtwald or city forest (1899), the Wedau as a venue for water sports and many other leisure activities (1919) and the zoo (1933). The other cities of the Ruhr underwent a very similar development – such as Gelsenkirchen, for example, heralded as the "green industrial city" in the 1920s with its famous Buer green belt. This improvement was

absolutely necessary at the time. In c. 1900, for example, there were just eleven square metres (118 square feet) of public park or forest per head of the population. This figure was even worse in Bochum (3.8 square metres / 41 square feet), Gelsenkirchen (2.7 square metres / 29 square feet) and Herne (2.2 square metres / 24 square feet). Botanical gardens and horticultural exhibitions also did their bit to brighten up the industrial sinkhole. The most famous park in Essen, the Grugapark laid out in 1927, was opened in summer 1929 with a grand exhibition of gardening. The Westfalenpark in Dortmund was created for the first of Germany's three national garden shows held here in 1959, 1969 and 1991. Just as much part of the Ruhr as the above are its countless allotments and private gardens, the five big parks opened in the 1970s and its expanses of water. Besides the green River Ruhr to the south and the Rhine near Duisburg, these include the Baldeneysee in Essen with its Weiße Flotte pleasure boats (1933) and the Kemnader See between Bochum, Hattingen and Witten (1979). People come here to swim or canoe as they do on local waterways like the Rhine-Herne Canal.

Even the Emscher River, the defamed cesspit of the Ruhr for over 100 years, is now a place of recreation. On the occasion of the Emscher Park International Building Exhibition (IBA, 1989 to 1999) much of the area was re-naturalised. The heart of the exhibition, which on the decline of the mining industry created new venues for business and industry along the Emscher and Rhine-Herne Canal, is the landscaped park on the Emscher with its popular cycling track and hiking trail. The fact that you are as likely to find working farms in Herten as you are in Essen-Kettwig is just further proof of the many green and pleasant attributes of this formerly very industrial region.

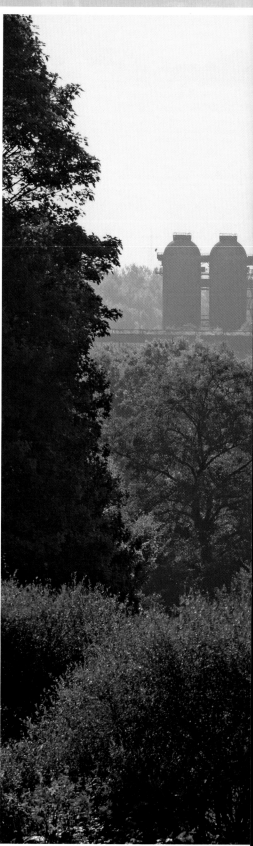

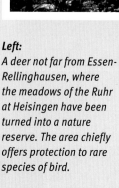
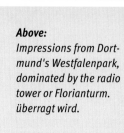

Left:
A deer not far from Essen-Rellinghausen, where the meadows of the Ruhr at Heisingen have been turned into a nature reserve. The area chiefly offers protection to rare species of bird.

Above:
Impressions from Dortmund's Westfalenpark, dominated by the radio tower or Florianturm. überragt wird.

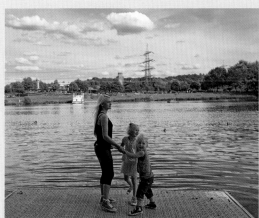

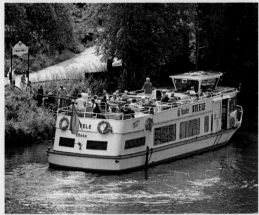

Small photos right, from top to bottom: The lake of Kemnade, the newest of six reservoirs on the Ruhr, is the biggest local lido in the Bochum/ Hattingen/Witten area.

On the cycle track that runs along the Ruhr Valley signposts point the way to where it all began: the Nachtigall colliery near Witten.

The highlight of any stay in Essen is a trip on one of the boats of the Baldeney Weiße Flotte, here gliding down the River Ruhr near Werden.

You can spot many a hobby sailor out on the Ruhr at the weekend: here in Essen-Werden.

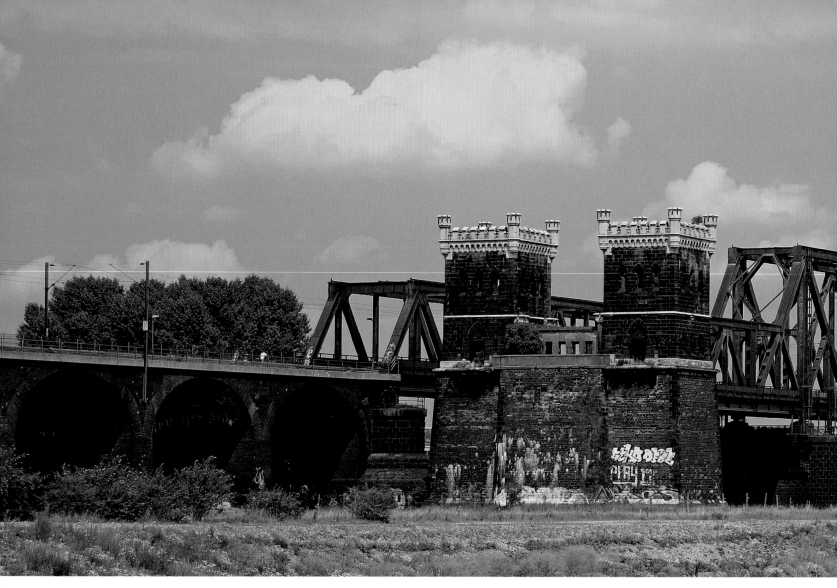

Above
This railway bridge crosses the Rhine and its wide river banks between Hochfeld and Rheinhausen in Duisburg. Trains still trundle across the massive stone and steel construction from 1927 on their way from the Ruhr to Aachen.

Right:
The Lower Rhine in late summer. Protected Rhine meadows, such as the one in Bislich-Vahnum in Wesel, act as flood plains when the river bursts its banks and help to preserve the landscape. They are also used as local recreation areas.

Left:
*The pollarded willow is
something of a local land-
mark on the rural Lower
Rhine, seen here near
Kalkar. Lush meadows
provide wild geese and
other migratory birds with
welcome places of rest
on their long journeys.*

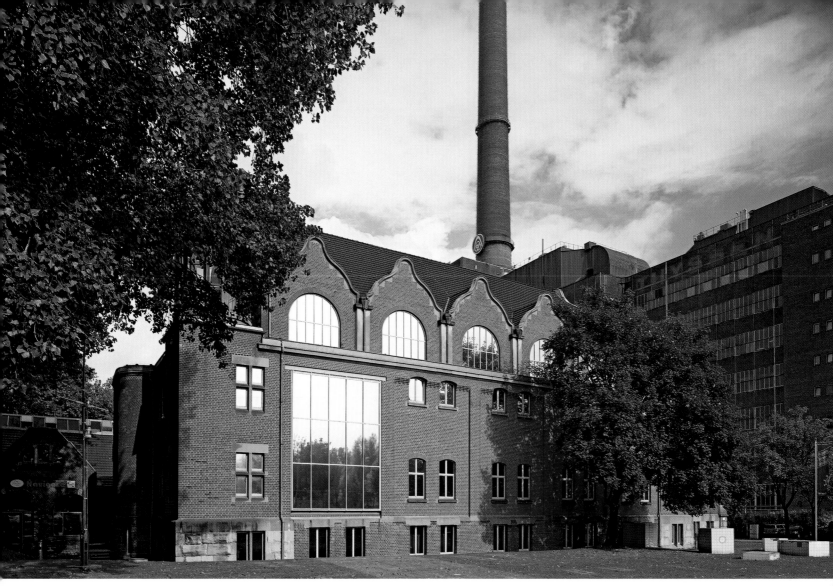

Above:
What better home could the German museum of inland shipping have than in Duisburg-Ruhrort?! Laid out in what used to be a swimming pool, the multimedia collection documents the history of shipping from the Stone Age to the present day.

Right:
The centrepiece of the museum and a real eye-catcher is the Goede Verwachting tjalk, a sailing boat in full sail from 1913.

Far right:
The exhibits at Duisburg's Kultur- und Stadt-historisches Museum in the inner harbour, with its modern entrance by Lord Norman Foster, document the city's history.

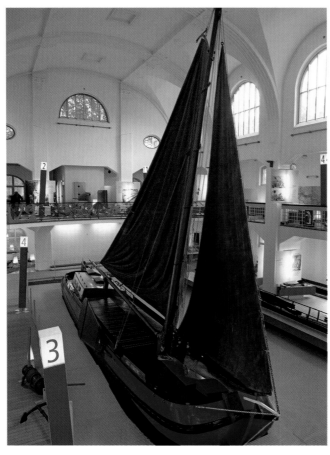

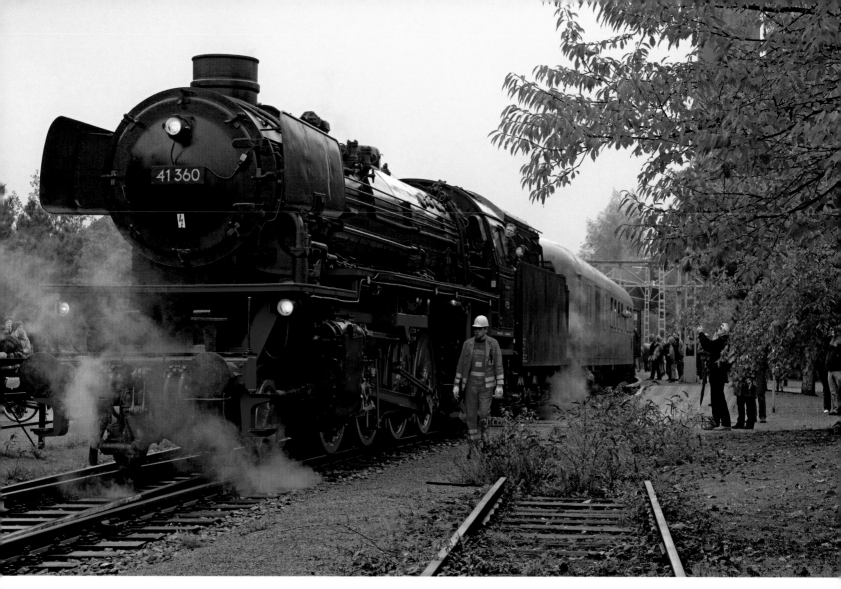

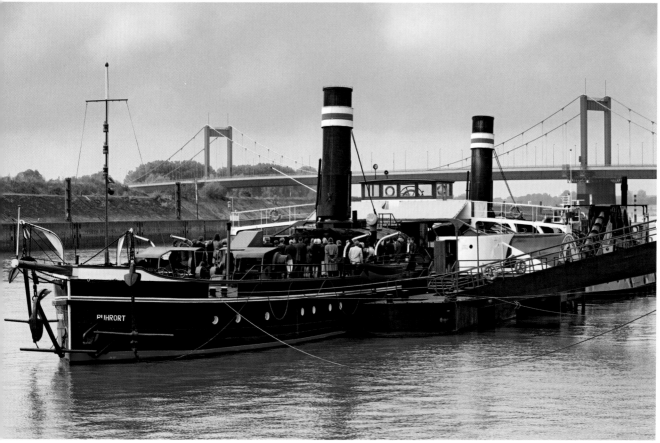

Above:
The people of the Ruhr believe in bringing history to life. Here the railway society of Gelsenkirchen proudly watches its enormous steam train roll into the Landschaftspark Duisburg-Nord.

Left:
The Oscar Huber museum ship has permanently dropped anchor in Duisburg Harbour. Built in 1922, the paddle steamer is a unique cultural monument; up until the 1960s it pulled up to seven unpowered loaded barges per trip up and down the Rhine. The era of the tug steamer came to an end when modern pusher tugs with diesel engines were introduced. The Oscar Huber was the only tug paddle steamer on the Rhine not to be scrapped.

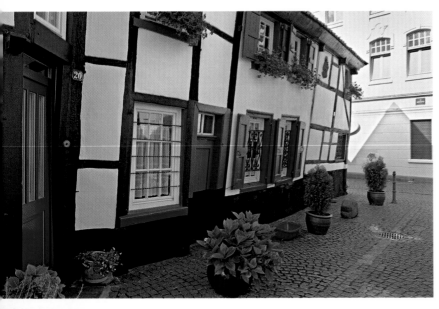

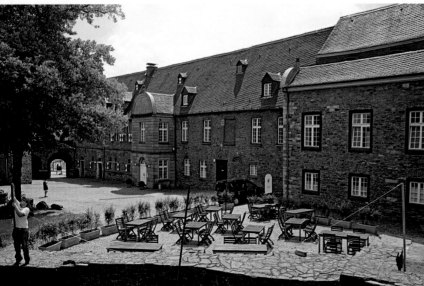

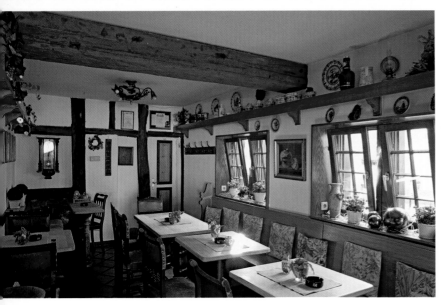

Top left:
Idyll in the heart of the industrial Ruhr Basin. Mülheim an der Ruhr is one of the few towns here to still have an amazing number of half-timbered houses that are pre-Industrial Revolution. These are on Kettwiger Straße.

Centre left:
Schloss Broich on the west bank of the River Ruhr in Mülheim-Broich is one of the best medieval fortresses in the northern Rhineland. It dates back to the 9th century.

Bottom left:
One popular place for an evening out is the Kortum Stube pub on Kettwiger Straße in Mülheim. The establishment serves good German food with a strong hint of the Italian, made all the more enjoyable by the historic setting.

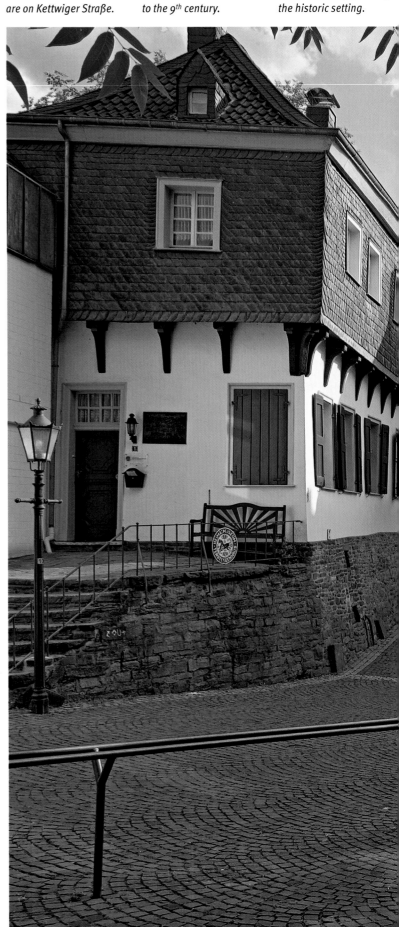

Below:
Some of the half-timbered houses in Mülheim are tiled with slate. These include the Tersteegen-haus, named after lay preacher and poet Gerhard Tersteegen. The building now holds the town museum dedicated to local history and culture.

Page 46/47:
The Ruhr at its best. Mülheim's river station, built in the 1920s in the shape of a ship's bow on an island, is the main port of call for the Weiße Flotte river cruisers and a good place for a classic Sunday outing. There's also a prom for strolling along and plenty of cafés serving afternoon tea, coffee and delicious German cake.

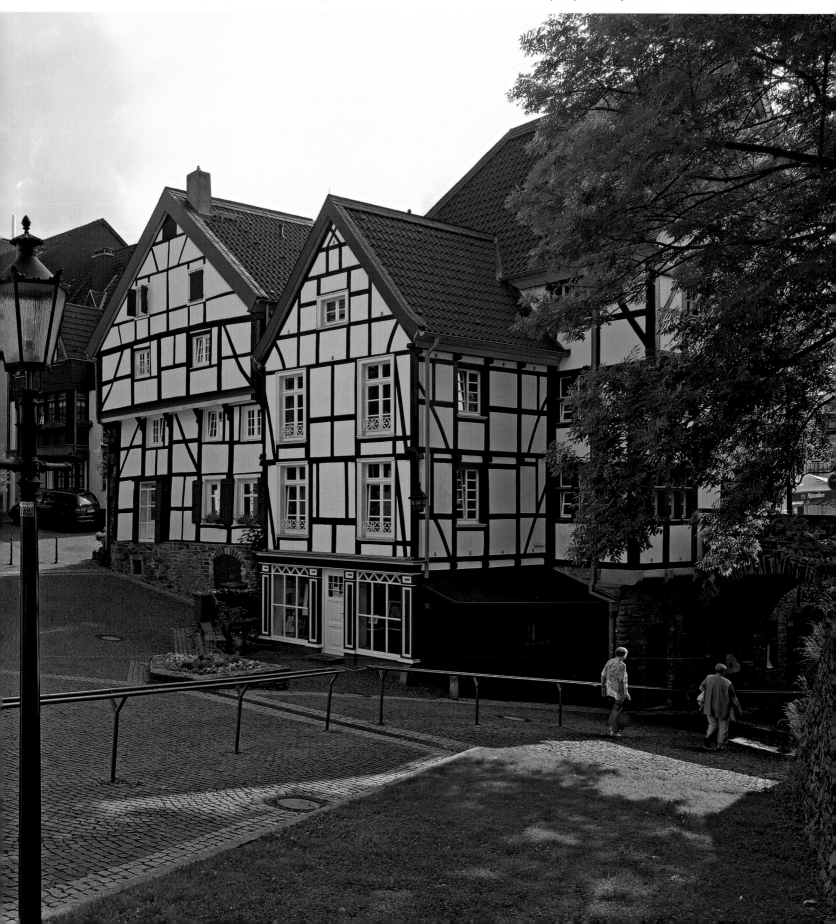

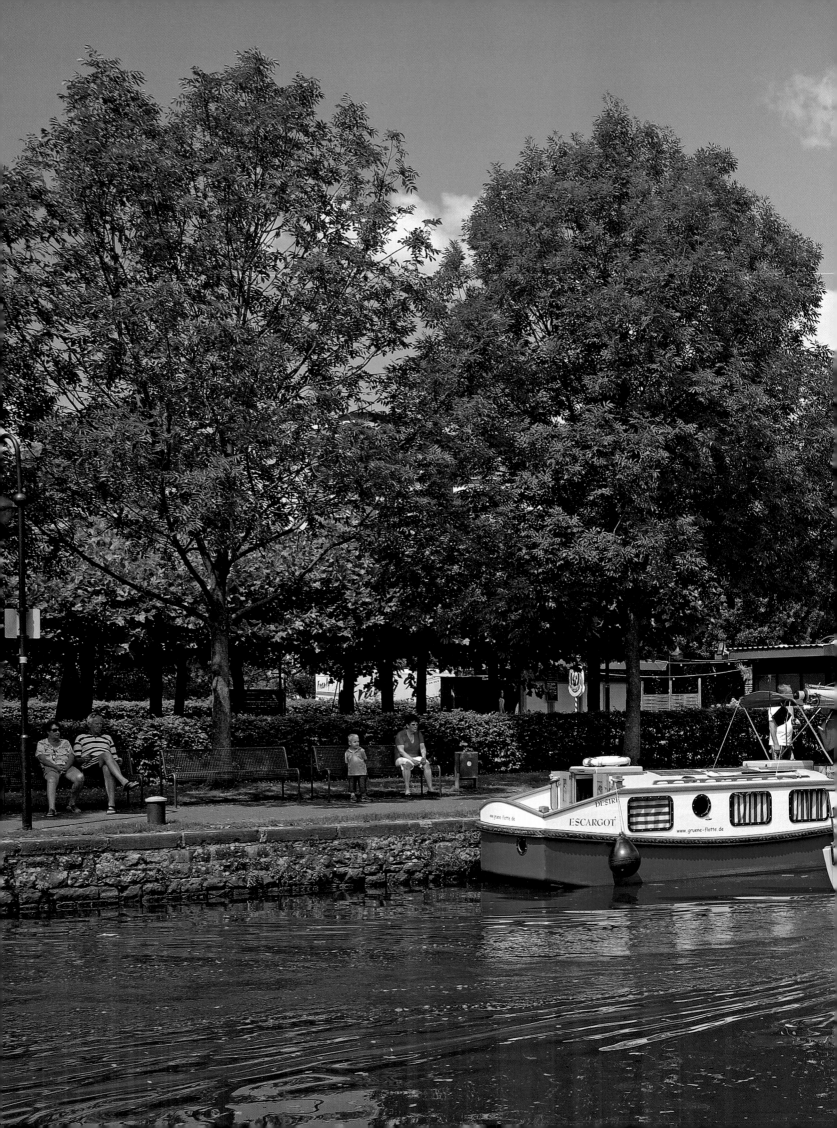

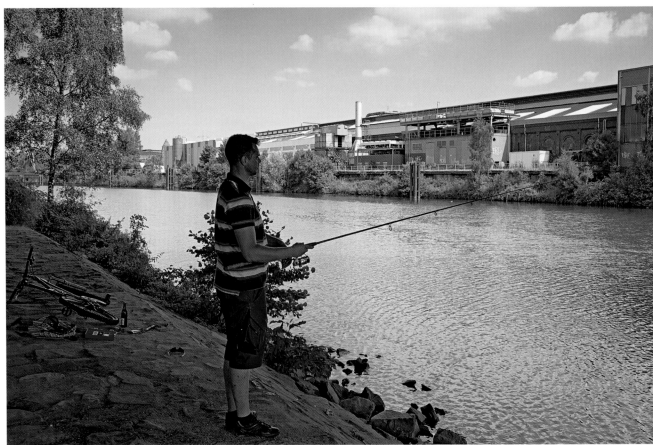

Above:
A zeppelin above the park of Schloss Broich. Airships take off regularly from the nearby airport in Mülheim on trips around the Ruhr, when you can see what the region between the Ruhr and the Emscher looks like from high up in the air.

Right:
Escaping the industrial grind of the Ruhr for a few hours: an angler fishing the River Ruhr near Mülheim.

Left:
The town hall tower in Mülheim rises high up above the River Ruhr. The prestigious building was erected between 1911 and 1915 from plans drawn up by architects Arthur Pfeifer and Hans Großmann.

Below:
The green Ruhr provides plenty of chances to relax; here, people are swimming not far from the Raffelberg hydroelectric power plant. The power station in the suburb of Speldorf is the last on the Ruhr before it flows into the Rhine just a few miles from here.

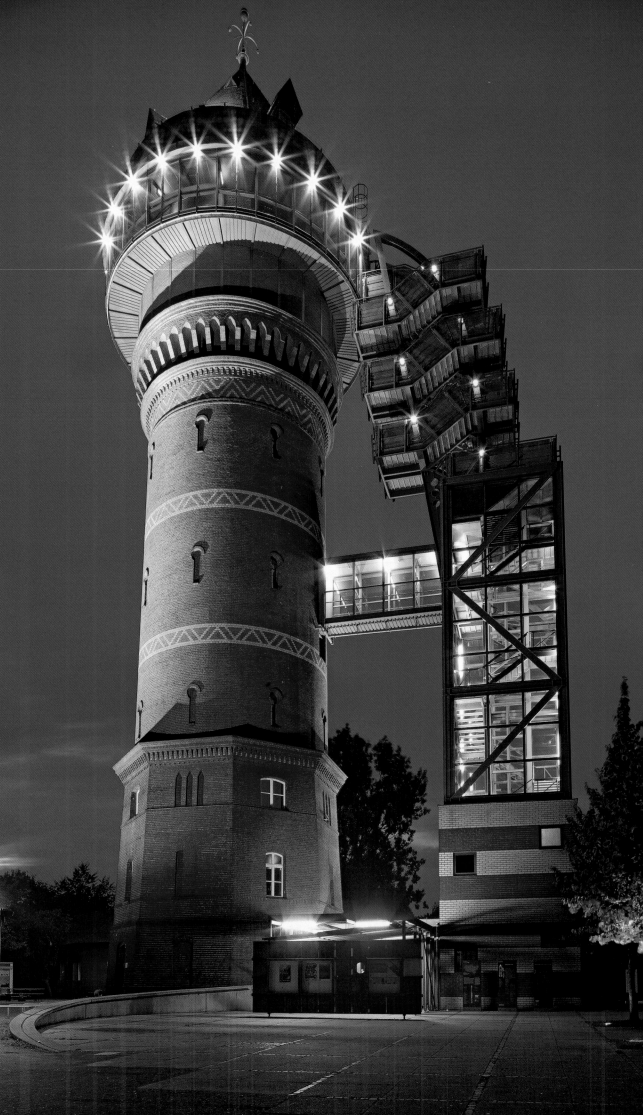

Right:
The Aquarius water
museum looms large on
the River Ruhr. The water
tower in the palace park of
Styrum, built in 1892/93,
was turned into a museum
in 1992 and has since won
several awards. There
are grand views from its
platform, 53 m / 174 ft up.

Right page:
Both industrial monument
and local landmark, the
gasometer in Oberhausen,
built from 1927 to 1929
to store gas for the blast
furnaces at the nearby
Gutehoffnung steelworks,
is now on the Industrial
Heritage Trail. Interesting
exhibitions draw tens of
thousands each and every
year. In the foreground is
the Rhine-Herne Canal.

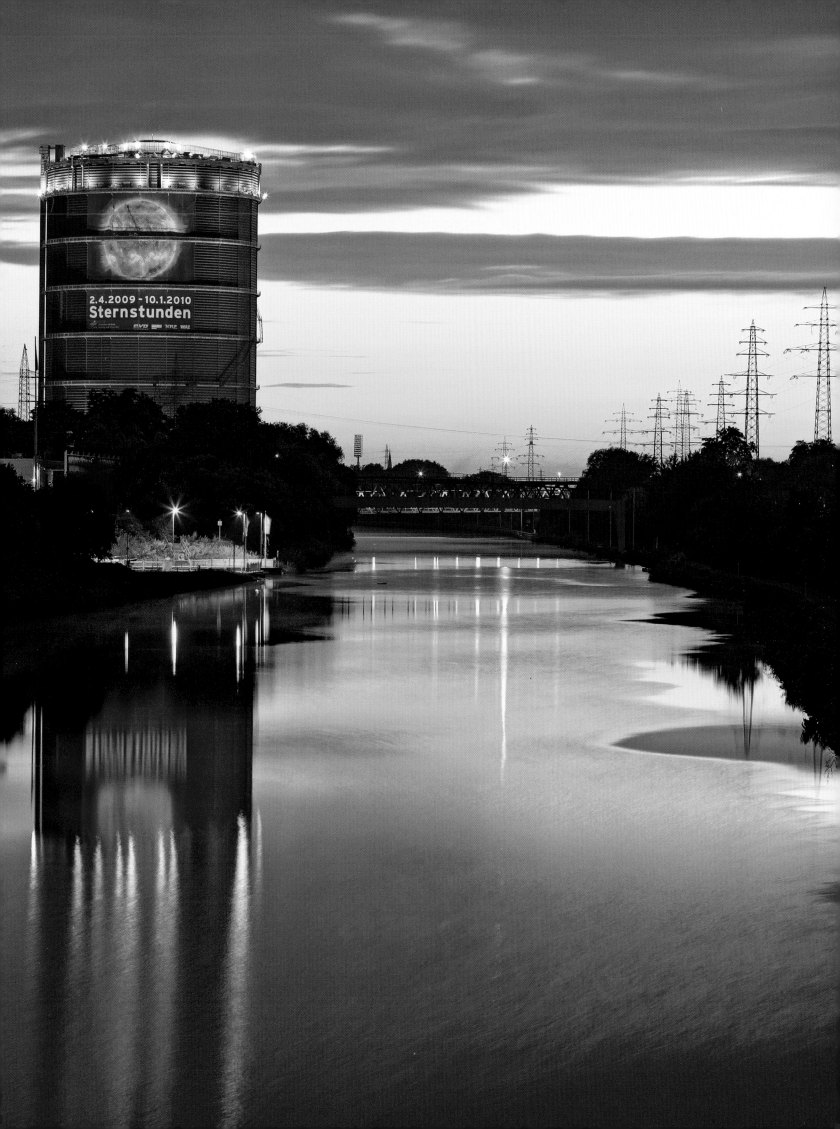

Work in progress – art and culture in Germany's biggest conurbation

The Ruhr, headed by Essen, is European Capital of Culture 2010. And with it comes the glitter and the glamour, the interest of a more international clientele and finally a little bit more of the renown that the Ruhr has long deserved but not had. However, to focus solely on Essen's Zeche Zollverein between the Rhine and Möhnesee, now an up-and-coming icon of the arts scene, would be to ignore the fact that the worlds of work and culture in the Ruhr have long been engaged in exciting dialogue – and on the far side of the cultural mainstream at that. The arts scene is like the seemingly endless patchwork of countryside along the Rhine and Ruhr, squeezing itself into the tiniest crevices, whether these be industrial wastelands, gardens gone to seed or abandoned office complexes. Minimalist art is staged in the greatest chaos imaginable. And you are encouraged to observe and participate not in sterile events halls but in walls that effuse a sense of history – at the Carl coalmine in the north of Essen, for example, or the Ringlokschuppen engine shed in Mülheim an der Ruhr, the Flottmannhallen in Herne and the Jahrhunderthalle in Bochum. Creative minds are now performing where their fathers and grandfathers once worked. The performers' flair for authenticity without all the pomp and circumstance is legendary. Their messages may be different yet their identity with the region is the same; whether comedians Herbert Knebel and Helge Schneider or pop legend Herbert Grönemeyer, their roots are clearly here.

(Yet more) beautiful things are supplied by the mail order firm Manufactum, well known throughout Germany. Its products range from handmade shoes and bags to furniture and electrical goods, all of which made a name for themselves decades ago and which have since disappeared from the shelves. Yet the commodities of the good old days are not making a comeback in the great cultural metropolises on the Elbe, Spree and Isar but at the disused mine in Waltrop, a place that history has otherwise completely overlooked. This is as crass as it gets, illustrating that authenticity and aesthetics do not cancel each other out in the Ruhr.

Cultural antitheses of the modern age

It's a known fact that the past is the millstone of the present, its omnipresence accelerating the quest for the ultimate novelty. The Ruhr is no exception, with attempted cultural breakouts not uncommon. Finnish architect Alvar Aalto's theatre of the same name is a true antithesis to the industrial environs of the city of Essen, for example. Next door to this superlative structure the new, light and airy Museum Folkwang, opened in 2010, is also causing a bit of a stir. Another cultural gem, the Gustav-Lübcke-Museum, can be found a little off the beaten track in Hamm. The University of the Ruhr in Bochum would probably never win first prize in a beauty contest, its merit lying instead in its very existence, it being the first university to be opened in the Ruhr in 1965. The university of Witten/Herecke also pays no heed to the past; on its founding it was the first private university in Germany, its appearance suitably unconventional.

On leaving the realm of high culture we find everyday 21st-century culture in the Ruhr epitomised in CentrO in Oberhausen. A city within a city, with everything tucked in under one roof, Europe's biggest shopping and leisure centre not only draws consumers to the Emscher; restaurants, cinemas, theatre, shows and musicals provide a huge wealth of entertainment and it's easy to forget that this was once where steel bubbled and boiled in the blast furnaces of an industrial plant.

Many who know the Ruhr claim that the most interesting example of new living accommodation is to be found in the inland port in Duisburg. The modern ensemble sprawled between the city centre and the harbour in Ruhrort creates a clear counterpoint to the otherwise Gründerzeit-dominated architecture of the Ruhr. The latter is clearly visible in carefully restored miners' housing and the Margarethenhöhe in Essen, a model estate founded by Margarethe Krupp that will again have you wondering just how pleasant and non-industrial the Ruhr can be.

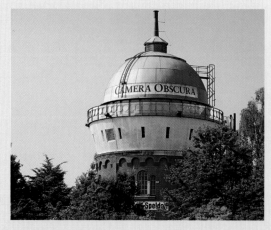

Left:
One of the highlights of Mülheim an der Ruhr is the Camera Obscura at Schloss Broich. Besides its many 360° panoramic photos the museum also has permanent and temporary exhibitions on the age before the invention of moving pictures.

Above:
New art in an old setting. The Küppersmühle museu of modern art in the inlan harbour in Duisburg includes works by Joseph Beuys and Georg Baselitz

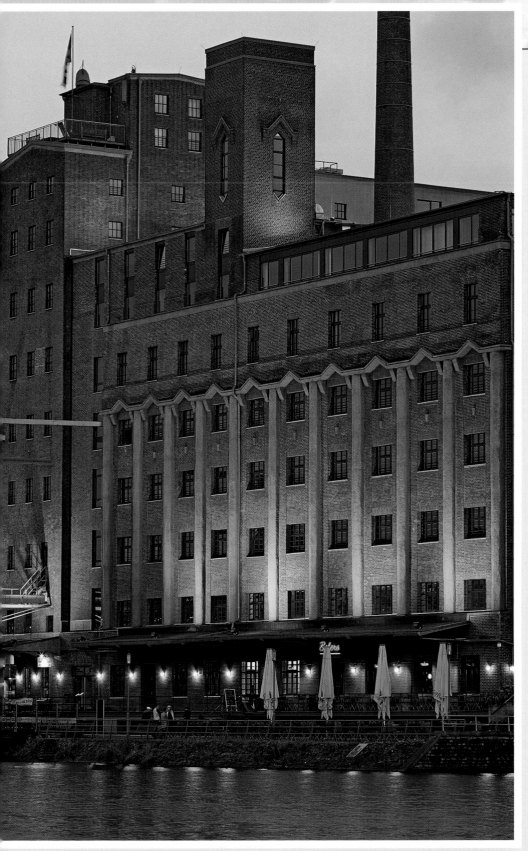

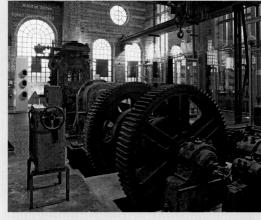

Small photos right, from top to bottom: View of the courtyard of Zeche Zollern in Dortmund-Bövinghausen with the winding tower and brick sheds.

Once upon a time Zeche Holland in Gelsenkirchen-Ückendorf and Watten-scheid was a hard coal mine. It has now been put to new use with its restau-rants and shops, offices and apartments.

The Rhineland museum of industrial and social history has branches in Oberhausen and the Rhineland, with exhibitions at six different sites.

Exhibition in Oberhausen. At the old Altenberg zinc factory visitors can find out more about coke, steel and zinc and how bells, giant wheels, pipes and the like are manufactured.

Above:
The local court in Oberhausen, opened in 1907, is on Friedensplatz in the centre of town. Four years after having been granted its town charter Oberhausen was made the seat of the royal Prussian court in 1879. It now falls under the jurisdiction of the regional court of Duisburg.

Right
The police headquarters is also centrally located on Friedensplatz in Oberhausen. Built by town architect Ludwig Freitag between 1924 and 1927, the building is a prime example of the brick Expressionist style in the Ruhr.

Left:
The Ruhr experienced its greatest period of growth during the Gründerzeit (1870s). Prestigious city dwellings, such as these houses in Oberhausen-Osterfeld, sprang up in all the local town centres.

Below:
One of the most popular places to go in Oberhausen is 13th-century Burg Vondern in Osterfeld. Concerts and exhibitions are now staged here and there is also a museum. One of the annual highlights is the medieval market with jousting in summer.

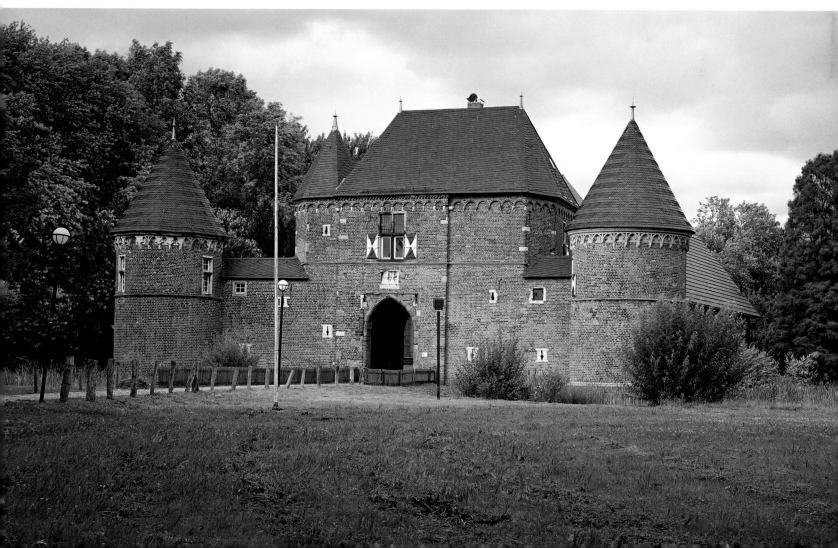

Not far from Neue Mitte and the CentrO shopping centre in Oberhausen-Osterfeld this typical Ruhr workers' estate clings to the edge of the Ripshorst arboretum. Like many of its kind it was due for demolition in the 1960s. The inhabitants fought for their homes to be saved, however, and today over 200 people live in the 68 houses which are part of the Ruhr's cultural heritage. Sections of the football film "Das Wunder von Bern" were even filmed here.

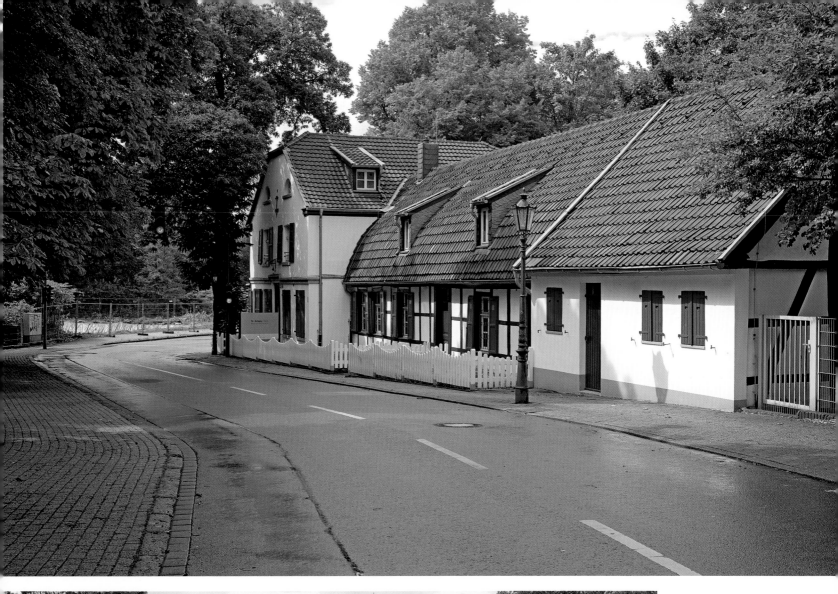

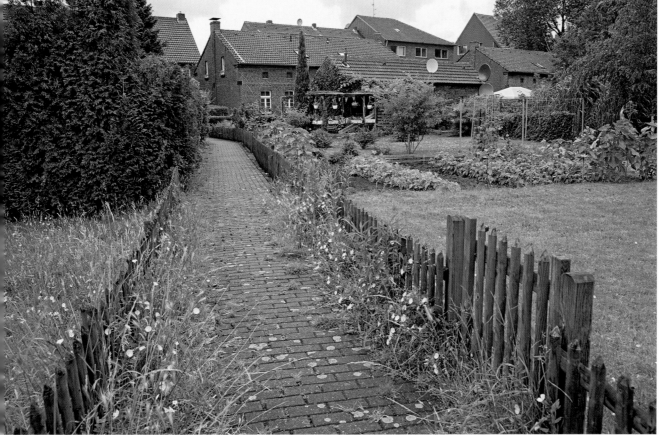

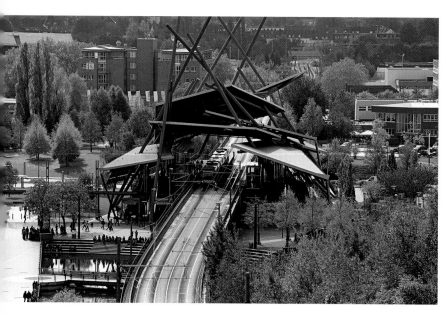

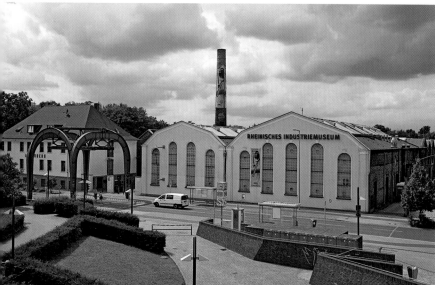

Top left:
View from the top of
the big wheel in the
amusement park at the
CentrO shopping centre
in Oberhausen. Here you
can see the tram line
running from the mall into
the centre of town.

Centre left:
Not far from the main
station in Oberhausen is
the old Altenberg zinc
factory. It now houses the
interesting Schwer.Indus-
trie museum and the popu-
lar Altenberg arts centre.

Bottom left:
The palace in Oberhause.
is very much part of the
town's history. A wander
through the neighbourin.
Kaisergarten park is a

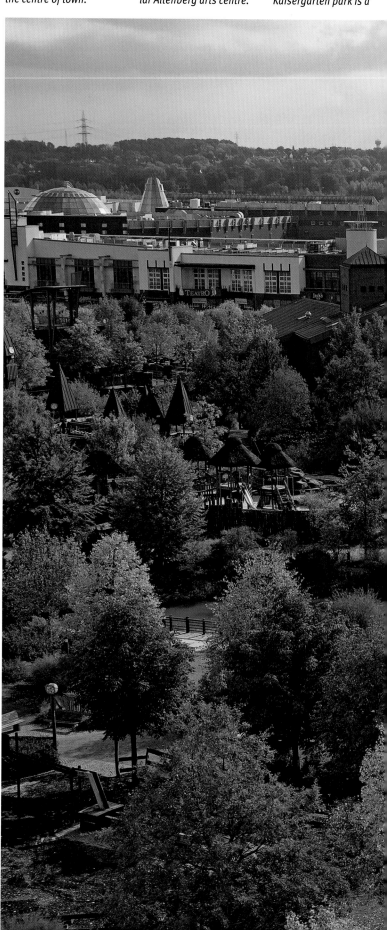

58

must on a sunny Sunday afternoon. The palace itself has an interesting collection of art in the Ludwig Galerie.

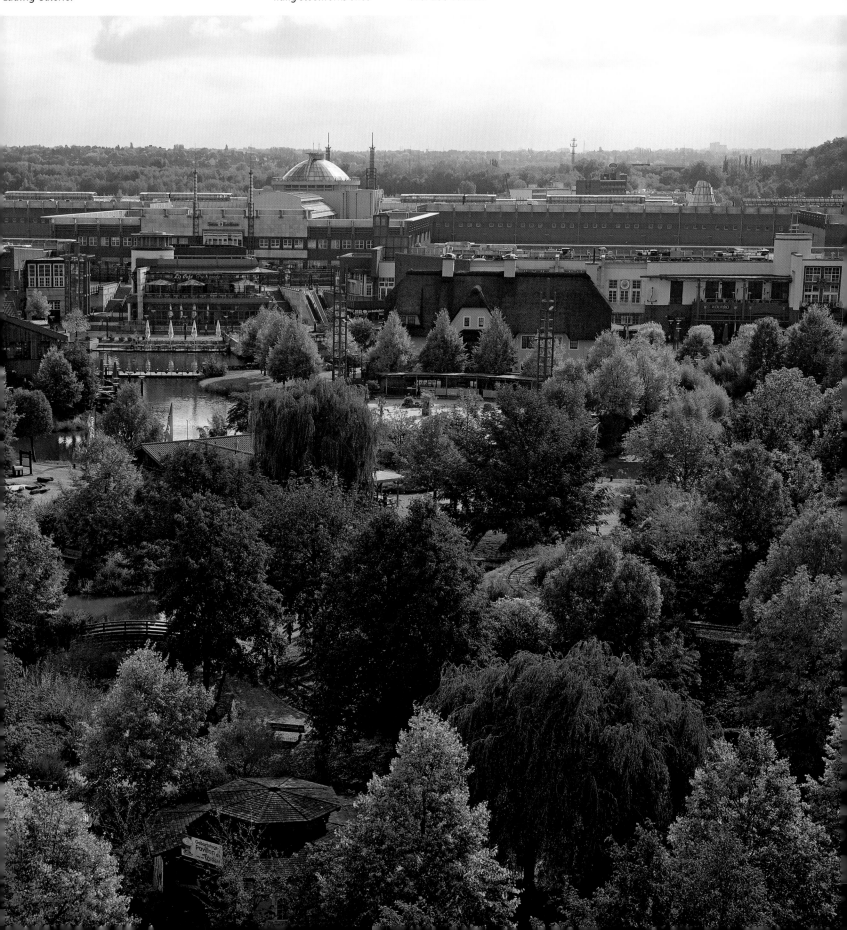

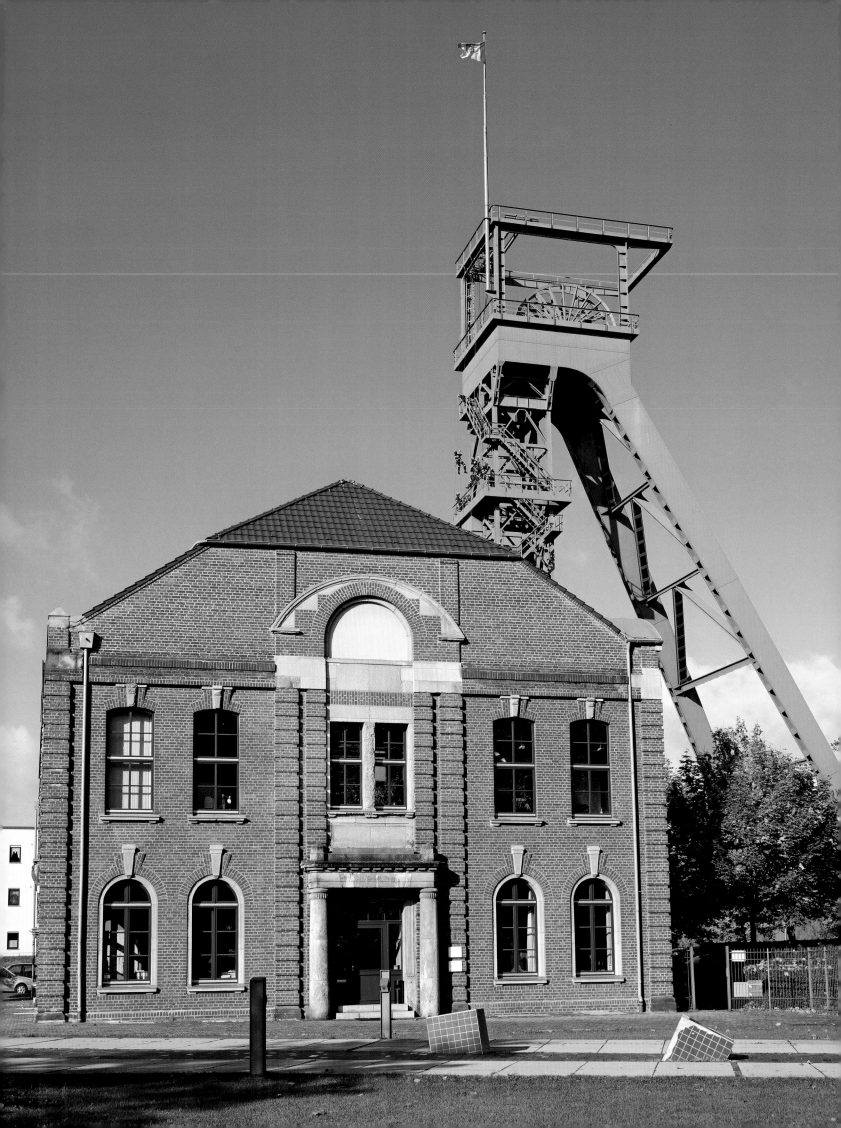

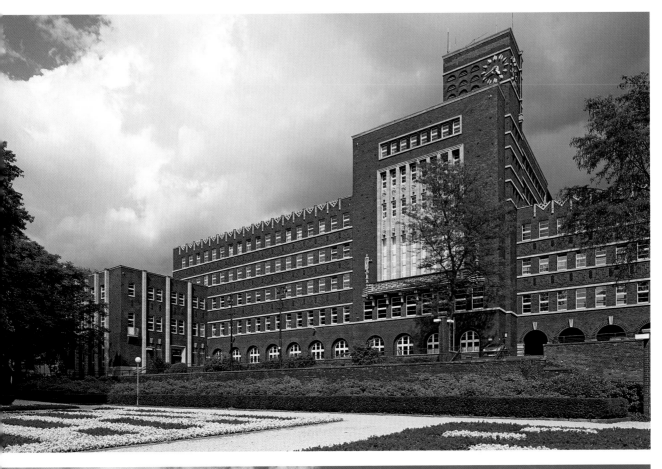

Left page:
The Osterfeld mining company in the Oberhausen suburb of the same name was in operation from 1873 until the 1990s. The former hard coal mine has now been largely landscaped, with Oberhausen's local garden show OLGA once staged on the former site of Zeche Osterfeld 1/3.

The town hall in Oberhausen, opened in 1930, is the seat of the local council and administration. The building is an important piece of architectural history, with the style alternating between brick Expressionism and Neues Bauen or new building. The various cubes lend it a certain dynamism.

Once on the line run by the Cologne-Minden railways, opened in 1846, the main station in Oberhausen is now serviced by IC and ICE trains. The present station, expressed in the cubist forms of the Modernist style, is a product of the early 1930s.

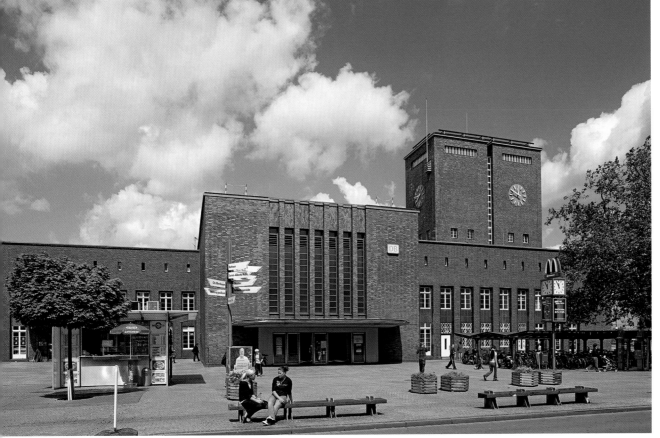

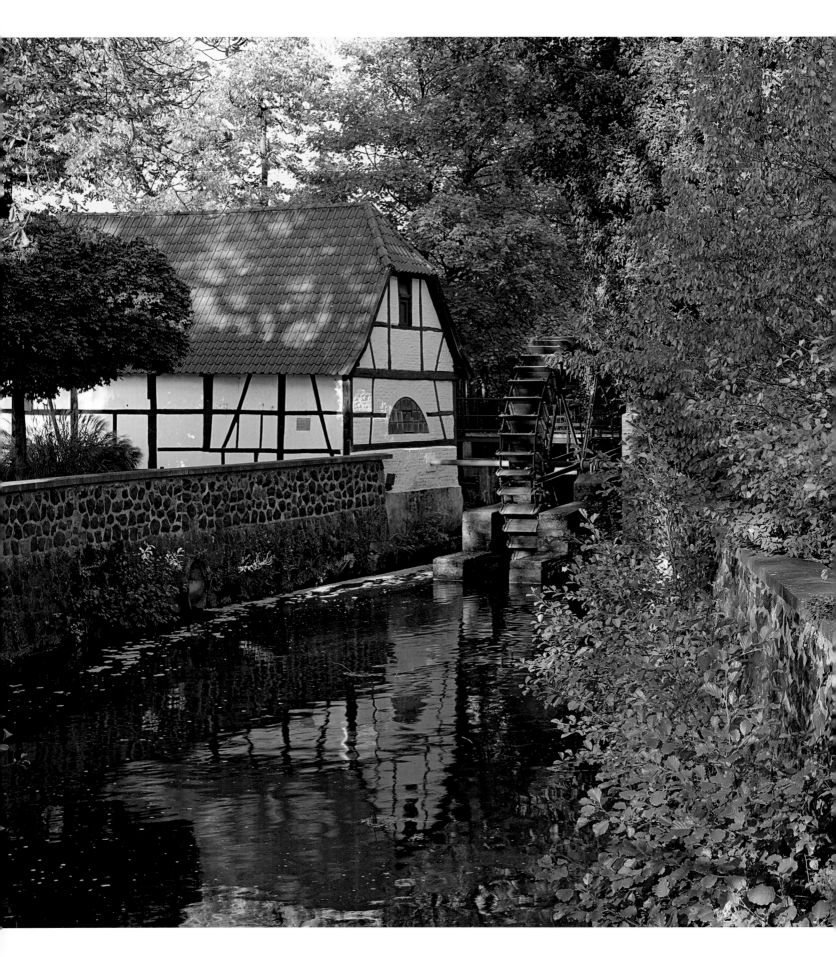

Left:
The mill museum in the Hiesfeld suburb of Dinslaken goes back to the 1970s. The centrepiece of this unique group of buildings on the Rotbach is the historic half-timbered watermill, erected in 1693.

Below:
The heart of the little town of Dinslaken on the northern edge of the Ruhr is without doubt the old marketplace or Altmarkt. This is where the old-fashioned annual fair and Christmas market are held.

Essen, Gelsenkirchen, Bottrop – in the heart of the Ruhr

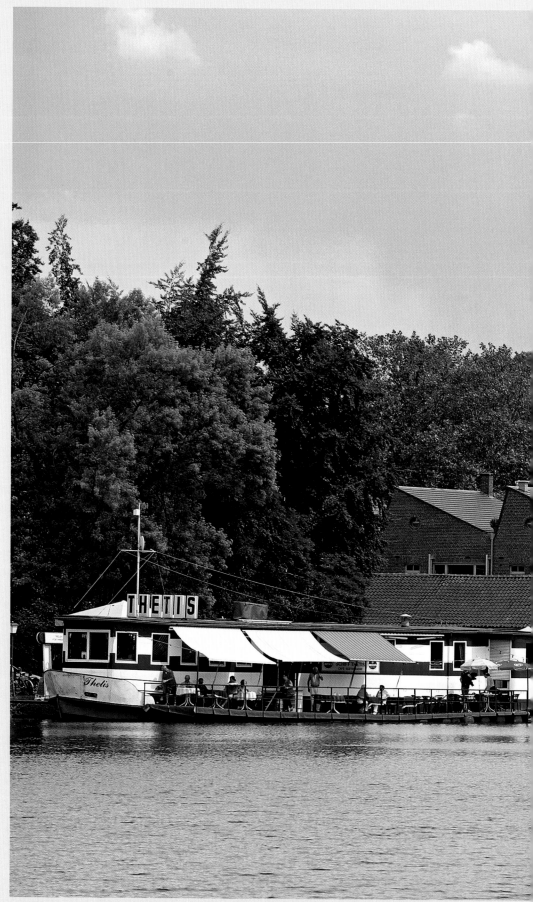

Summer on the Ruhr. Kettwiger See south of Essen-Kettwig was dammed between 1940 and 1950 and is one of the smaller of the six Ruhr reservoirs. The Scheidt cloth factory is its main attraction, in whose hallowed halls artists and artisans, agencies and other creatively-minded folk have set up shop.

Historically speaking, the three big cities at the heart of the Ruhr Basin owe their size and development to the old trade routes that once ran from west to east here. Today it's more their central position between the River Rhine and the great urban centres of Westphalia that lend them their sense of character – admittedly with difficulty in some cases. Incidentally, the dividing line between North Rhine and Westphalia doesn't adhere to geography; the cities of Bottrop and Gelsenkirchen in the north of the Ruhr are politically part of Westphalia and not North Rhine as you might expect.

The heart of this central region is clearly Essen, a 600,000-strong metropolis with many different sides to it. The workers' estates of Katernberg and Stoppenberg in the north and the upper-class south on the elysian strands of the Baldeneysee are worlds apart. Travelling the 17 kilometres (10 miles) on the number 107 tram from its start in Bredeney to the main station in Gelsenkirchen poignantly uncovers the social-historic components that make up the Ruhr. The differences are crass; the Krupp estate with its Villa Hügel smacks of finery and nobility where the Zeche Zollverein colliery is a monument – and one with world heritage status – to the proletariat.

This counterpoint is missing from Gelsenkirchen to the northeast. Once the largest mining town in Central Europe with its 24 mines and 60 pit shafts, Gelsenkirchen is now fighting a little heeded yet fairly successful battle for structural change. Schloss Horst and the moated castle of Berge provide two historical spots of colour in the city's otherwise rather drab existence. Emotions in Gelsenkirchen are fuelled by the Schalke 04 football club, undoubtedly the city's most famous ambassador. The third in the trio is Bottrop, known as Bottrowski at the beginning of the 20th century for its sizeable population of Poles who at 14,000 made up over half the population. One architectural gem that still marks this period is the Malakoffturm at the Prosper II colliery. Bottrop is now largely dedicated to entertainment. It boasts the longest indoor ski run in the world, for example, and Movie Park Germany, a vast centre for all the family devoted to the glittering world of film.

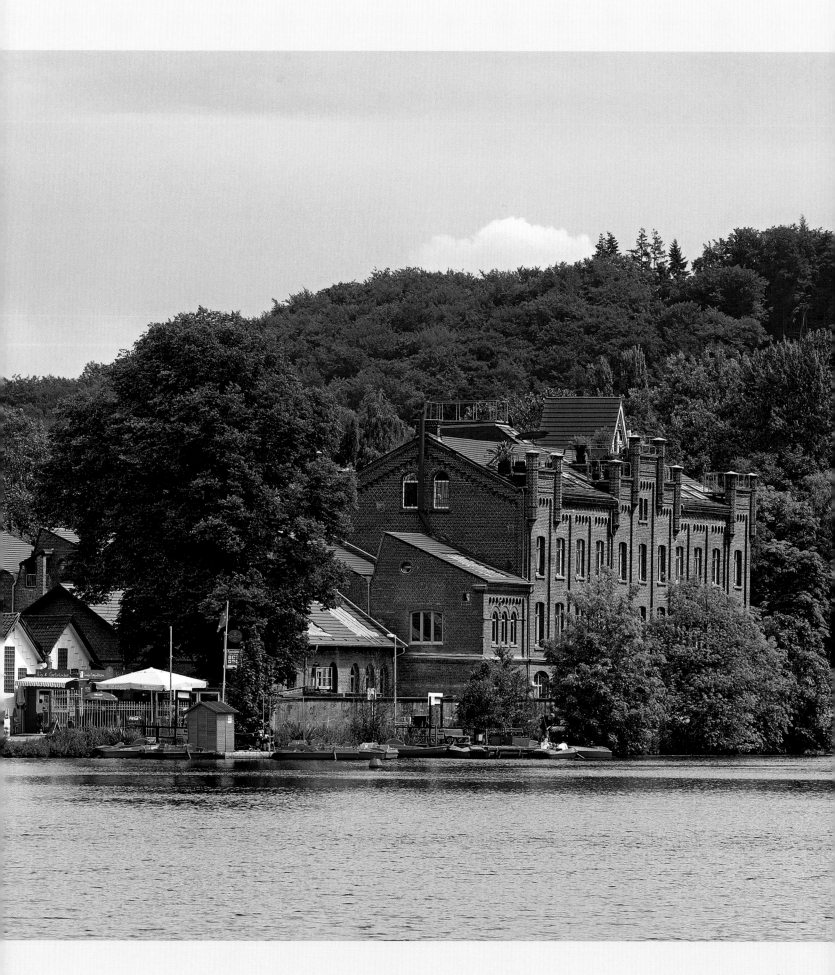

Right:
From place of work to cultural monument: the Zeche Zollverein on Gelsenkirchener Straße in Essen-Stoppenberg is a central monument to the coal mining industries of the 19th and 20th centuries.

Right:
Closed down in 1986, the Zollverein was initially threatened with demolition. It's now the only site worldwide where the complexity of this branch of industry can still be easily discerned.

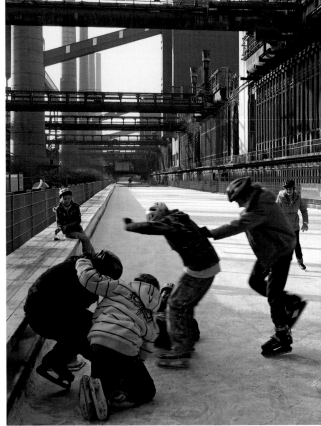

Far right:
From hard work to play: once a mine, now a venue for various events and home to the Ruhr Museum and the Design Centre NRW, among other institutions. In winter the Zeche Zollverein is even turned into an ice rink.

Right:
Various restaurants and Café Kohlenwäsche in the old coking plant at the Zeche Zollverein cater for hungry and thirsty visitors.

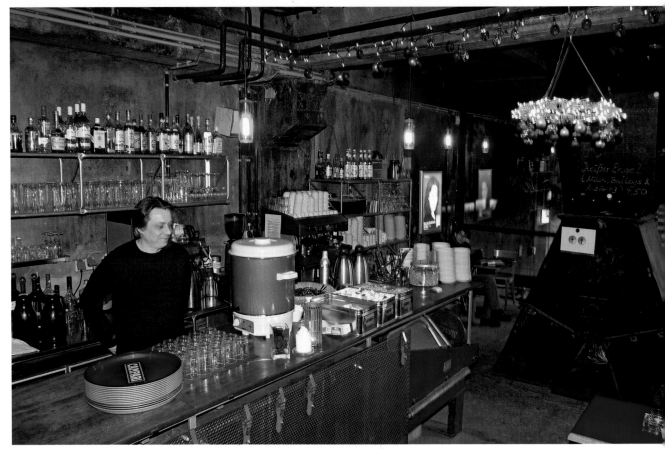

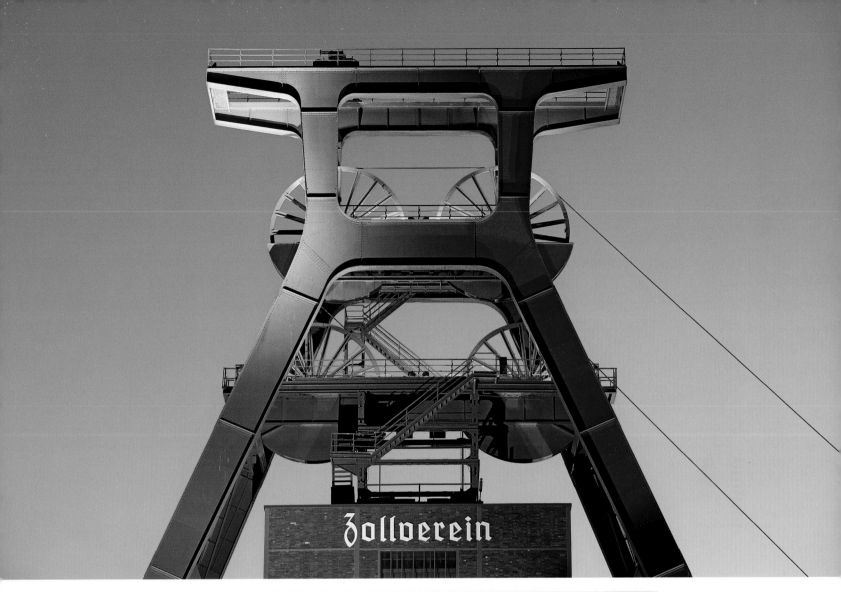

Above:
The showpiece of the Zeche Zollverein, said to be the most beautiful mine in the world, is without doubt its double winding tower. The symmetrical site, built according to the doctrines of New Objectivity, is now a UNESCO World Heritage Site.

Left:
Workshop for metal design in Essen-Kupferdreh. The manufacturing plant is housed in a copper hammer works where copper was once processed in the valley of the Deilbach. The mill opened in the second half of the 19th century.

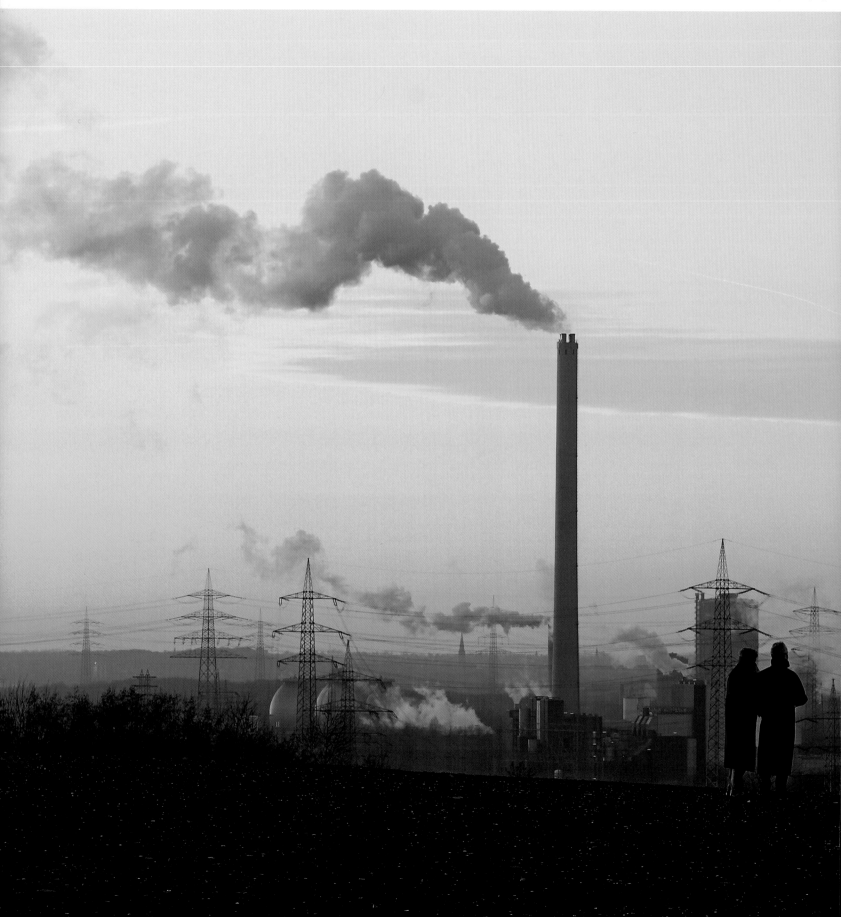

Below:
Mine dumps are as much part of the Ruhr as its blast furnaces and industrial chimneys. Consisting of the waste dug up from the pits underground, many of these marked elevations are now viewpoints, like the Schurenbachhalde in Essen which once belonged to the Zeche Zollverein.

Top right
You need sure footing and a good head for heights i you want to enjoy the view from the top of the Tetrahe dron in Bottrop. Almos 60 m / 200 ft high, the stee landmark was erected i 1995 not far from the A2 motorway on top of the

90-m/300-ft dump from the Prosper Haniel mine. There are about 400 steps but the climb is worth it for the spectacular views of the Ruhr, all the way out to Essen, Oberhausen and Dortmund.

Centre right:
"Slab for the Ruhr". American artist Richard Serra's steel sculpture was the new summit added to the Schurenbachhalde in Essen in 1998.

Bottom right:
Rheinelbe science park in Gelsenkirchen is another example of structural change. The former site of a crucible steelworks was turned into a research institute for renewable energy, such as solar power, in the 1990s.

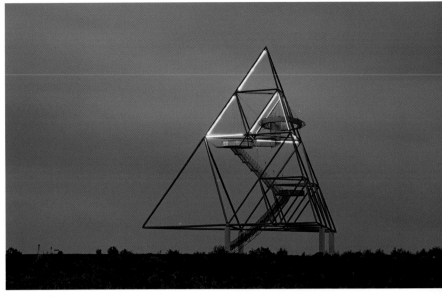

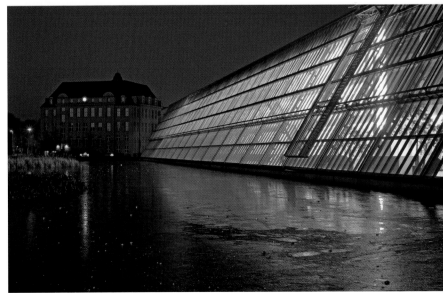

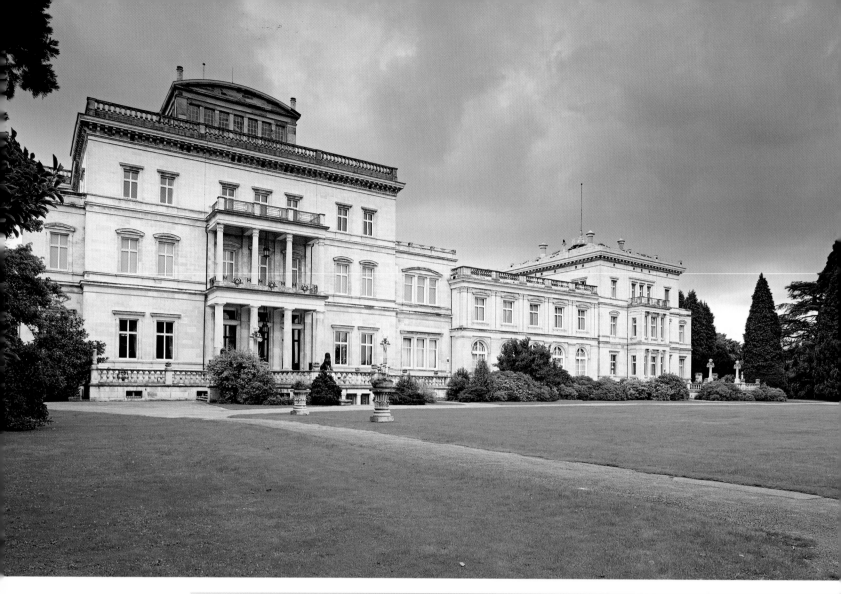

Above:
Villa Hügel in Essen-Bredeney, opened in 1873 by Alfred Krupp high up above the Ruhr, is now extremely popular with the people of Essen, not least for its park. Regular exhibitions, concerts and other events are also staged at the spacious villa.

Right:
The Marktkirche in the heart of Essen is a place of quiet reflection. The late Gothic house of God, heavily damaged in the Second World War, still stands on the original market square where the Ruhr metropolis once went about its economic, political and religious business.

Above:
The Rathaus in Essen is domineering in the full sense of the word. 106 m / 348 ft high, the administrative building from 1979 is one of the tallest town halls in Germany. From the 22nd floor 100 m / 330 ft up, on a clear day visitors have a good view out over Essen and the Ruhr. In the foreground is Essen Minster.

Left:
One of the best-known arts venues in Essen and the Ruhr, the Aalto Theatre, was designed by Finnish architect Alvar Aalto in 1959 but not built until 1983. It was finally opened in 1988.

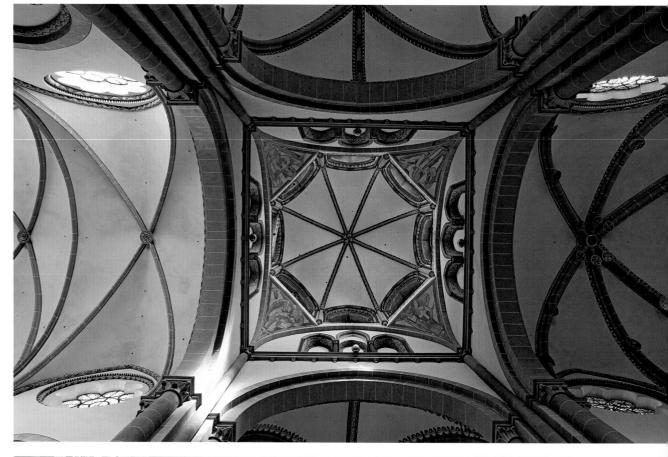

Clear forms and designs marking the transition from Romanesque to Gothic abound in the beautiful former abbey church of St Ludger's in Essen-Werden.

The baroque high altar, paintings by Werden artist Theodor Mintrop, the treasury with the Helmstedt Crucifix and the Carolingian crypt containing the bones of St Ludger are the main attractions of St Ludger's Church.

Right page:
The basilica of St Ludgerus towers above Essen-Werden. Originally built as an abbey church in 799, following several fires it was reconsecrated in 1275. The church, named after the missionary Ludger, is claimed to be one of the most beautiful churches in the Rhineland and a prime example of the regional transitional style.

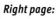

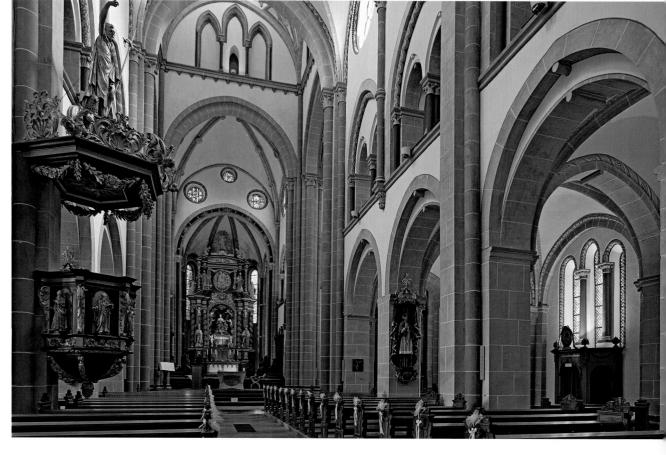

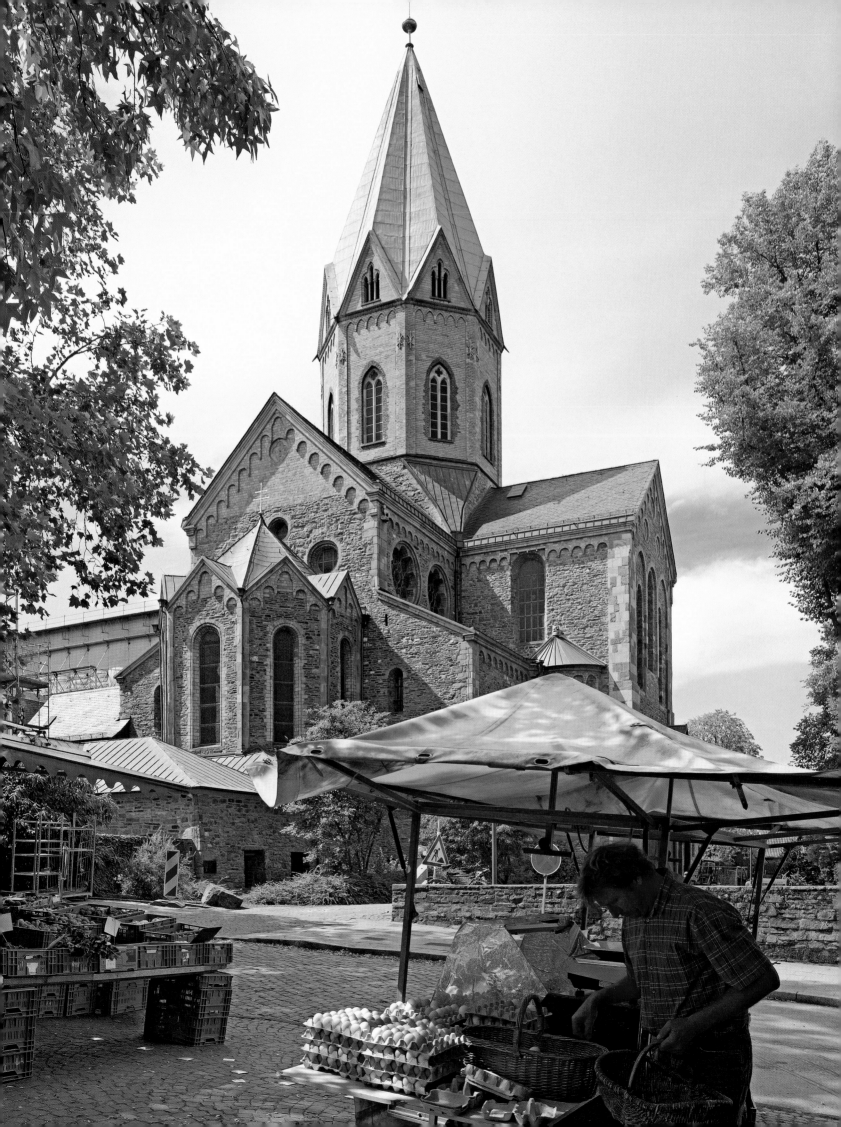

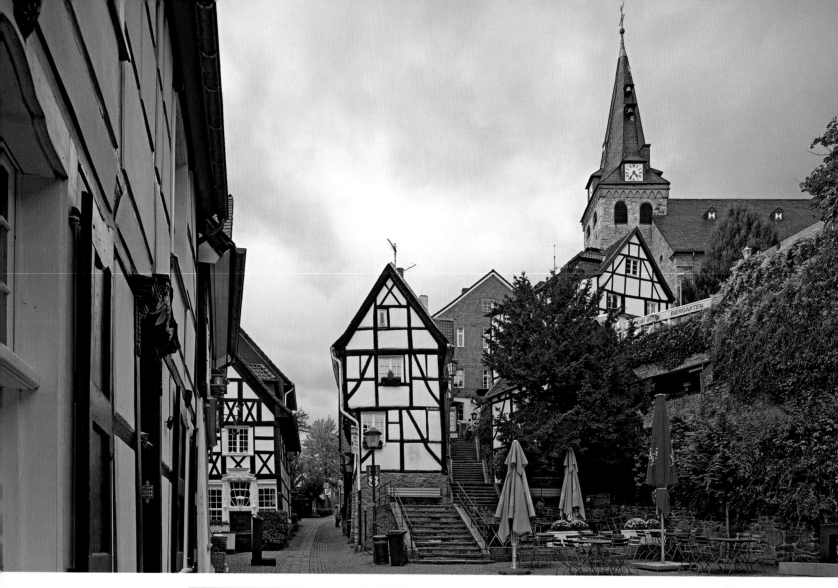

Above:
Time seems to have stood still in the old centre of Essen-Kettwig. The black-and-white half-timbering is typical of the towns in the western Ruhr Valley.

Right:
The Essen suburb of Kupferdreh (copper milling) is appropriately named, for here as in the entire Ruhr Valley there are plenty of metalwork forges, some of which are still in use.

Left:
The garden city of Margarethenhöhe in the south of Essen is still very much a desirable place of residence. Founded by Margarethe Krupp, it was built between 1909 and 1920.

Below:
The old town of Essen-Werden is now one of the best addresses in the Ruhr metropolis, its provincial country flair a crass contrast to the sober city centre.

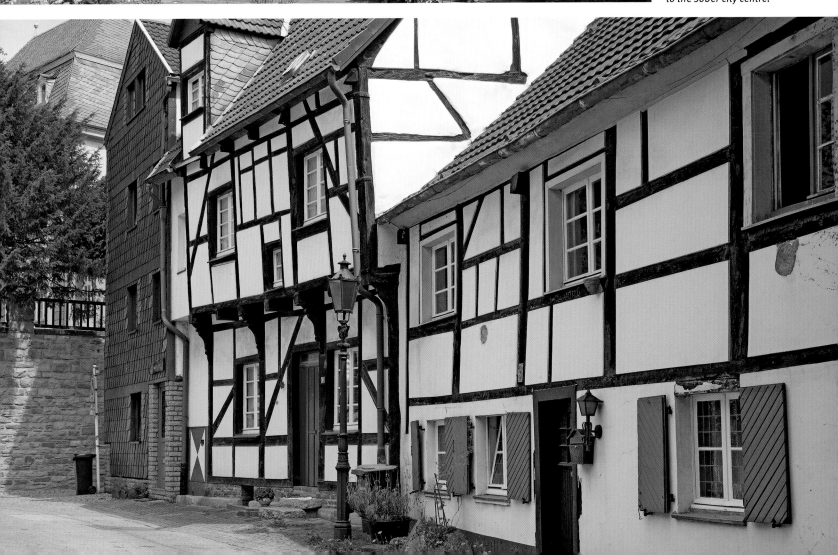

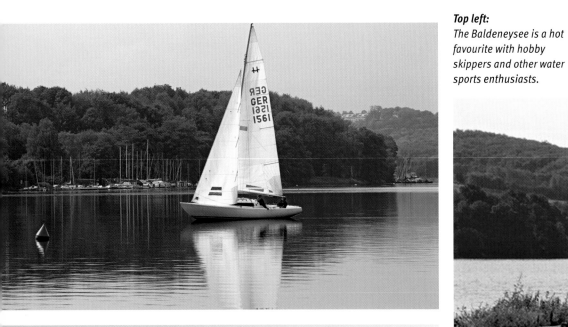

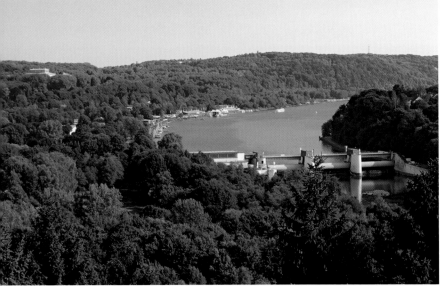

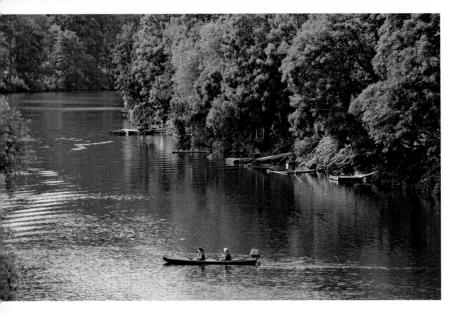

Top left:
The Baldeneysee is a hot favourite with hobby skippers and other water sports enthusiasts.

Centre left:
The Baldeneysee to the south of Essen is almost eight kilometres / five miles long. The Ruhr was dammed to create the lake between 1929 and 1932 as part of a job creation scheme.

Bottom left:
The Ruhr near Essen-Werden is extremely romantic and almost primeval in its natural beauty.

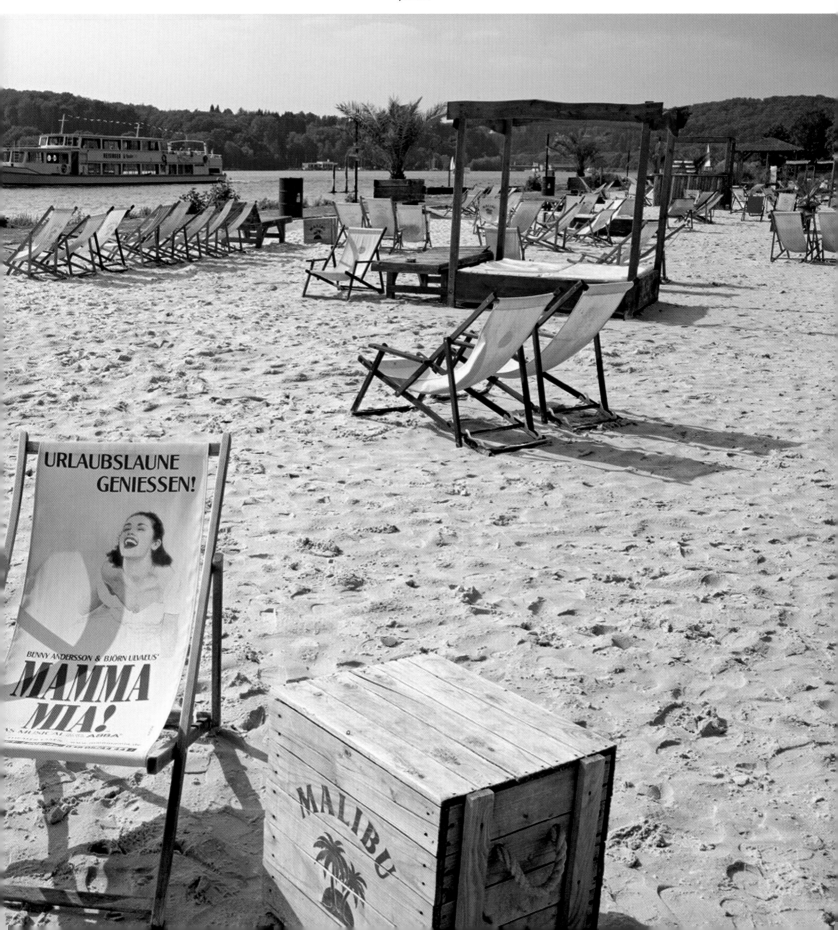

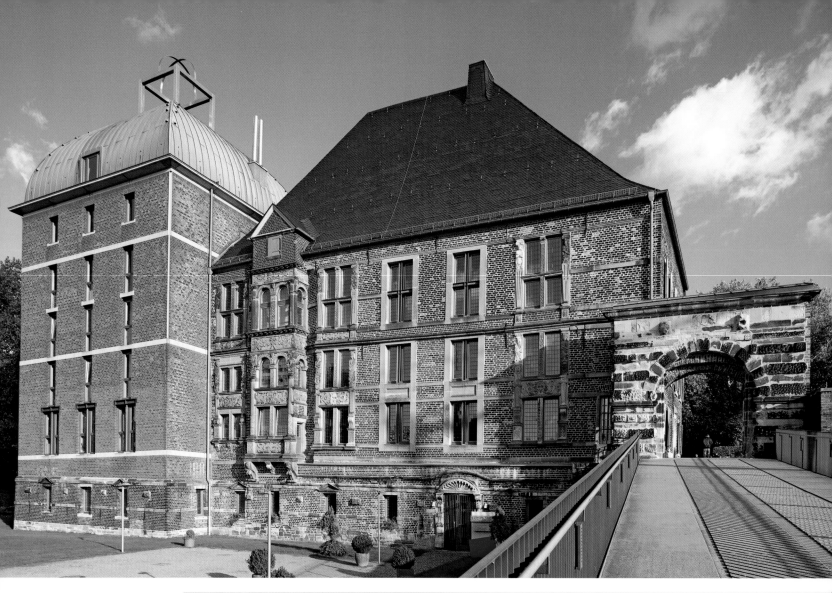

Above:
Gelsenkirchen Renaissance. Schloss Horst is one of the few historic pearls in the traditional working-class town and boasts a splendid glass-roofed inner courtyard.

Right:
Haus Hegehof is in the otherwise very industrial suburb of Altenessen in the north of Essen.

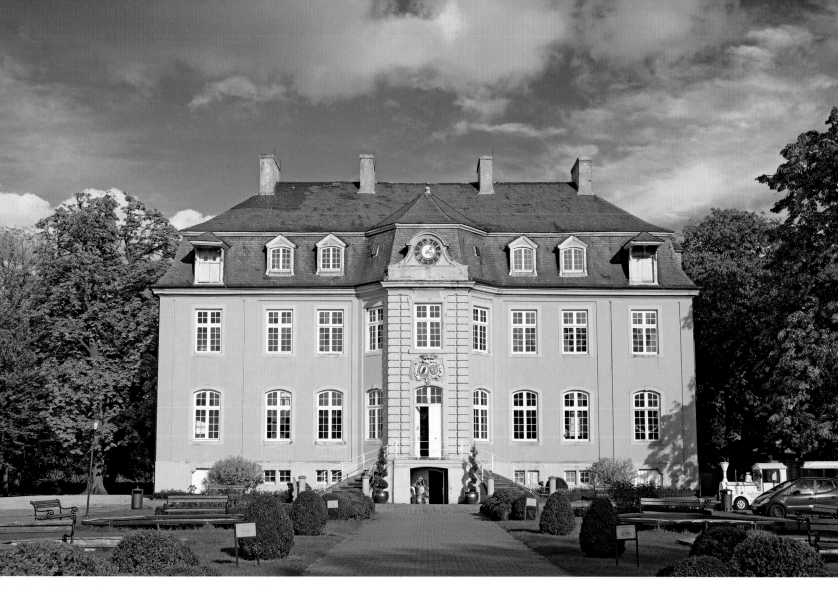

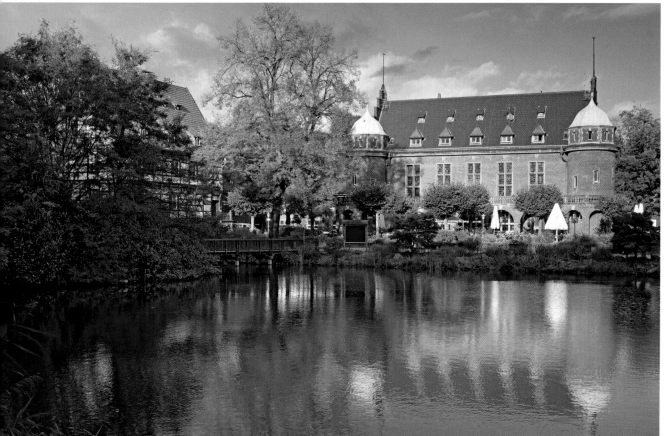

Above:
The moated castle of Beck is one of the loveliest late baroque buildings in the west of Westphalia. The prestigious edifice is now at the heart of the amusement park in Bottrop.

Left:
Schloss Wittringen in Gladbeck is an impressive example of Lower Rhine Renaissance. The adjoining half-timbered building houses the town museum.

The Zweckel machine hall in Gladbeck has palatial proportions. The old pit has been an industrial monument since 1997 and is now where various events are held.

The Oberschiur pit at the old Consolidation mine in Gelsenkirchen-Feldmark is now spic and span instead of smeary and sooty.

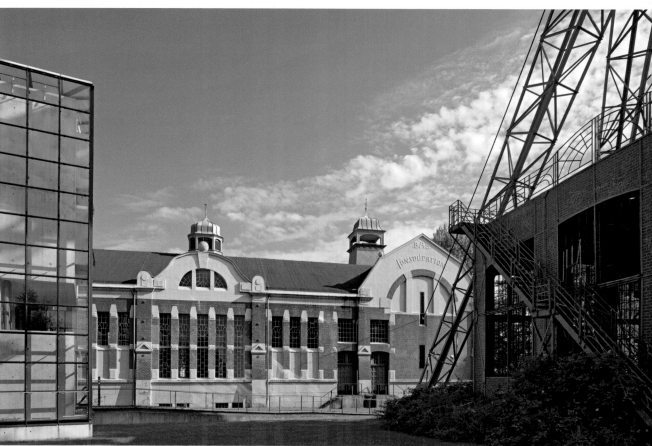

Right page:
The old Propser II colliery in Bottrop boasts a genuine Malakoff tower, with winding towers of this type taking their name from the Russian redoubts erected outside Sebastopol.

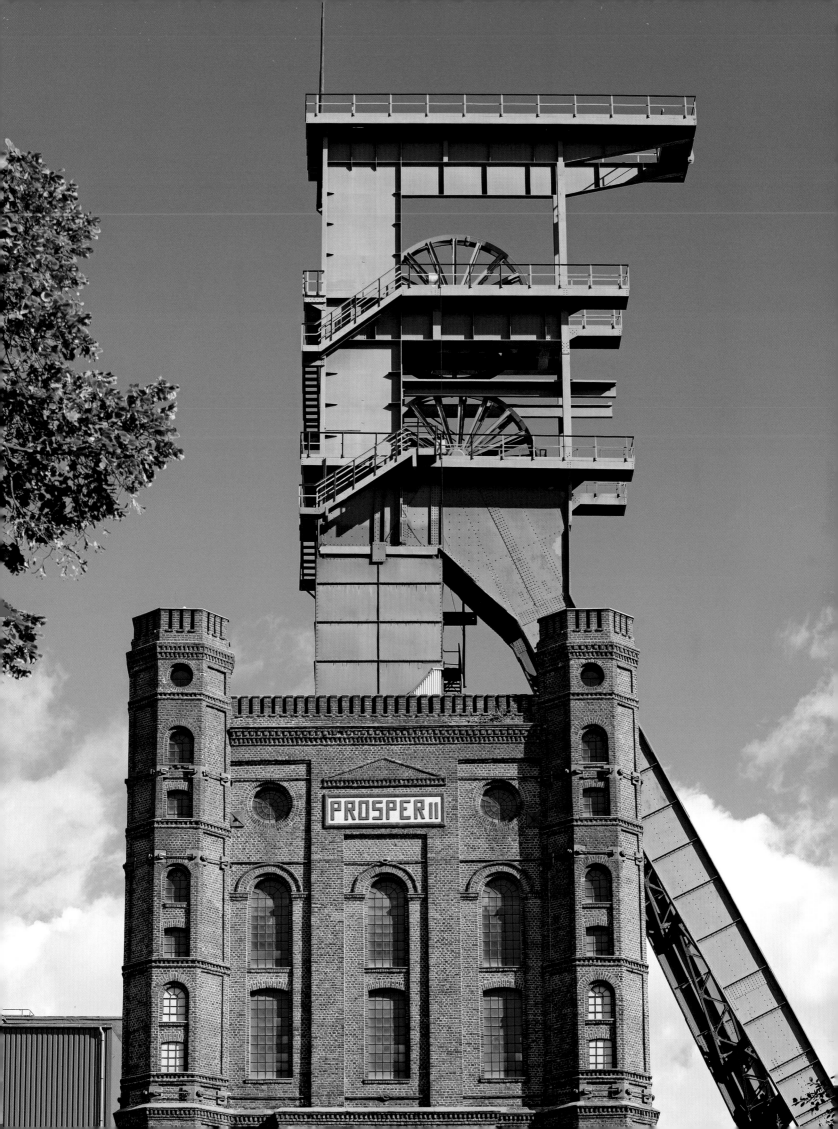

CONTEMPORARY WITNESSES – ON THE INDUSTRIAL HERITAGE TRAIL

Blast furnaces, gasometers and winding towers constitute the face of the Ruhr. Yet coal and steel, which once guaranteed hundreds of thousands of people a steady job, have beat a rapid retreat in the past few decades. The statistics are impressive; where in 1957 there were 141 pits between Duisburg and Dortmund, by 2009 this number had shrunk to just four. At the same time the blast furnaces also began to disappear, with the around 30 of the 1930s now down to a mere three.

These former sites of production continue to play their part as local landmarks and as important symbols for the people here. They are also witnesses to more than 150 years of industrial history and to a period of structural change that has not yet come to a head. The steel crisis of the 1980s signalled the end for many blast furnaces, from the August-Thyssen-Hütte in Oberhausen (1979) to Hattingen to Duisburg-Meiderich (both in 1986). The fight for the steelworks in Duisburg-Rheinhausen was symbolic of the demise of Krupp; the battle was lost and the works closed in 1993.

Building exhibition and culture

The fact that not all of the abandoned industrial sites between the Emscher River in the north and the Ruhr in the south were simply torn down is largely accredited to the Emscher Park International Building Exhibition (IBA) and its initiator Karl Ganser. In 1989 the town planner began realising his vision of reclaiming the steelworks and power plants, the coke ovens, mines and chemicals plants in the Emscher region and turning them into a landscaped park for the local inhabitants. The IBA created new links between the cities of the Ruhr along disused railway lines once operated by the mines. A budget of about 2.5 million euros enabled important witnesses to the area's industrial heritage to be saved, among them the Jahrhunderthalle in Bochum from 1902, once a blower house for blast furnaces and now a festival hall for the theatre and music staged during the Ruhrtriennale, the industrial park in Duisburg-Nord on the site of the ironworks in Meiderich, closed in 1985, and the gasometer in Oberhausen, erected in 1929 and now an absolutely fascinating exhibition hall.

They all line the Industrial Heritage Trail (www.route-industriekultur.de), 400 kilometres (250 miles) of themed tourist route that takes in former steelworks and also famous workers' estates, such as the Margarethenhöhe in Essen and Eisenheim in Oberhausen. Along the way there are many prime sites to explore,

such as the Zeche Zollern mine opened in 1898 in Dortmund, its impressive architecture elegantly pinpointing the transition from Historicism to Jugendstil. Just a few miles down the road is the old Henrichenburg ship hoist, unveiled on August 11 1899 by none other than Kaiser Wilhelm II. Further highlights include the German museum of mining in Bochum, the Nachtigall mine in Muttental near Witten, heralded as the cradle of the industrial Ruhr, the Henrichshütte in Hattingen, Villa Hügel in Essen, the Aquarius water museum in Mülheim an der Ruhr and many more.

Local landmark Zeche Zollverein XII

The undisputed anchor of the Industrial Heritage Trail is Zeche Zollverein XII in Essen – once a place of work for 1,100 people and now a UNESCO World Heritage Site (since 2001). Where 12,000 metric tonnes of coal a day used to be mined and turned into coke, now much-frequented events are held and attractions are housed, including North Rhein-Westphalia's Design Centre and the Ruhr Museum on the history of the region opened in 2010. The latter is based on Essen's Ruhrland Museum from 1904, one of the oldest and most traditional museums in the Ruhr Basin. Visitors to the museum follow the trail of the coal once washed here. At all levels the exhibition tries to forge a link between the natural and cultural history of the Ruhr to create an integral concept. The trail starts in the present with the 'myth' of the Ruhr, going on to elucidate the traditions of the industrial age. After examining how coal was formed in the geological carbon era, the museum concludes by taking a look into the future.

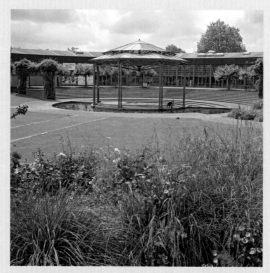

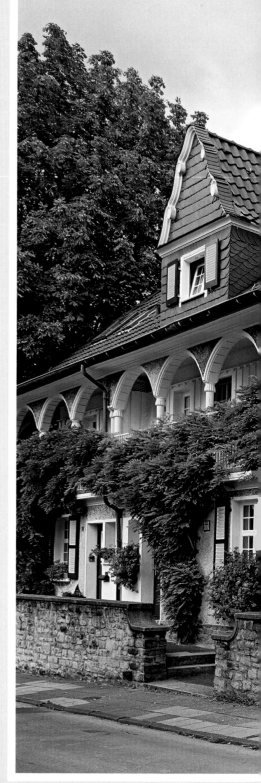

Left:
Once the biggest engine repair shop belonging to the Deutsche Reichsbahn or German railways, the Ringlokschuppen in Mülheim an der Ruhr is now possibly its most attractive venue.

Above:
Many of the houses on Margarethenhöhe in Essen are smothered in climbing plants that creep up to cosy arbours.

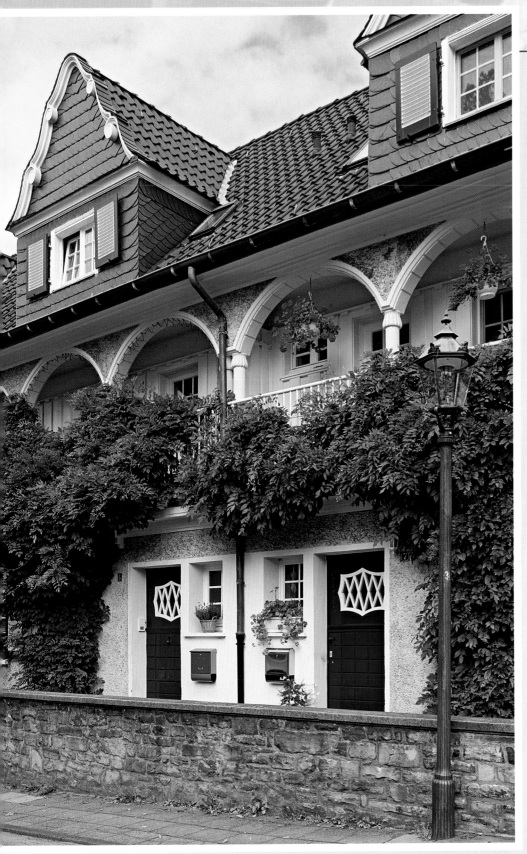

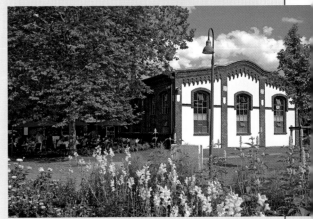

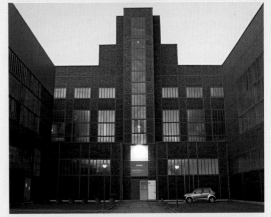

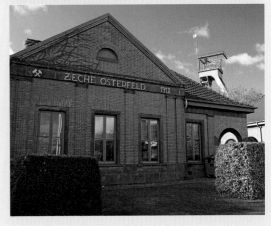

Small photos right, from top to bottom: *In the middle of the Nordsternpark in Gelsenkirchen where Germany's national garden show was held in 1997.*

The lush Maximilianpark with its bevy of blooms in Hamm in Westphalia covers much of what was once the Zeche Maximilian mine. The federal state's regional garden show was staged here in 1984.

The old boiler house at the Zeche Zollverein in Essen is now the red dot design museum, the largest exhibition of contemporary design in the world.

The gatehouse at the old Zeche Osterfeld colliery in Oberhausen is a real gem.

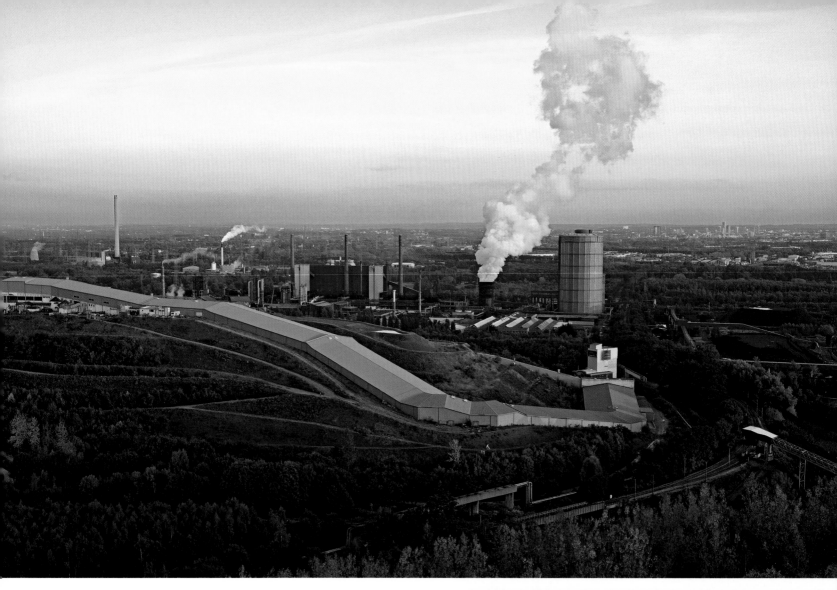

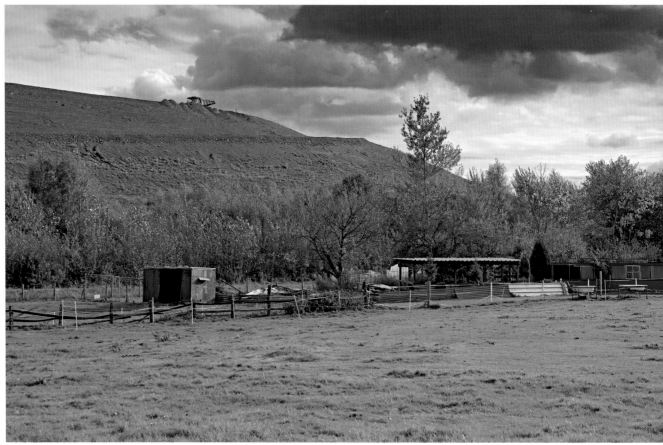

Above:
Bottrop's ski centre looks like a giant UFO that has landed next to the industrial site of the Prosper central coking plant.

Right:
Mine dumps – here the Mottbruchhalde in Gladbeck – are the highest elevations in the northern Ruhr. Their reuse impressively documents the dramatic change in the industrial landscape of the Ruhr.

84

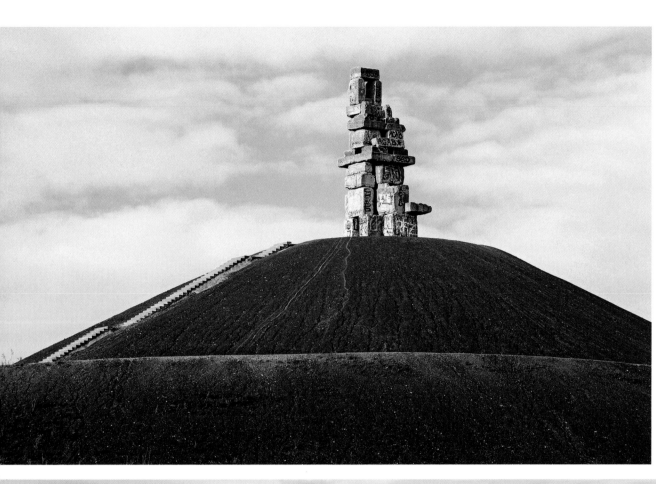

Left:
35 concrete blocks salvaged from demolished mines have been used to create this Jacob's Ladder atop the Rheinelbe overburden dump in Gelsenkirchen. The sculpture is the work of artist Hermann Pigran.

Below:
The steel installations on the Rungenberg waste dump in Gelsenkirchen-Buer can be seen for miles around and are on the themed Landmarken-Kunst (landmark art) tourist route.

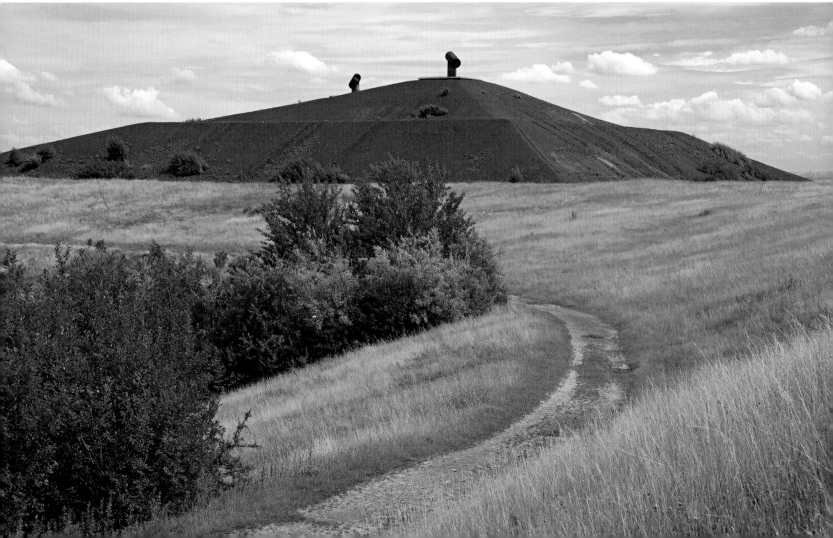

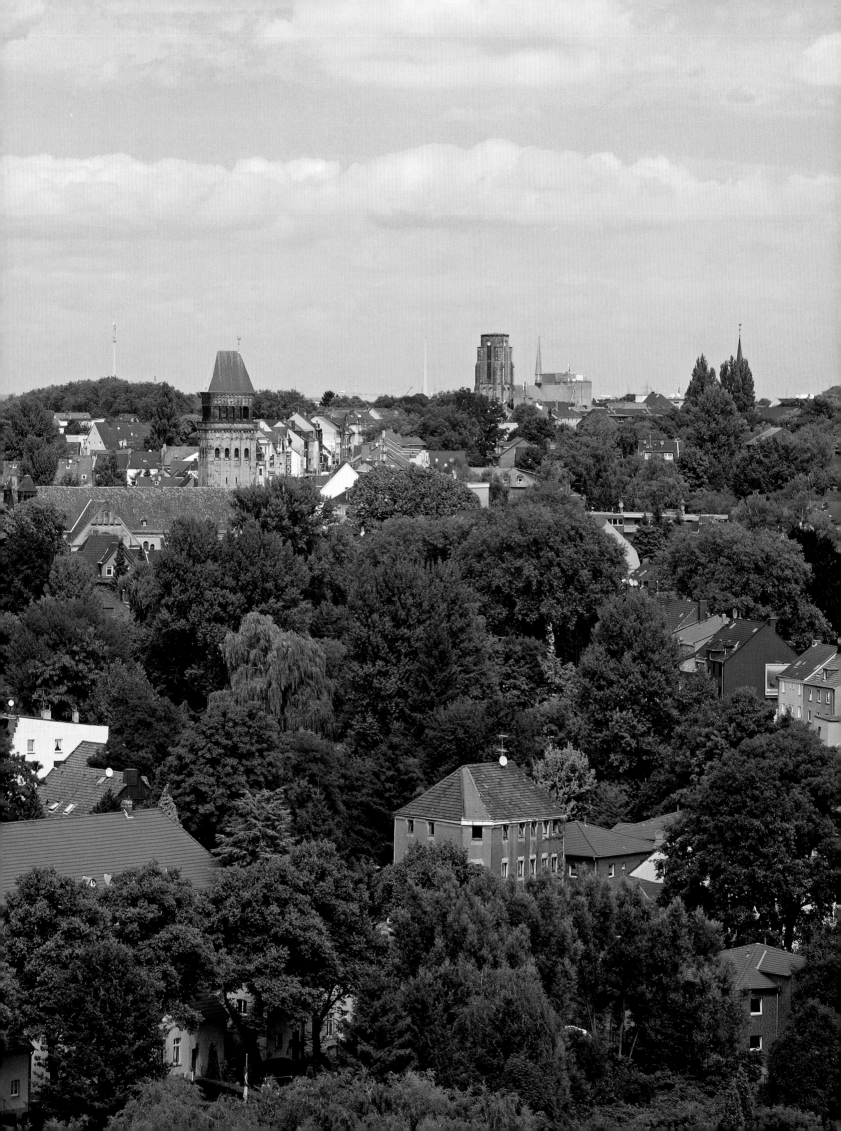

Right:
All under one roof. The very private character of the houses here, like this one in Schüngelberg/ Gelsenkirchen, is a sure sign that they were once miner's cottages.

Below:
Even in the Gelsenkirchen suburb of Buer the rural Münsterland isn't far away.

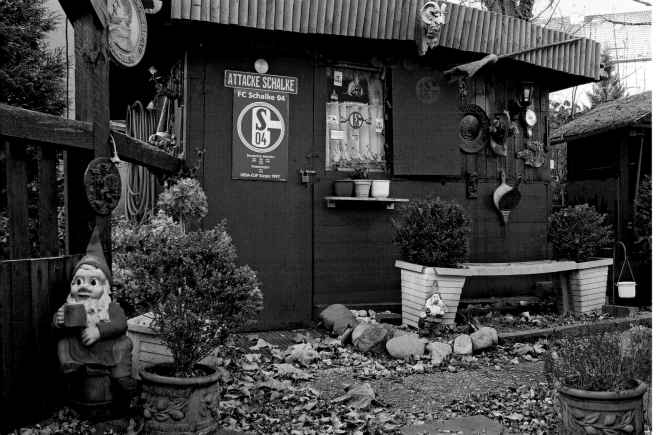

Above:
*Every inch of space has
been put to good use on
the Schüngelberg estate,
with nothing left to chance.
Nevertheless, the neat
rows of houses still seem
more rural than urban.*

Left:
*A garden or allotment is
a must – here in Gelsen-
kirchen – even if you only
sit in it to enjoy a beer
after work or barbecue
with friends on a warm
summer's evening.*

89

Bochum, Dortmund et al – new avenues to the east

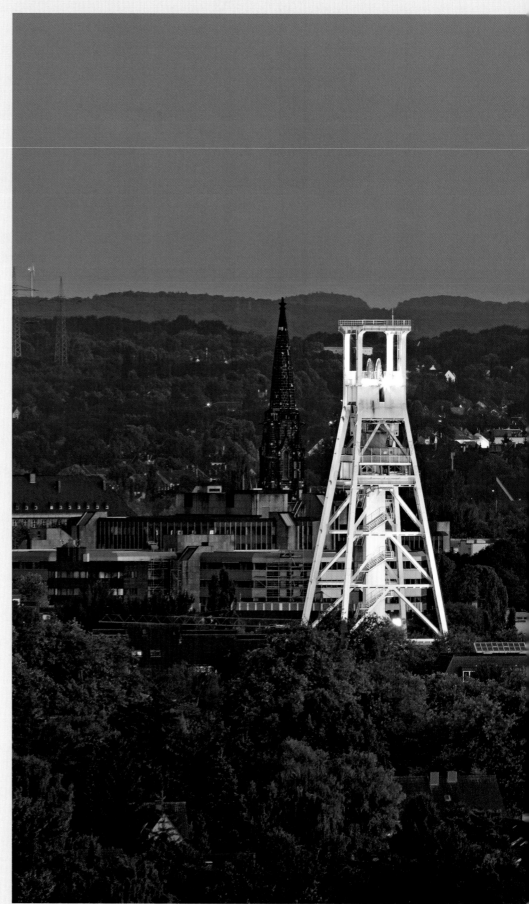

There are breathtaking panoramas from the Tippelsberg in the Bochum suburb of Riemke, spreading out over the centre of town to the hills of the Ruhr Valley in the south. The monumental winding tower of the German museum of mining in Bochum makes a grand centrepiece.

Constancy, a definite down-to-earth quality and the occasional moment of obstinacy are the traits normally attributed to the people of Westphalia. Proof of this is only sporadically found in the cities in the east of the Ruhr; countless breaks in the architecture and forms of settlement here provide greater evidence of change, albeit not always intended or even desired.

Perhaps the most underestimated of the cities of the Ruhr – which are not exactly classed as tough talkers at the best of times – is Bochum, tucked in between the rolling hills that encircle the dominant metropolises of Essen and Dortmund. The city's self-confidence was given a big boost at the beginning of the 1980s when German singer Herbert Grönemeyer released his ode to it on the album *4360 Bochum*. The struggling or fallen icons of Opel and Nokia, a theatre famous throughout Germany and the unstoppable *Starlight Express* lend Bochum its vitality, with the Ruhr's first university of the 20th century keeping it young.

This is a development that neighbouring Dortmund would like to echo. The city on the old Hellweg trade route and former brewing capital of Europe that has had to stand by and watch the sorry demise of several traditional industries, including the Phoenix steelworks, is fighting hard for successful structural change in the 21st century. The defiant symbol of this exploration of new avenues is the main building of the (defunct) Union Brewery, now on course to make Dortmund a fixed feature on the international artistic and cultural map.

To the south of Dortmund the Hohensyburg looks out onto the rather rural environs of the city. From the ruin of this knight's castle there are grand vistas out across the Hengsteysee to Hagen and the elevations of the Sauerland. The open-air museum in Hagen provides a comprehensive insight into the history of Westphalia, complete with over 70 historic workshops and factories. There are plenty of surprises in store, both past and present, in the various other towns of the region, with the icon museum in Recklinghausen, cradle of mining Muttental near Witten, Schloss Cappenberg in Selm, the Henrichenburg ship hoist in Waltrop and the enormous glass cube at the old Mont Cenis colliery in Herne just a few of the many examples.

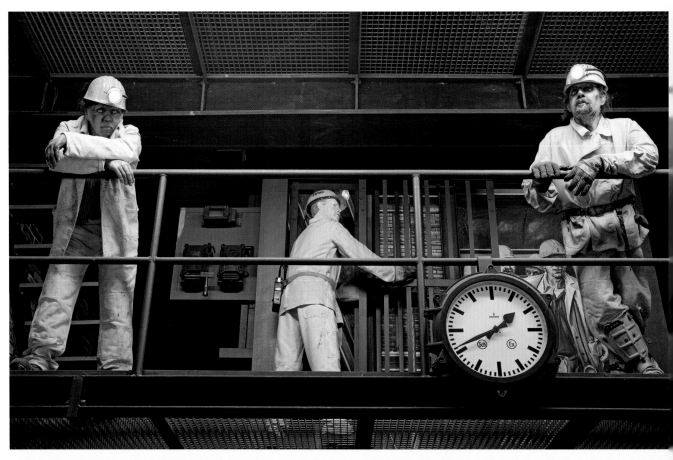

The clock has stopped for most of the miners in the Ruhr – but has kept on ticking at the German museum of mining in Bochum since 1930.

Nowhere else in the world is the mining profession illustrated as vividly and impressively as at the mining museum in Bochum which attracts an average of 400,000 visitors a year.

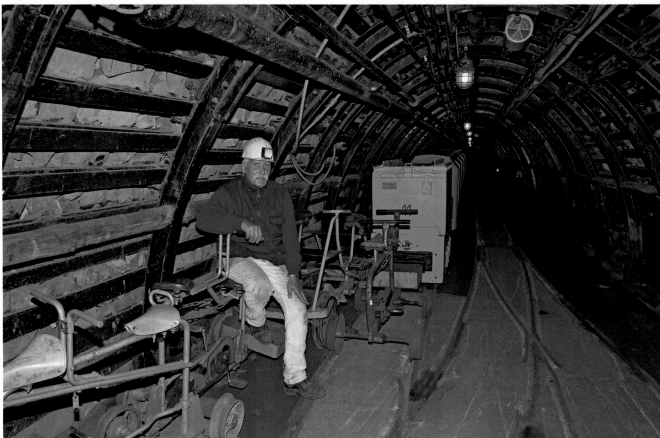

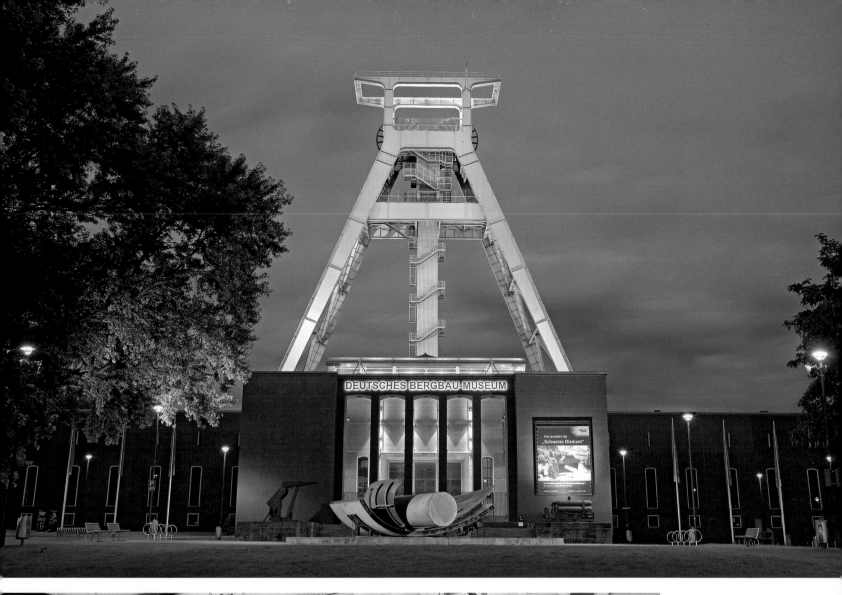

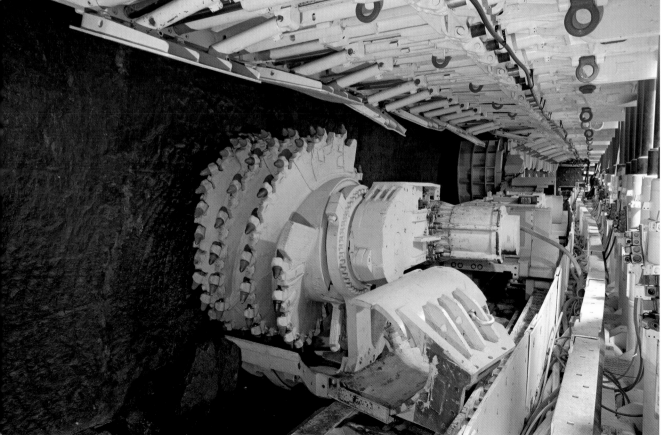

Above:
The winding tower at the mining museum is both Bochum's local landmark and an excellent example of industrial aesthetics.

Left:
Once sooty and extremely loud, the conveyors that dug deep into the coal seam are now spruce and quiet in their museum environment.

Page 94/95:
Industrial history and art meld harmoniously at Zeche Zollern II/IV in Dortmund. The site is also on the Industrial Heritage Trail.

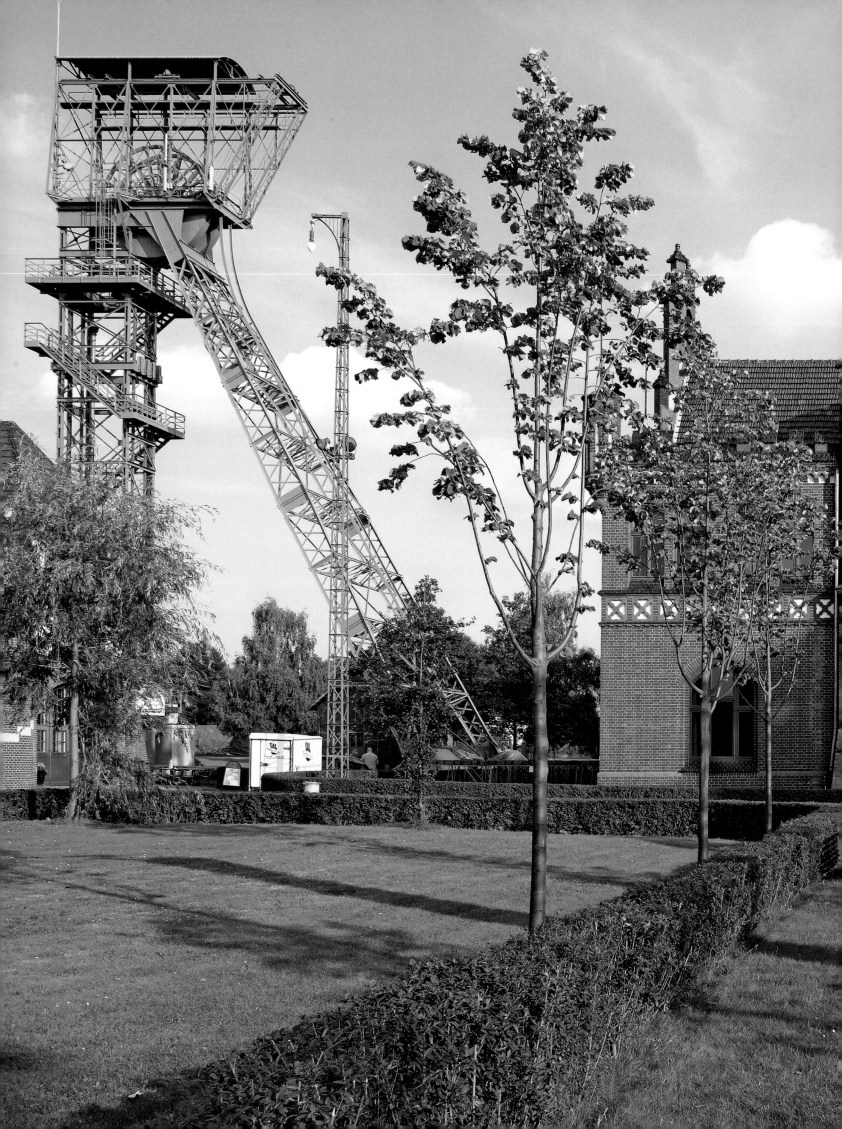

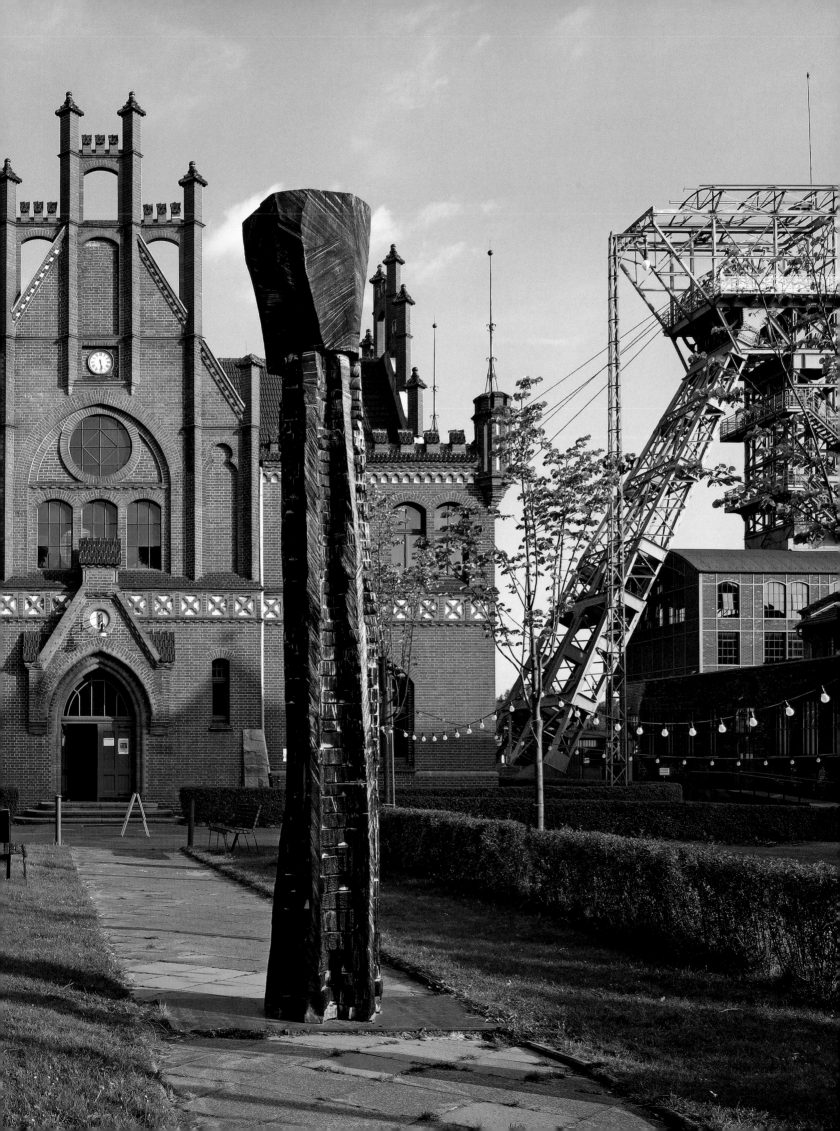

Below:
Originally an exhibition hall for the Düsseldorf exhibition of trade and industry, the Jahrhundert-halle was moved to the Bochumer Verein site in 1903.

Bottom:
Gas blowers and dynamos once powered the blast furnaces of the Jahrhun-derthalle. In their silence these abandoned industrial giants now lend the complex a certain dignity.

Right:
The old factory site surrounding Bochum's Jahrhunderthalle provides the city with a valuable green space. It also accen-tuates the special character of this industrial cathedral which has long established itself as a top venue for all kinds of events.

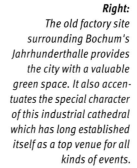

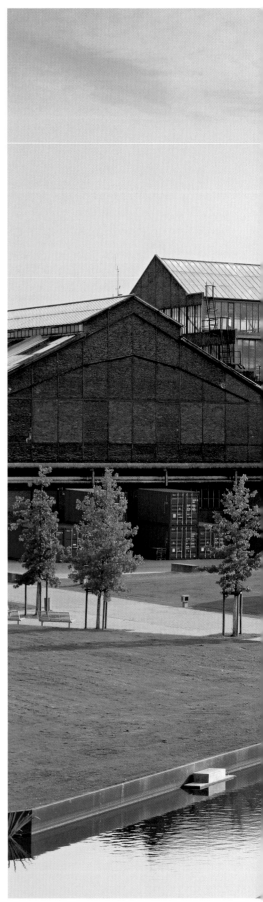

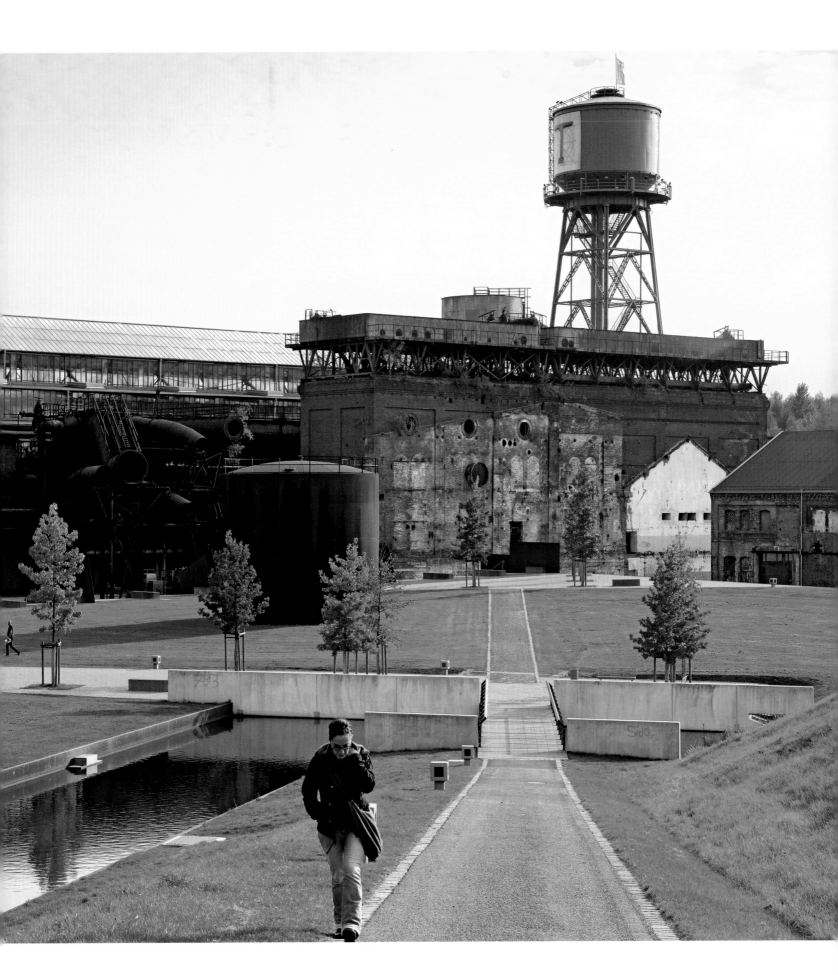

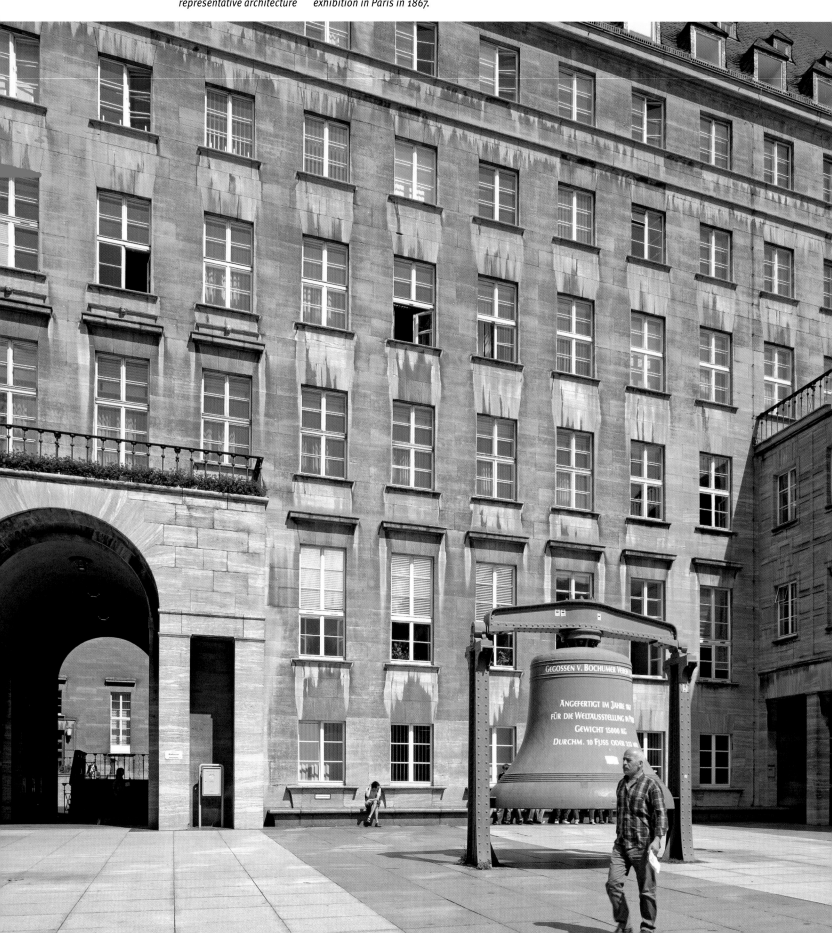

Below:
The town hall in Bochum, built between 1926 and 1931, is one of the most important examples of representative architecture in the Ruhr. The bell manufactured by the Bochum association of mining and crucible steel fabrication was exhibited at the world exhibition in Paris in 1867.

Top right:
Not only Dortmund and Essen are traditional brewing towns. Bochum also knows how to make a good pilsner.

Centre right:
With pubs, cafés and restaurants catering for over 8,000 , it's easy to 'disappear' in the crowds in Bochum's very own Bermuda Triangle (Bermuda3Eck) between the main station and theatre.

Bottom right:
Sausage stands in the Ruhr are more popular than ever – not least since local pop guru Herbert Grönemeyer released his hit "Currywurst".

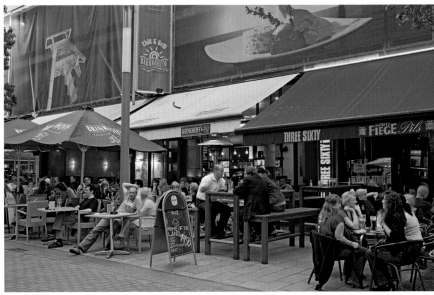

SNACK BARS, *CURRYWURST* AND THE KIOSK – RUHR CUISINE

To get straight to the point: in the biggest conurbation in Germany, with a population structure that includes about half of the nations of the world, you can expect to find just about everything on the menu that these people have brought with them from their native homeland. There are also the obligatory standard fast-food chains that gum up every traffic-free zone between Moers and Hamm. Yet there is more genuine Ruhr cooking than you might think, the roots of which go far back into the 19th century. If you like good, hearty fare with no frills, you've come to the right place. Why not try *Pannas* with mashed potatoes, for example, a kind of pork meal sausage made of black pudding and liver sausage, mince, onions and bacon? There's also Rhineland *Sauerbraten*, braised beef served with sultanas and a rich sauce, chicken fricassee or *Himmel und Erde*, a classic dish of mashed potato and apple appropriately called "heaven and earth". Fans of nouvelle cuisine may turn up their noses; in the day and age when these dishes were initially victorious, beautiful presentation was totally irrelevant, the idea being to provide enough calories for men working all day down the pit or at the blast furnace – and cheaply at that. The staples of yore are now creatively prepared at establishments with fine-sounding names, with many local pubs going upmarket in the quest for both tradition and culinary sophistication. With a good degree of success, it must be said. Restaurants with any number of stars or chef's hats naturally cater for the connoisseurs of the Rhine and Ruhr, with the search for haute cuisine possibly necessitating a trip beyond the city boundaries but no longer the long haul to chic Düsseldorf.

If you've only got time for a quick snack, the Ruhr is unbeatable. And why bother with one of the faceless fast-food outlets you can find anywhere when you've got snack bars with such promising names as Borbecker Brutzelhütte or Erikas Braterei? This is where you can buy *Pommes rot-weiß* or 'red-and-white' chips with ketchup AND mayonnaise, shish kebabs and the inevitable *Currywurst*, that famous fried sausage smothered in ketchup and curry powder. *Currywurst* is serious business; the people of the Ruhr seem to be permanently engaged in a pseudo-religious war with the inhabitants of Berlin for the copyright and best quality of this simple dish. At least one *Ruhri* has written an ode to it (the Ruhr's token singer Herbert Grönemeyer). Germany's most popular one-legged bird (*halbes Hähnchen* or half a roast chicken) is still prized in the makeshift cafés

of the Ruhr despite stiff competition from the doner kebab et al. And just a quick look at the rest of the menu will remind you of the fact that the Ruhr is not very far from the Netherlands, with strange-sounding items such as *Bitterballen* (meatballs) and *Frikandel* (meatloaf sausages) available for consumption.

"When I grow up, I'm going to be a kiosk." This may seem a strange childhood prophesy – until you appreciate just how many thousands of tiny kiosks there are dotted about the region that trade a vast assortment of food, sweets and other objects of daily use through the open window. Once somewhere where miners came for their after-work tipple, kiosks are now a fixed feature in all parts of town and in some places on every main road, with three of four of these tiny shops often within sight of one another. Open until late in the evening, they will sell you the things you forgot or didn't have time to buy during the day. Let's hope that children still want to grow up to become kiosks for many years to come …

The days when beer was the ultimate working man's drink and indispensible in the proletarian circles of the Ruhr Basin are long gone. Just watching one of the TV ads posted by the brewing industry betrays a strong desire and will to penetrate more elevated spheres. Despite this, a glass of ice-cold pilsner undoubtedly tastes nowhere better than in the pub on the corner in the company of neighbours, colleagues and friends. Practically every town and city in the Ruhr also has its own brewery where you can spend a pleasant evening. Beer produced by such houses of renown as König in Duisburg, Jacob Stauder in Essen, Moritz Fiege in Bochum and the Dortmund Actien-Brauerei is highly prized by beer drinkers all over Germany.

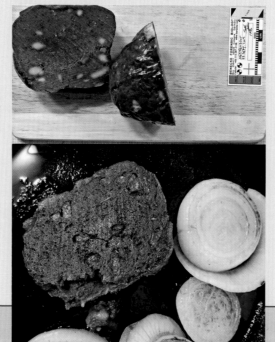

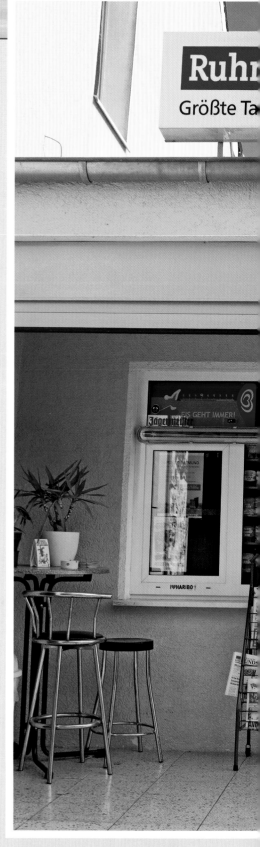

Trinkhalle

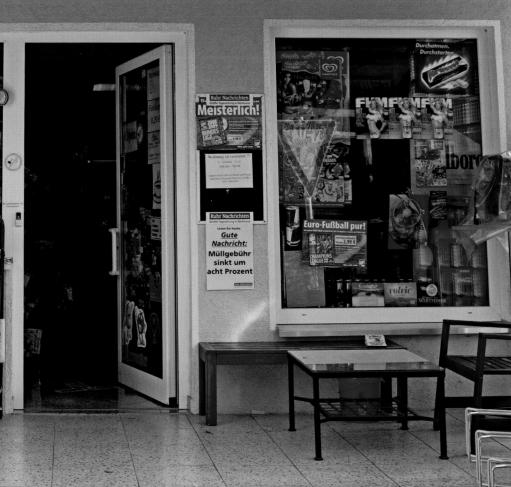

Small photos right, from top to bottom: The number of garden pubs along the River Ruhr is legendary. This sign points the way to the next watering hole near Hattingen.

A delicacy to die for: the simple, calorific, famous and hotly desired Currywurst.

It doesn't matter if you eat your Currywurst with a roll or chips. Just don't forget the ketchup and curry powder ...

Beer has long been a staple in the Ruhr. This landlord is tapping a glass of Schlegel-Bier in Oberhausen.

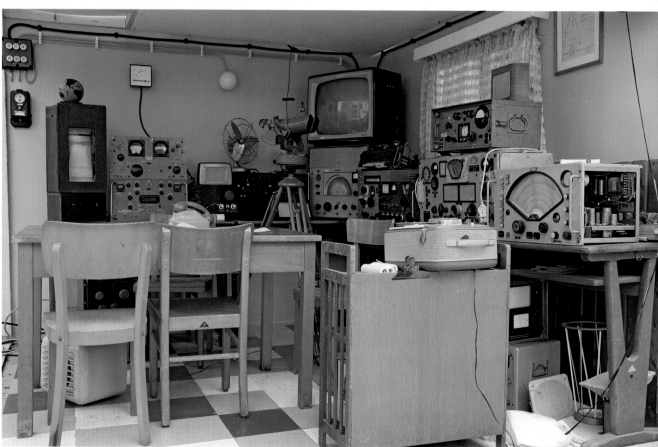

Above:
Aesthetically pleasing it's not; Bochum's university is better known for its size and expansiveness. It was also the first university to be founded in the Ruhr.

Left:
This "pig's snout" train from Wismar is just one of the treasures on show at the railway museum in Bochum-Dahlhausen, one of the largest of its kind in Germany. Days when the trains are running are a fixed feature in any railway buff's diary.

Page 104/105:
View from Blankenstein Castle of the Bochum suburb of Stiepel. Here in the Ruhr Valley heavy industry seem miles away.

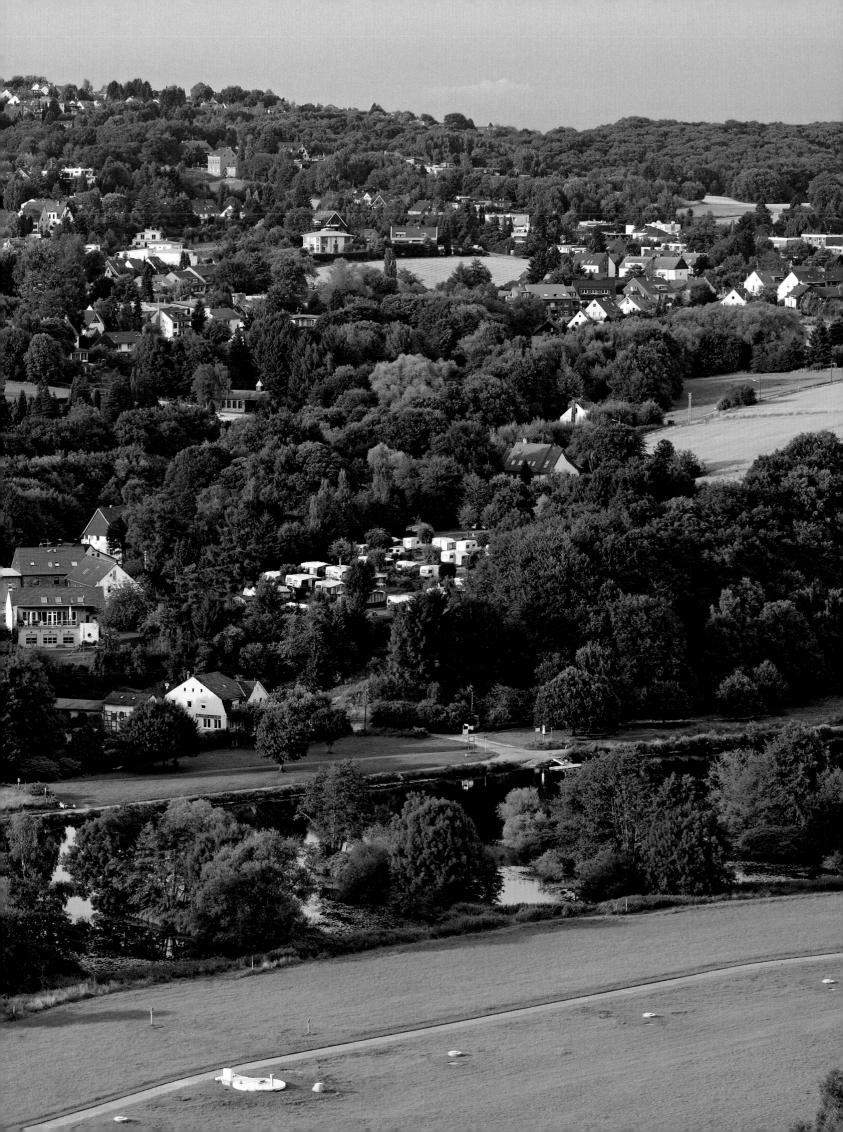

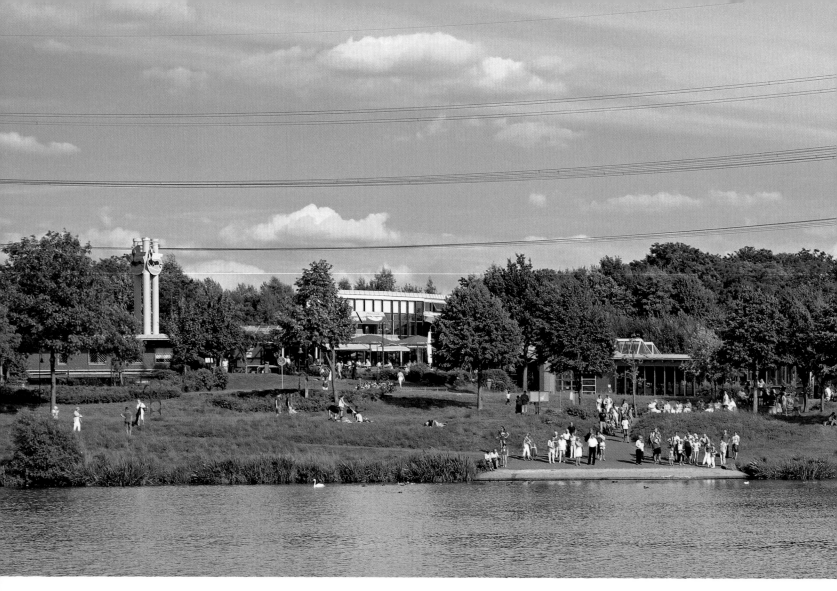

Above:
The River Ruhr not only provides the region it gives its name to with plenty of fresh water but is also a good source of recreation. Reservoirs like the Kemnader See are popular places of refuge.

Right:
You don't have to go to the coast to enjoy splashing around in the water. The lake at Kemnade is just as good for some aquatic fun and games.

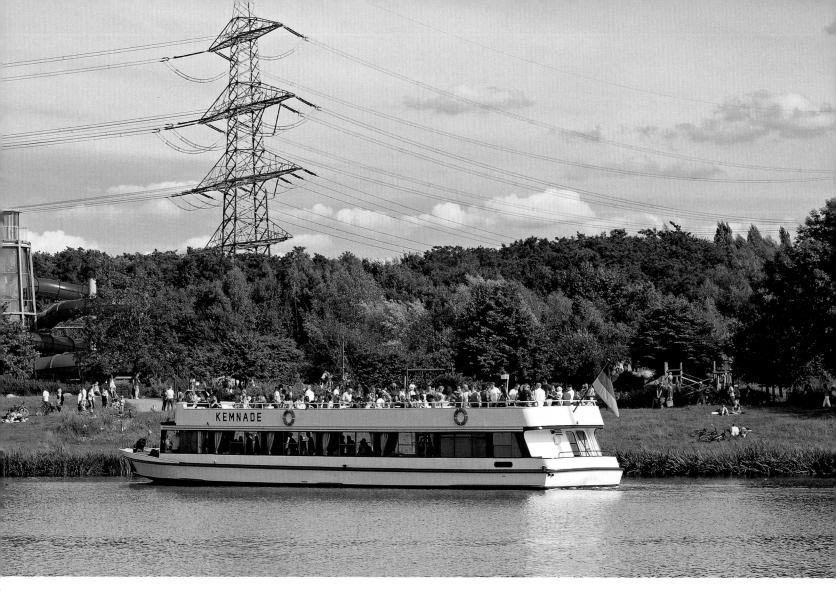

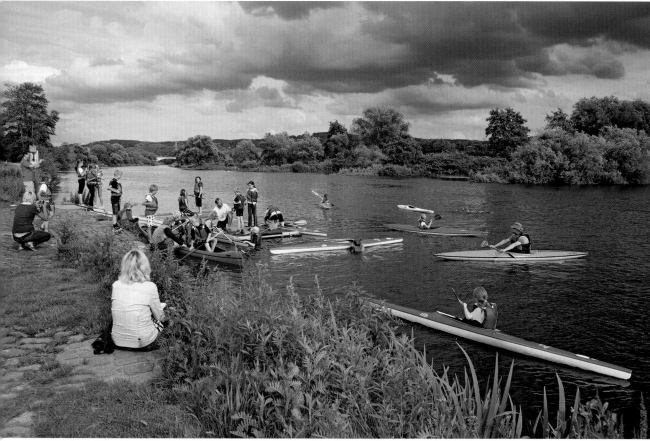

Left:
At the weekends and in the evenings the River Ruhr is busy with canoes and kayaks. Rhine barges can only navigate it as far as the river station in Mülheim an der Ruhr.

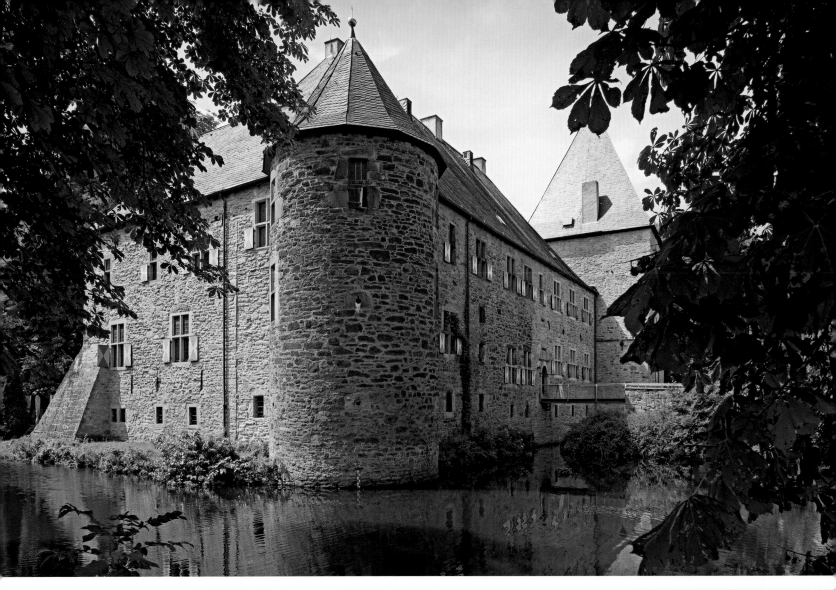

Above:
Haus Kemnade has pride of place on the water meadows of the Ruhr. The moated castle, which is on land belonging to Hattingen, is now owned by the city of Bochum and houses several museums.

Right:
The 800-year-old frescoes in the village church in Bochum-Stiepel, dating back to its founding years, make it one of the most unusual places of worship in Westphalia.

Above:
Large detached homes
with an identical plan
housing four families
were once typical of the
Stahlhausen workers'
estate in Bochum. Now on-
ly a handful remain, many
converted to provide just
two larger family units.

Left:
The houses in Stahl-
hausen have plenty of
space around them, a
feature that during the
days of heavy industry
was considered a great
privilege.

Above:
This semi-detached miner's house on Rudolf-straße in Lünen has been furnished as it would have been in the 1930s. The museum is run by a sponsorship association and is open three afternoons a week.

Right:
Home sweet home. The tidiness and cleanliness of the home was a pleasant contrast to the hard and dirty conditions down the pit.

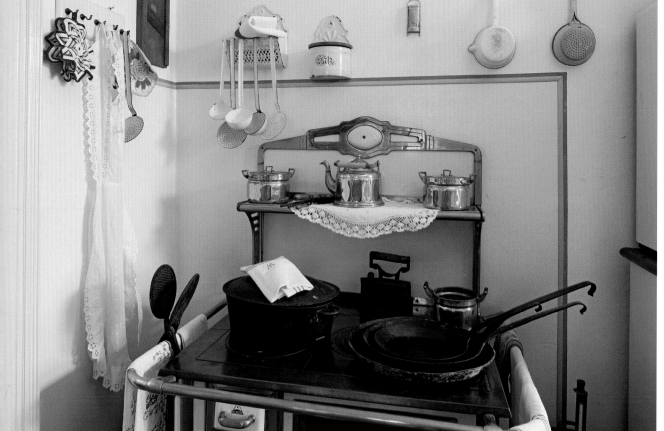

Above:
The kitchen dresser, here at the miners' museum home in Lünen, was one of the most important pieces of furniture in the house, where crockery, glasses, pots, pans and also food were kept.

Left:
Having a coal stove in the kitchen was of course obligatory in the Ruhr! Not only was the fuel readily available; miners were also given a coal allowance.

Below:

The historic moated castle of Strünkede is not what you'd expect to find in the middle of Herne-Baukau. The palace is heralded as one of the most beautiful Renaissance buildings of the 16th and 17th centuries in the west of Germany.

Bottom:

The Teutoburgia estate in Herne is a garden city par excellence. Not only the gardens are magnificent; the architecture of the houses is also pleasingly diverse and attractive.

Right:

A spectacular glass palace now stands where once the Friedrich der Große–Mont Cenis coal mine operated in Herne. One of its functions is to serve as an academy of further education for the North Rhine-Westphalian ministry of the interior.

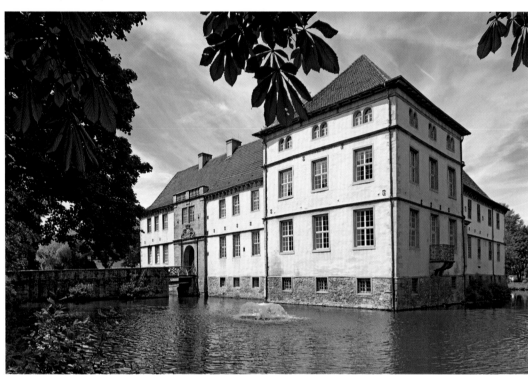

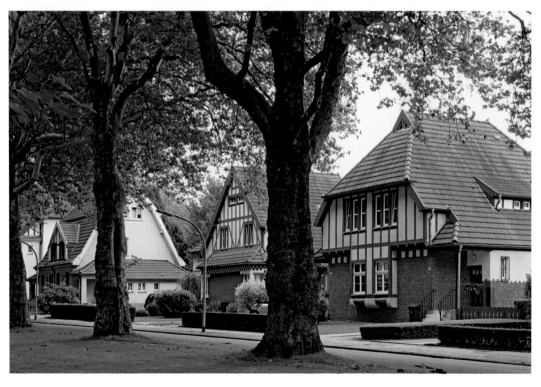

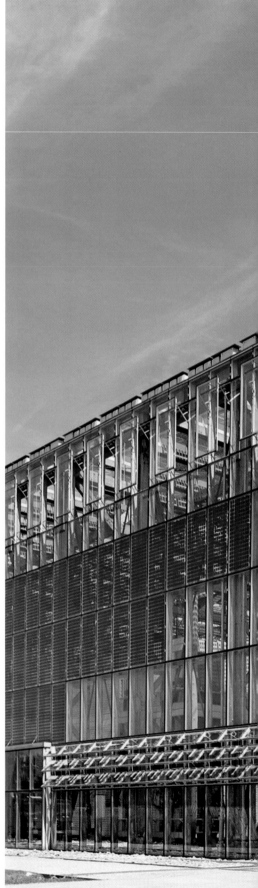

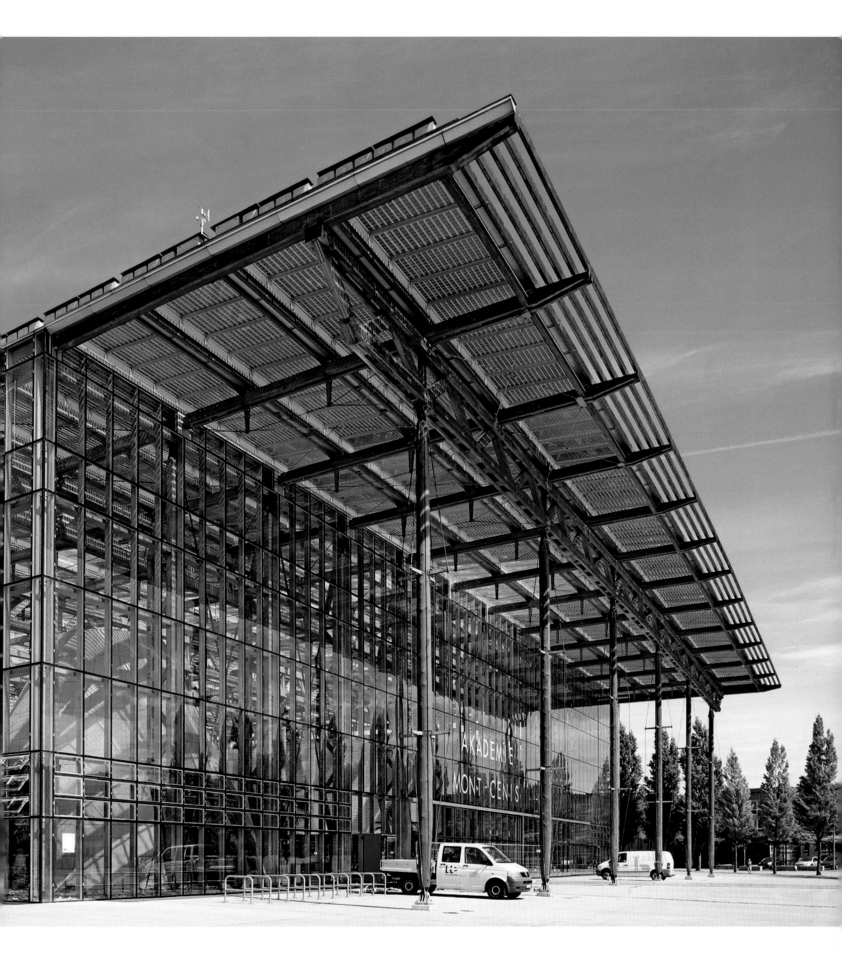

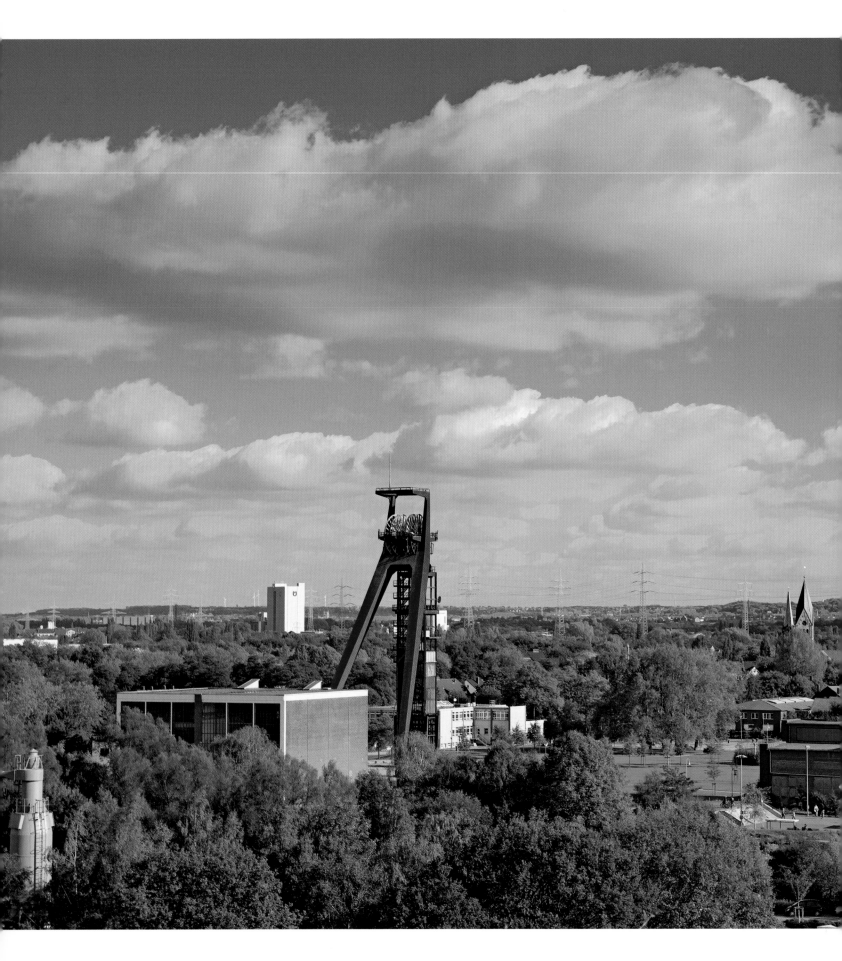

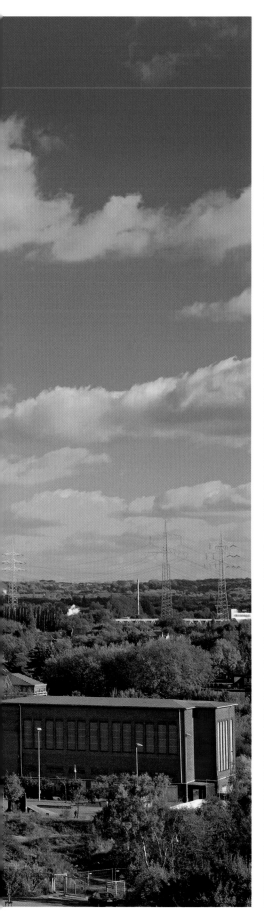

Left:
Together with the neighbouring Hoppenbruch the Hoheward mine dump to the south of Herten is the biggest in the Ruhr. Its many diverse vistas include this one out over the Zeche Klärchen pit in Emscherbruch.

Below:
The 'summit' of the Hoheward overburden heap is marked by a 'horizon observatory', a sculpture consisting of an enormous circle and two equally vast arches. It forms part of a network of landmarks that distinguish other mine dumps in the region.

Bottom:
You can see how quickly nature reclaims disused industrial land at the Hoheward waste dump. The former site is now a recreation area for the inhabitants of Herten and Recklinghausen.

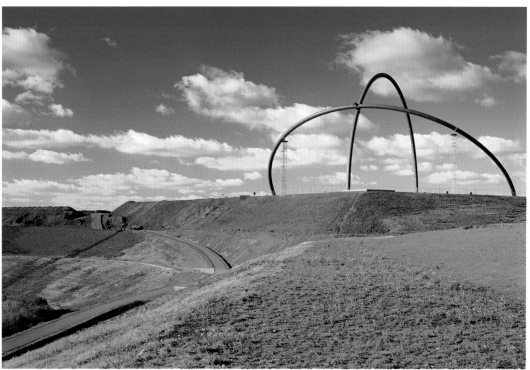

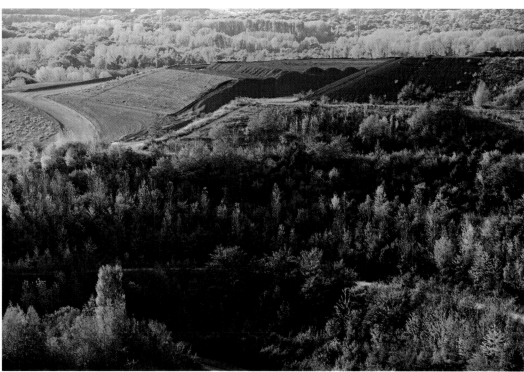

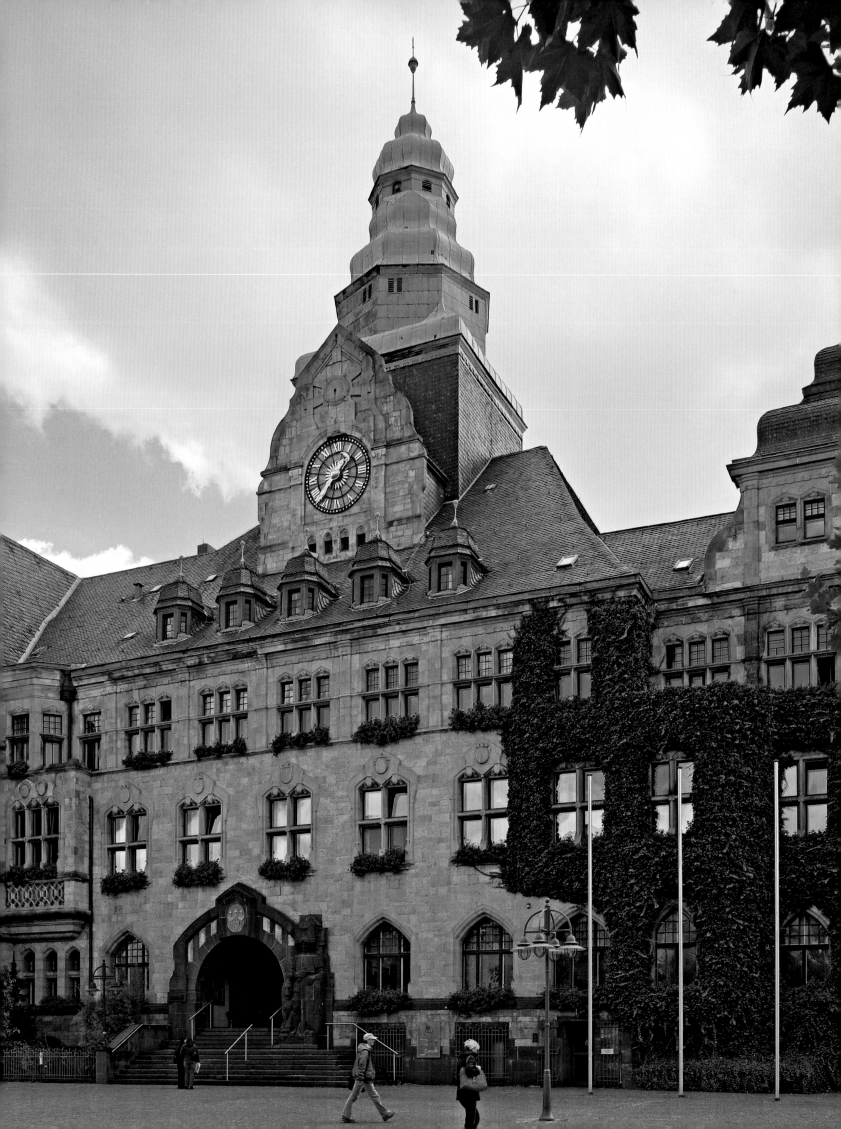

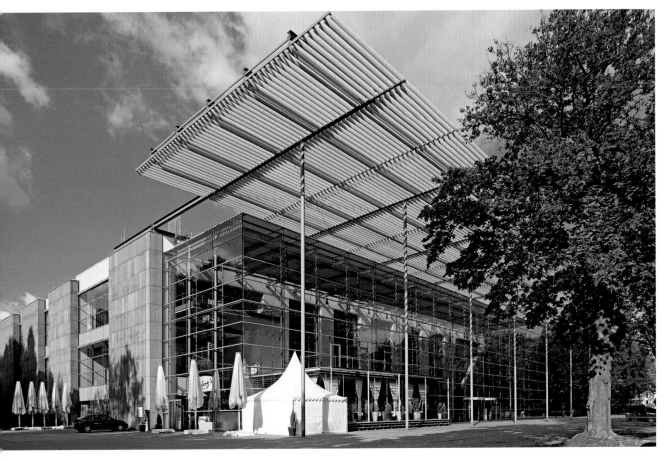

Left page:
The town hall in Recklinghausen from 1908 is said to be one of the most conspicuous pieces of municipal architecture in the industrial Westphalian Rhineland area. It is also historically symbolic, representative of what was once an aspiring mining town.

The Ruhrfestspiele in Recklinghausen are a cultural institution in Germany. Borne of the hardships of the post-war winters, they are now one of Europe's leading festivals of drama. Once a year the world of theatre congregates at Recklinghausen's Festspielhaus for the proceedings.

The North Sea, Baltic and Mediterranean are a long way off, prompting the canals and harbours to dream up ever more ingenious substitutes. Recklinghausen, for example, has a typical Ruhr ersatz in the Lemon Beach Club.

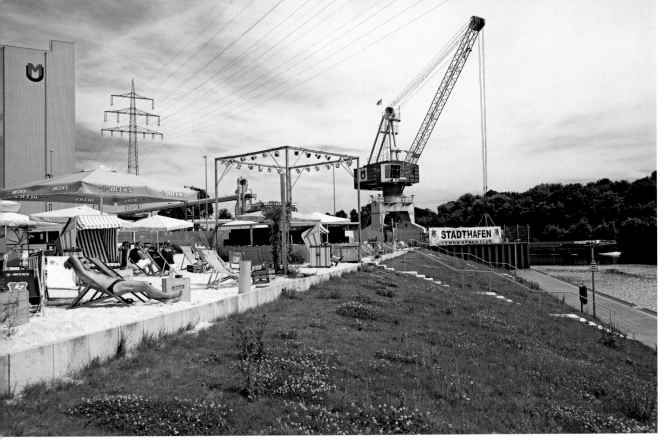

117

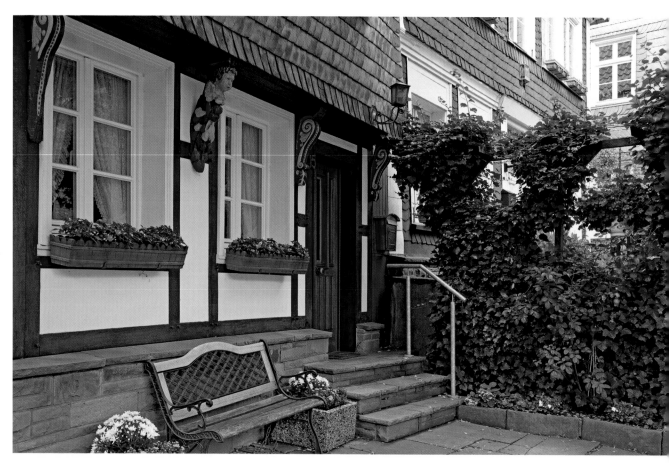

Right:
Hattingen's pride and joy is its medieval old town, packed with half-timbered houses from the 16ᵗʰ to 18ᵗʰ centuries. Despite once having one of the largest steelworks in the Ruhr Basin, the Henrichs-hütte (now closed), the town has managed to retain much of its provincial character.

Below:
The toll house in the old town of Hattingen. The slate cladding is typical of houses in the Bergisches Land which has its northernmost boundary here.

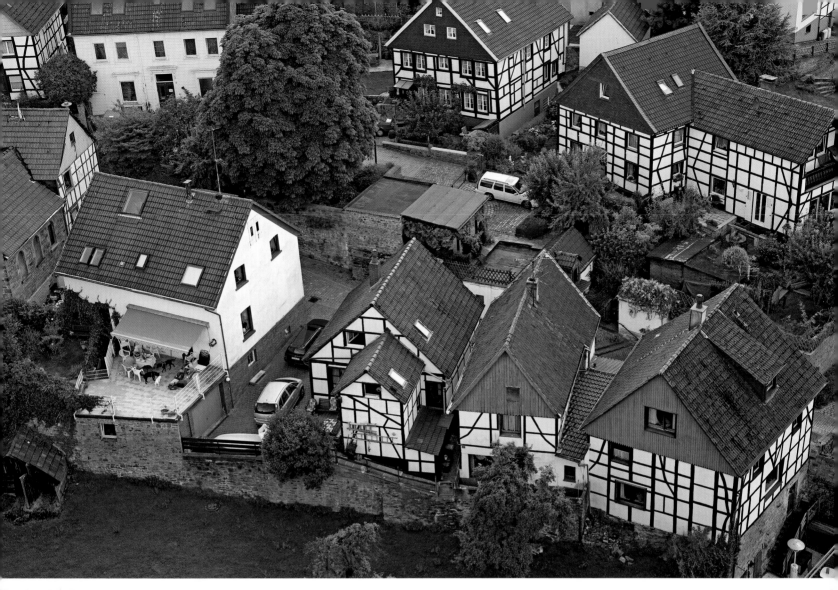

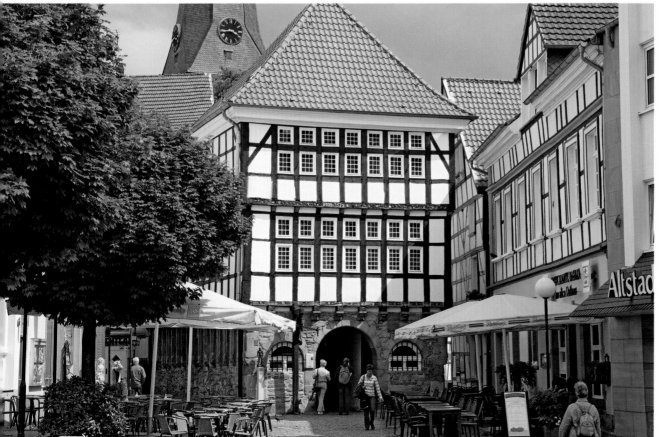

Above:
The castle in Hattingen-Blankenstein towers high up above the old town, with the houses spread out like a town plan in 3D beneath its walls and turrets.

Left:
The splendid Renaissance town hall in Hattingen from 1576 smacks of the wealth of a town that once belonged to the Hanseatic League. The extraction of iron ore and also cloth-workers, tanners and merchants helped guarantee the town a long period of prosperity.

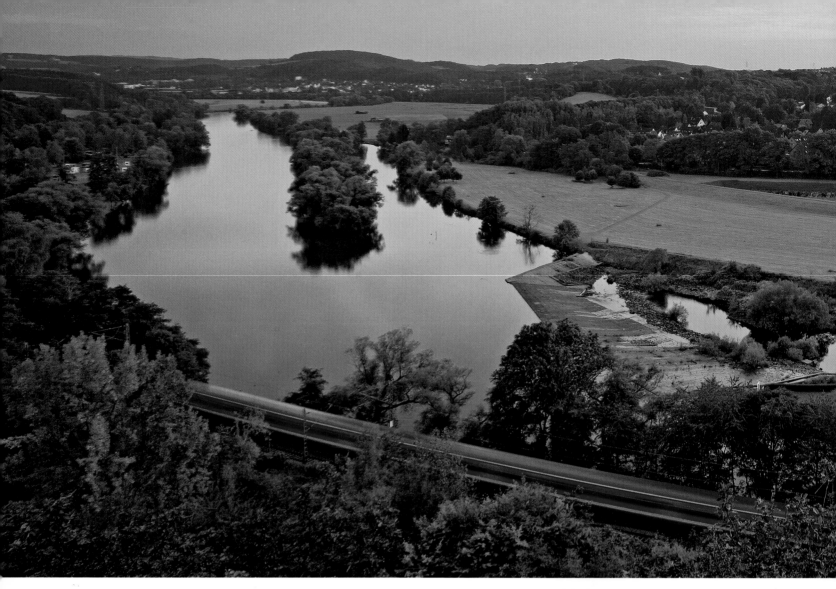

Above:
Dusk on the Ruhr near Witten. The hydroelectric power station of Hohenstein is one of many which help to power the industries of the Ruhr Basin.

Right:
Close to the ruins of Hardenstein Castle near Witten-Herbede a small ferry takes people, animals and bicycles across the narrow Ruhr. With the laying out of a cycle track along the banks of the river from its source to its confluence, interest in cycling here has boomed.

Hardenstein

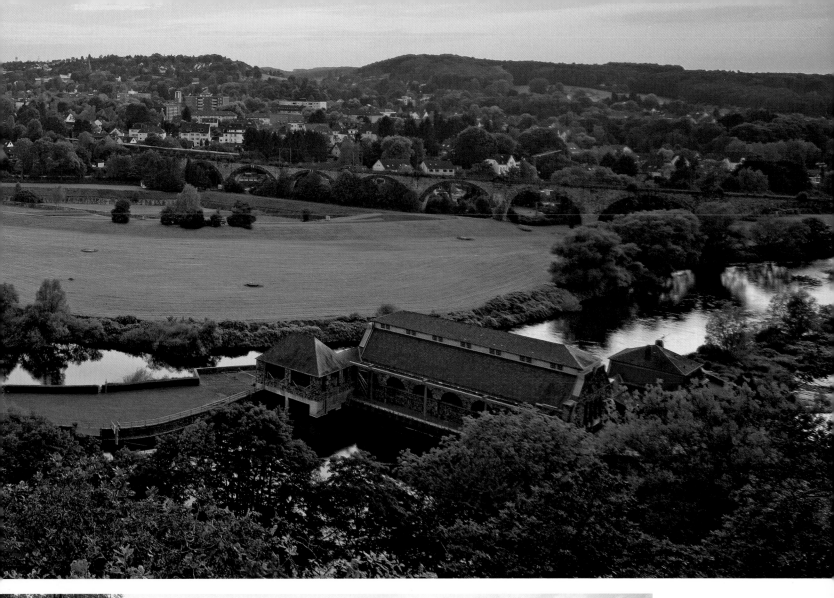

Left:
Like the proverbial phoenix, many of the older houses in the Ruhr have taken on a new lease of life following extensive restoration and are now much sought after, not least for their lovely gardens.

Page 122/123:
Typical Ruhr scenery from the Harkortberg near Wetter. The lake of Harkort between Hagen, Herdecke and Wetter not only acts as a purifying plant for the river; it also has a permanent campsite and caravan site. In the background is the distinctive Ruhr viaduct.

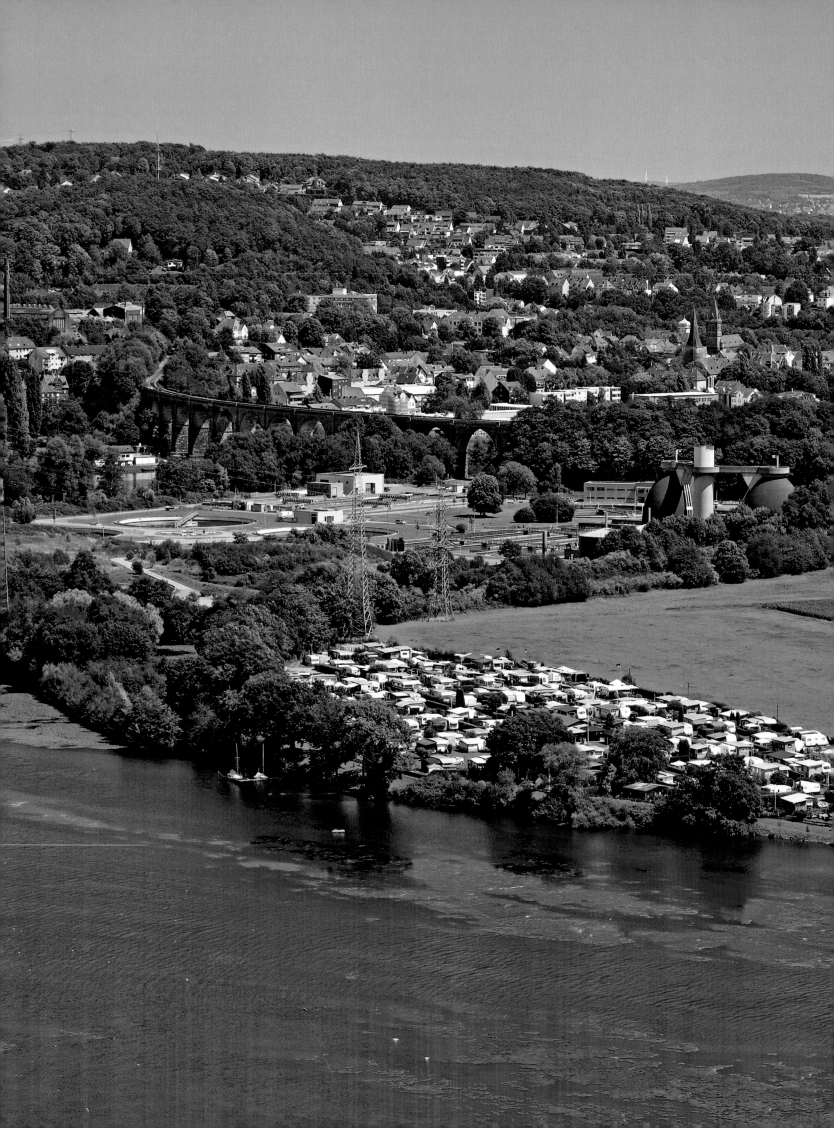

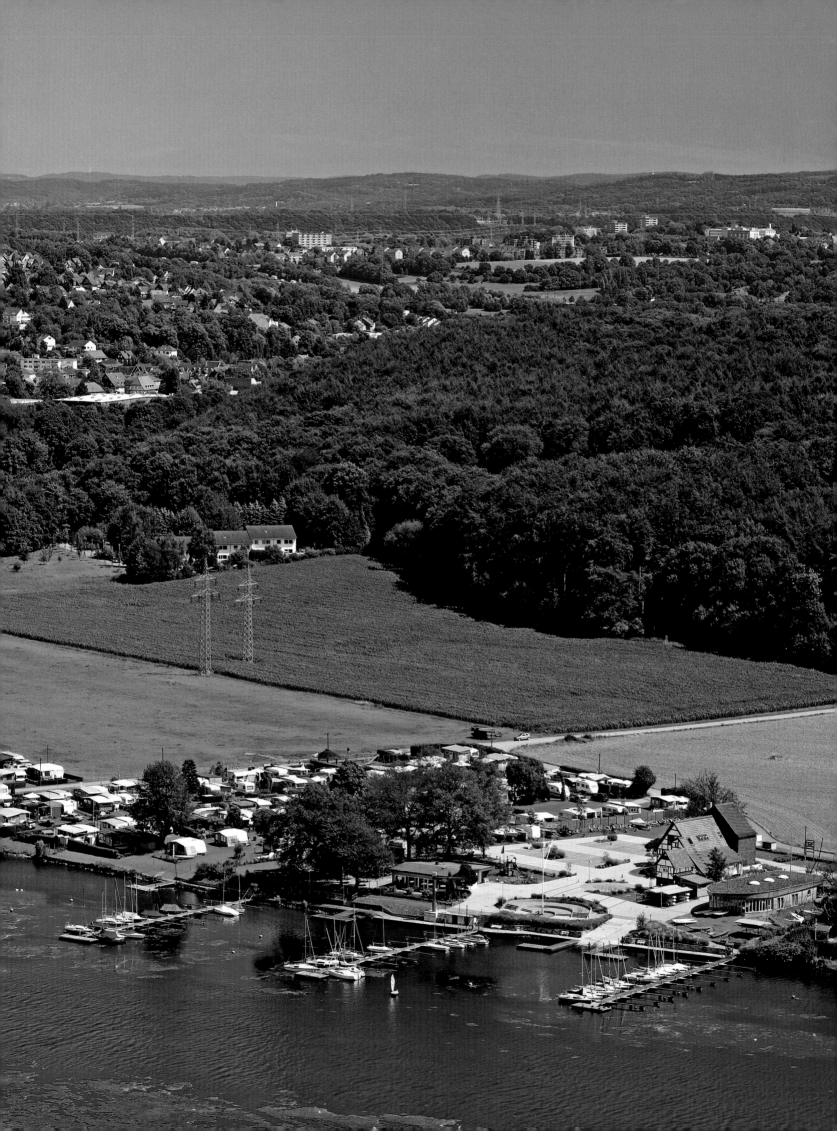

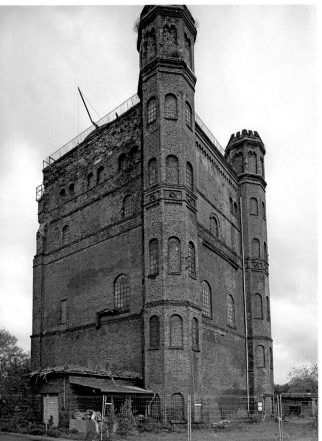

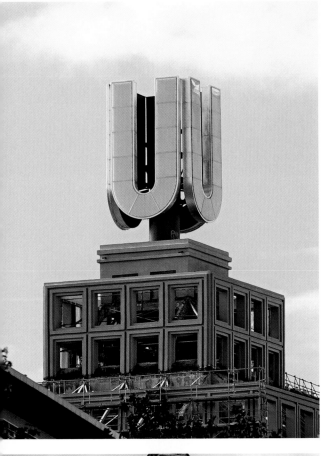

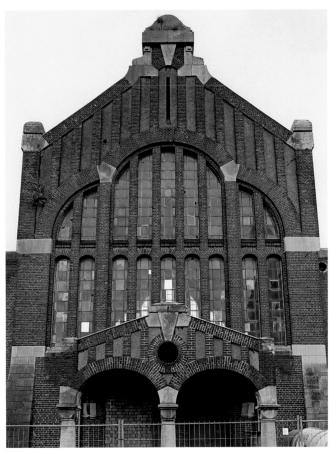

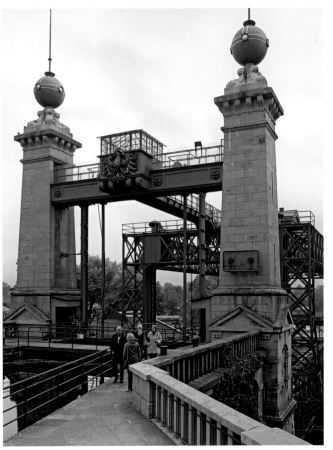

Left page:
The architects of the harbour authority offices in Dortmund based their designs on the coastal towns of North Germany and The Netherlands. The neo-Renaissance building, completed in 1899, is now part of the largest canal port in Europe.

Far left:
The giant U on the site of Dortmund's old Union-Brauerei, visible far and wide, now adorns the roof of a humming arts centre. It used to be the logo of what was one of the largest breweries in the world.

Left:
A giant from the days of yore: the Malakoffturm at the Westhausen colliery.

Far left:
The industrial age also produced some grand architecture, such as this payments hall at the Zeche Westhausen in the Dortmund suburb of Bodelschwingh.

Left:
Perhaps the most famous industrial monument in the Ruhr is the Henrichenburg ship hoist in Waltrop that attracts visitors from all over the world to the Dortmund-Ems Canal. On its closure in 1970 it began to fall into ruin; now this magnificent feat of engineering is part of Westphalia's industrial museum.

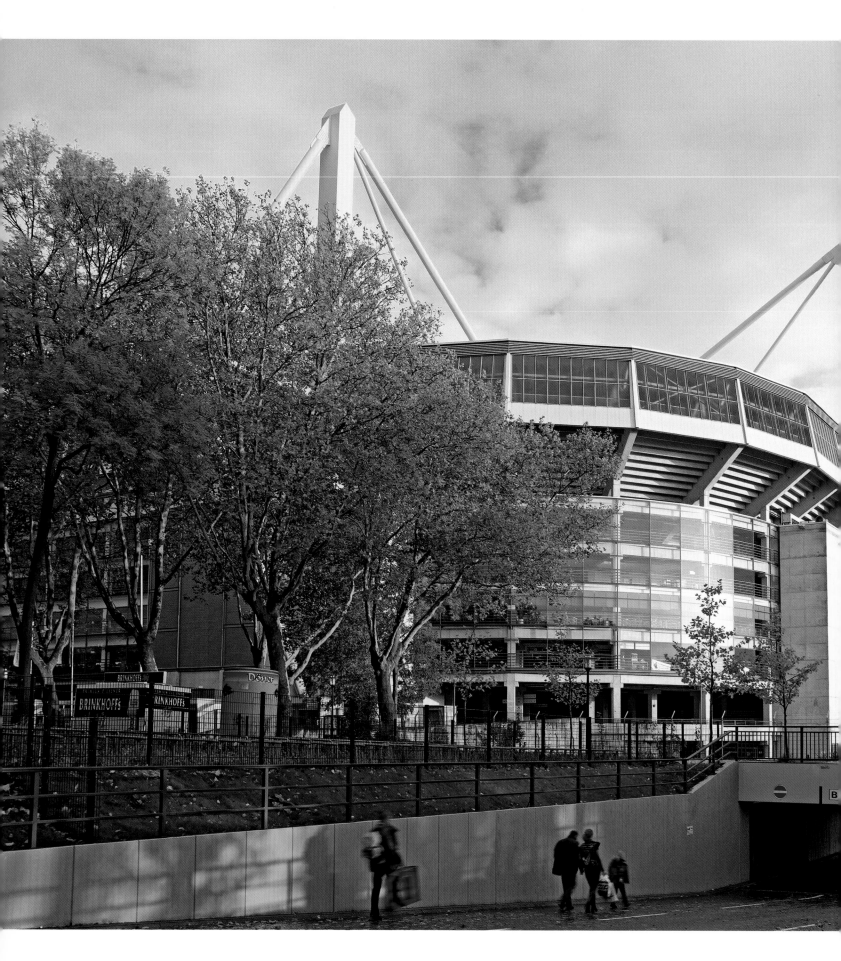

Left:
Every second weekend during the German FA Cup Signal Iduna Park vibrates to the raucous cheers of thousands of fans shouting for their home team, Borussia Dortmund.

Below:
With 80,500 seats the Borussia Dortmund stadium is the largest used solely for football in Germany. Its distinctive yellow pylons are visible for miles around.

Bottom:
Football has always played a big role in the Ruhr. The players of Borussia Dortmund have fired the enthusiasm of crowds over many decades. The highlights of the club's history include six German titles and winning the European Cup Winners' Cup in 1966 and the Champions' League in 1997.

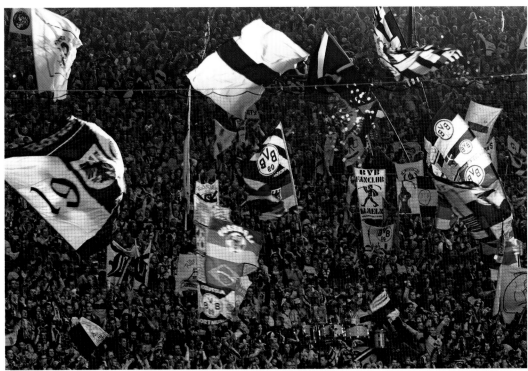

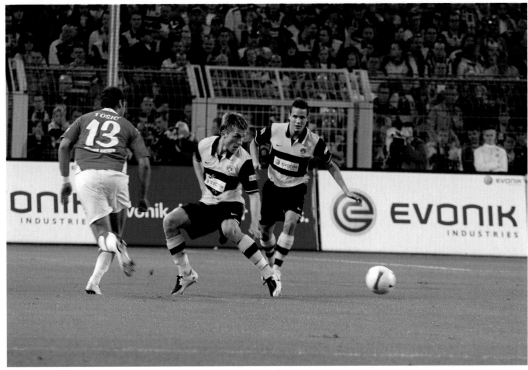

127

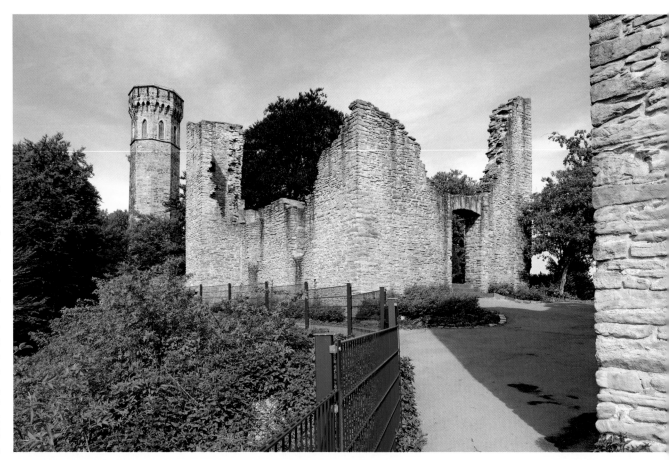

Right:
The ruins of the Hohensyburg in the south of Dortmund. From the plateau 220 m / 720 ft up there are lovely views of the Hengsteysee and the valley of the Lenne which flows into the River Ruhr beneath the castle.

Below:
Very few historic buildings still stand in the centre of Dortmund. One of these is the Reinoldikirche, an aisled basilica with a nave and lofty west tower, the latter now a local landmark.

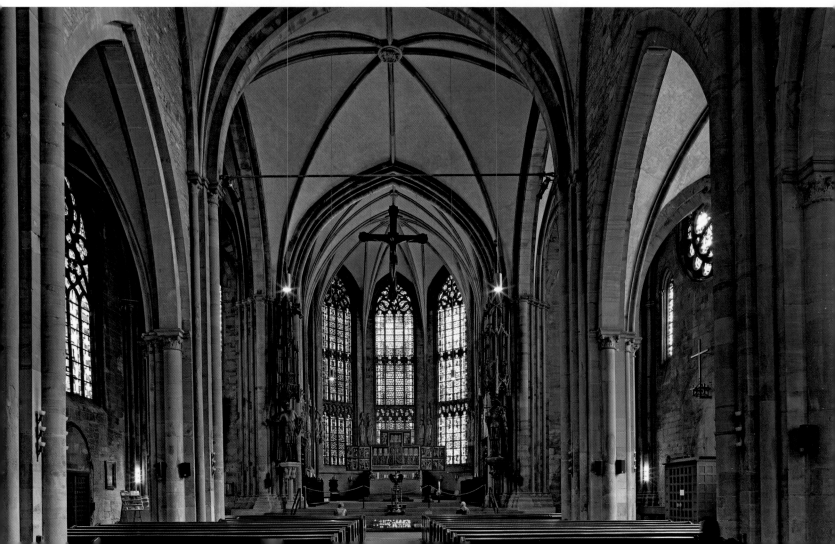

Above:
Dortmund's city and state library is distinguished by its clarity of form and was erected between 1996 and 1998. It was designed by Swiss star architect Mario Botta.

Left:
The centre of Dortmund is not only busy on sunny days. With about 580,000 inhabitants and a huge range of shops and cultural activities, the Westphalian metropolis has a large catchment area.

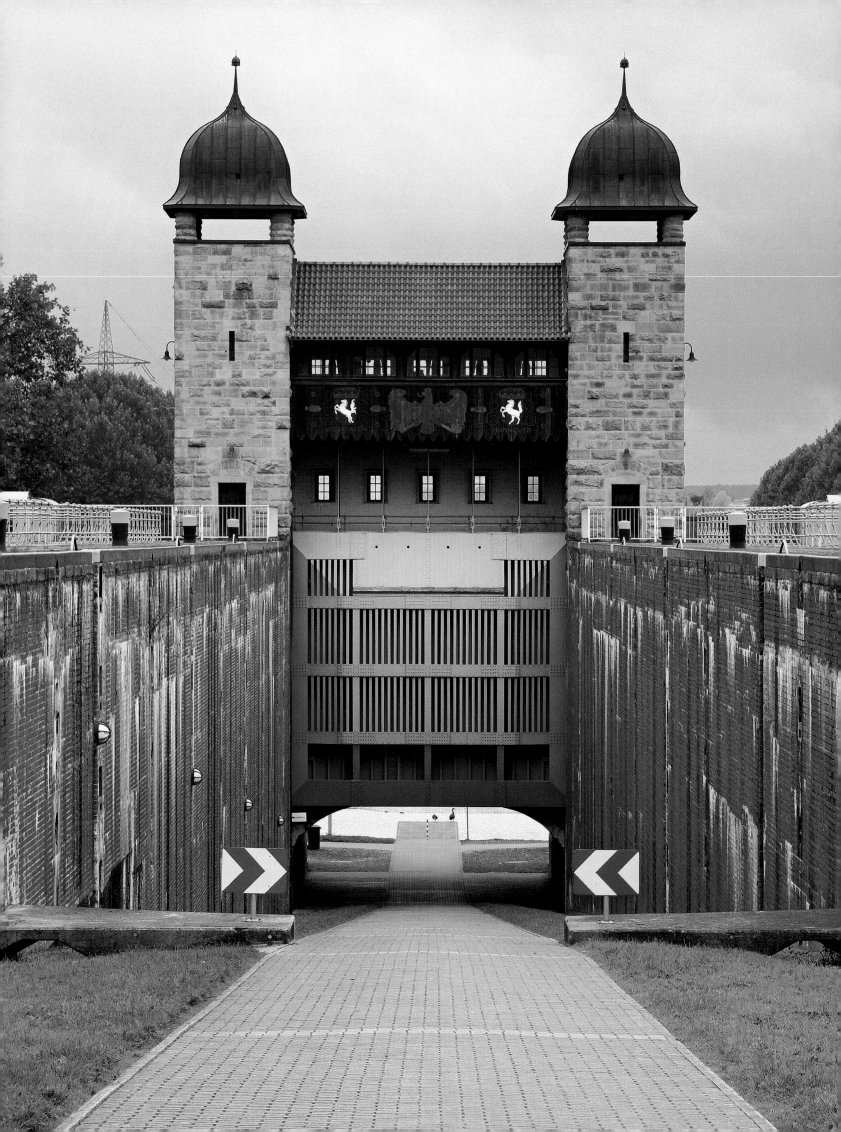

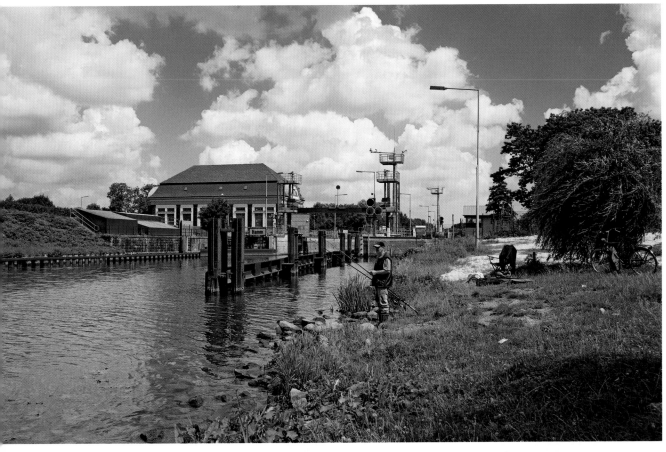

The Hamm lock on the
Datteln-Hamm Canal. The
calm waters upstream
of the lock provide ideal
fishing conditions, with
carp a good catch here.

Taking a break in the
harbour. River barges are
very much part of life in
nearly all of the towns
between Duisburg and
Hamm.

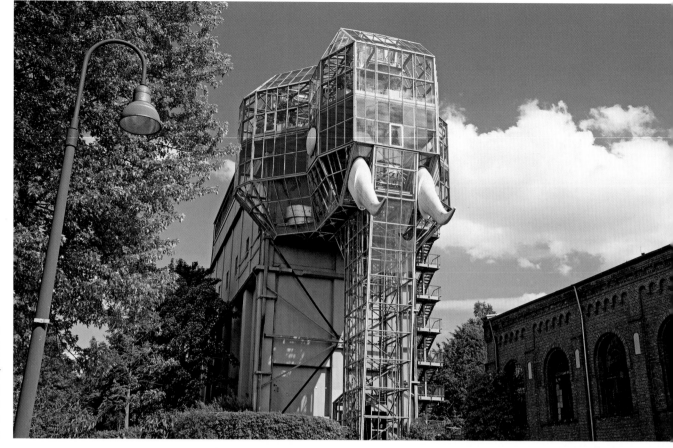

This glass elephant in the Maximilianpark in Hamm is one of the more unusual architectural treatments of a disused industrial site. It adorns what was once the coal washing plant at the Maximilian colliery.

One of the largest South Indian temples in Europe is in Hamm, providing a novel contrast in the otherwise typical industrial environment of the Ruhr. Built in keeping with stringent ritual guidelines, the Sri Kamadchi Ampal Temple was opened in 2002.

Right page:
Have aliens landed in the Ruhr? The giant Colani 'egg' gracing the top of the old winding tower at the Minister Achenbach colliery in Lünen certainly has something extraterrestrial about it! The giant UFO is in fact a set of offices, symbolic of structural change in the region as is their location: the LÜNTEC centre of technology.

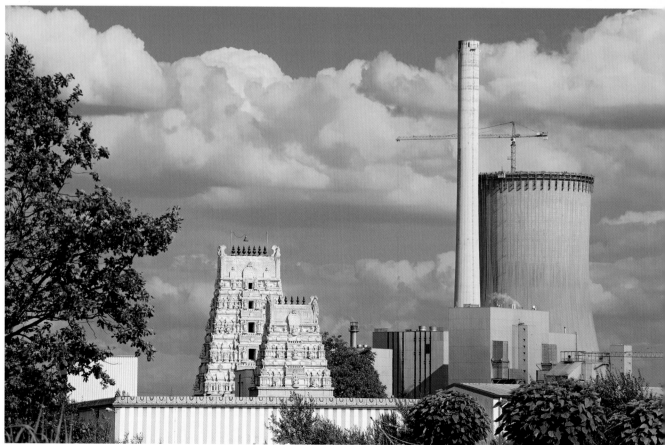

Index

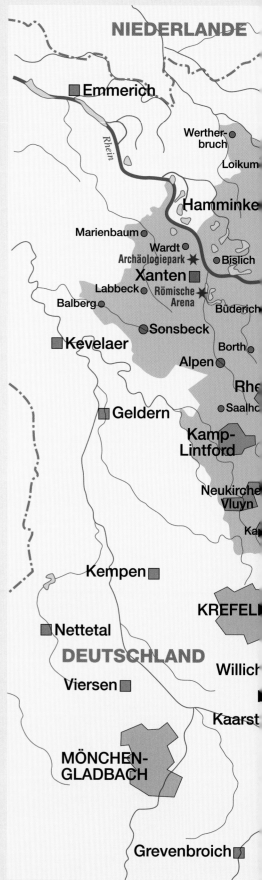

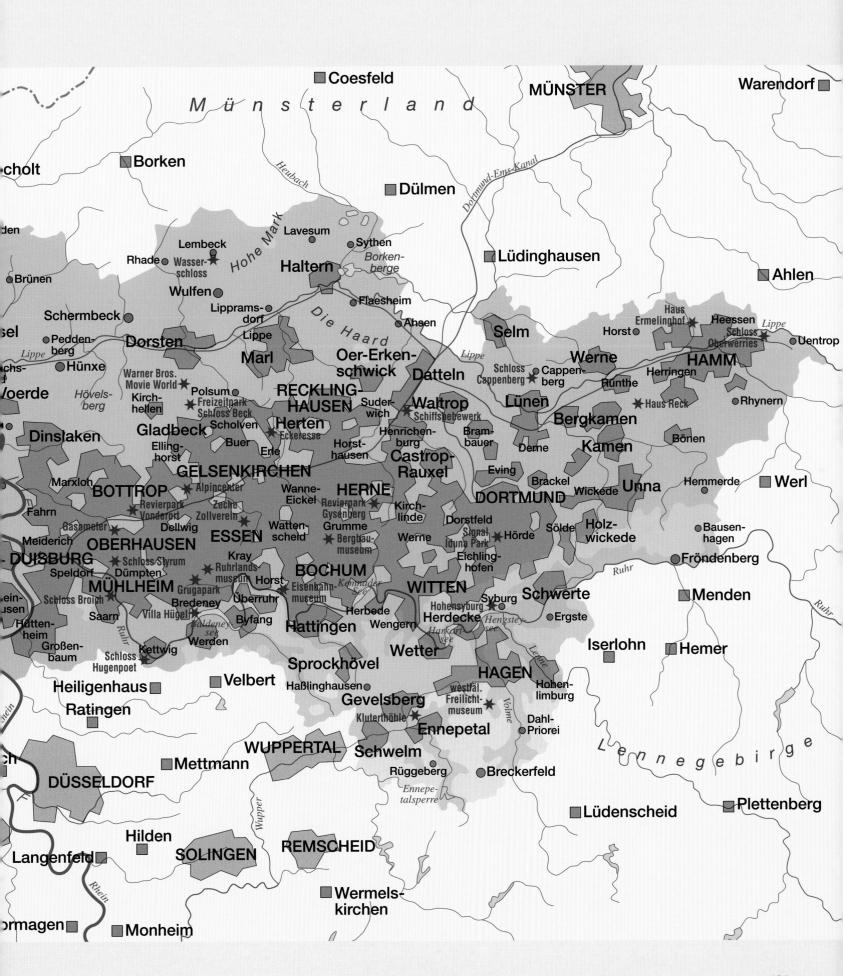

The day's done, time to clock off. How about a quick beer from this kiosk in Dortmund?

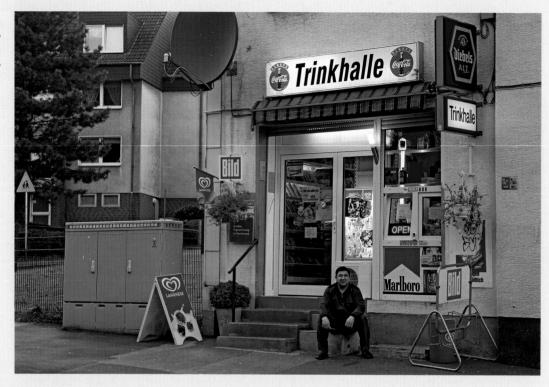

Design
www.hoyerdesign.de

Map
Fischer Kartografie, Aichach

Translation
Ruth Chitty, Stromberg
www.rapid-com.de

Printed in Germany
Repro by Artilitho snc, Lavis-Trento, Italy –
www.artilitho.com
Printed/Bound by Offizin Andersen Nexö, Leipzig
© 2010 Verlagshaus Würzburg GmbH & Co. KG
© Photos: Brigitte Merz
© Text: Reinhard Ilg and Christoph Schumann

Photo credits
All photos by Brigitte Merz with the exception of:
p. 100 links: mark benecke and kristina baumjohann /
www.benecke.com
p. 127, top and bottom: Borussia Dortmund / www.bvb.de

ISBN 978-3-8003-4064-4

Details of our programme can be found at:
www.verlagshaus.com

Glückauf